WOMEN PHOTOGRAPHERS

AT NATIONAL GEOGRAPHIC

Cathy Newman

WOMEN PHOTOGRAPHERS

AT NATIONAL GEOGRAPHIC

Cathy Newman

NATIONAL GEOGRAPHIC

Washington, D.C.

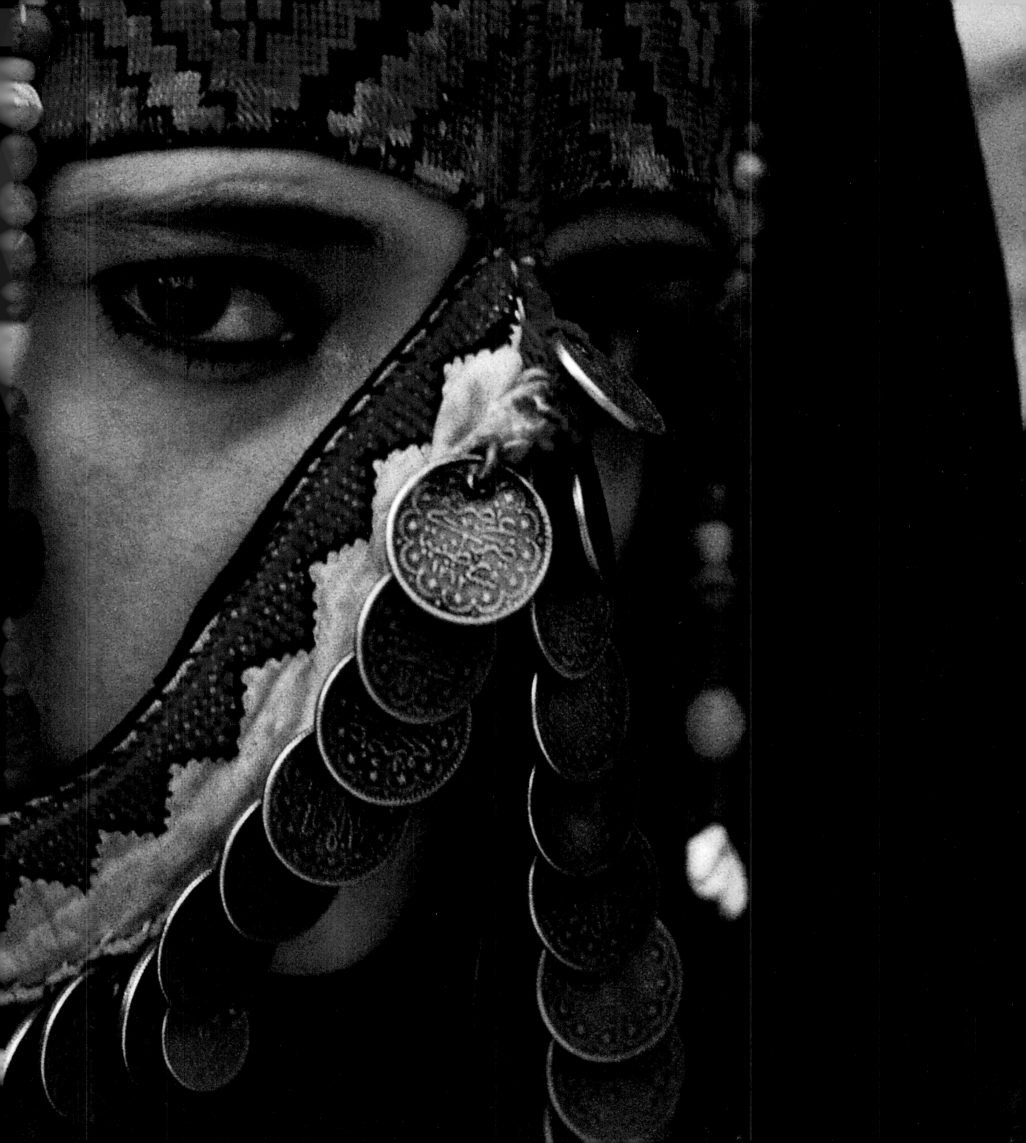

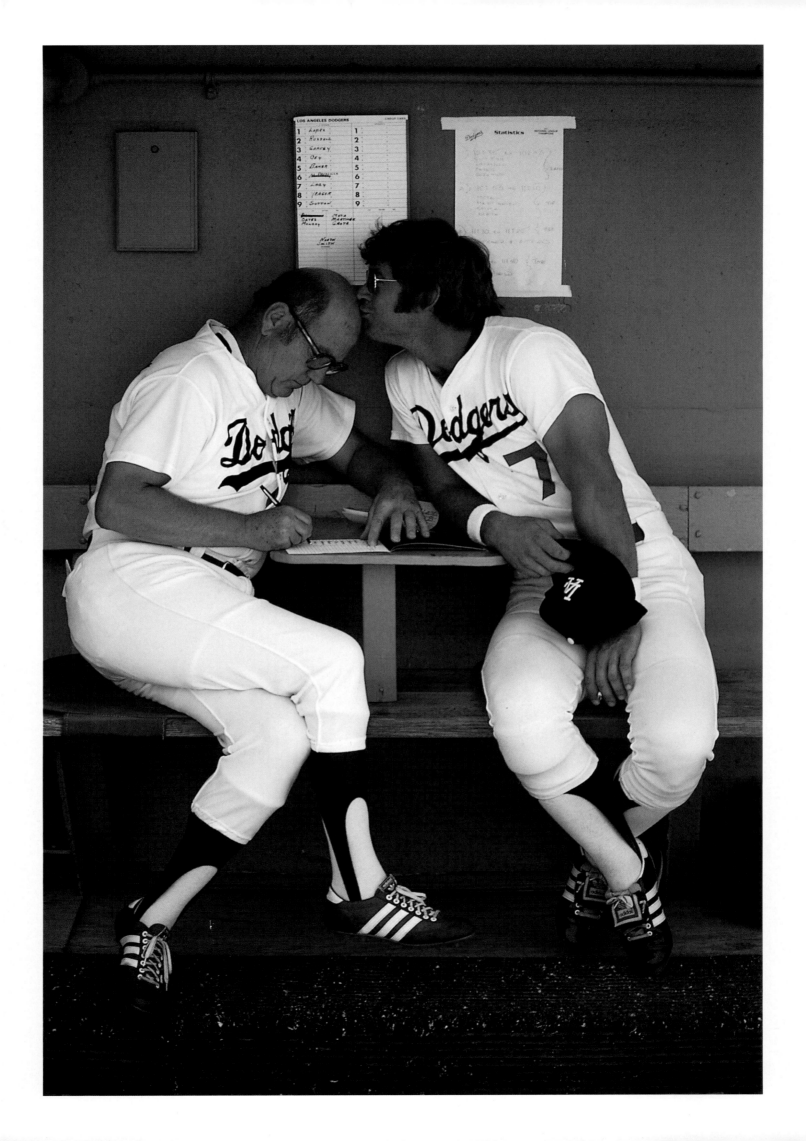

TABLE OF CONTENTS

Foreword by Tipper Gore
Introduction by Naomi Rosenblum

JOANNA PINNEO • JORDAN 1992
A young woman models the traditional finery of her Palestinian culture.

JODI COBB • LOS ANGELES 1979
Fa r play: Los Angeles catcher Steve Yeager gives coach Monty Basgall a big smooch on the head.

PORTFOLIO: SUSIE POST • ARAN ISLANDS 1995 A setting sun heightens the Irish beauty of Maírín Ní Fhlatharta
JODI COBB • NICE 1998 Finalists in the Elite Model Look compete in the search for a new look and fresh face.
ANNIE GRIFFITHS BELT • WYOMING 1997 Yellowstone National Park in winter turns into a bare-bones landscape.
JODI COBB • HONG KONG 1991 A Vietnamese child peers through the wire mesh walls of a refugee camp.
DES AND JEN BARTLETT • NAMIBIA 1983 A herd of elephant cows and their young drink at a
watering hole at Etosha National Park.

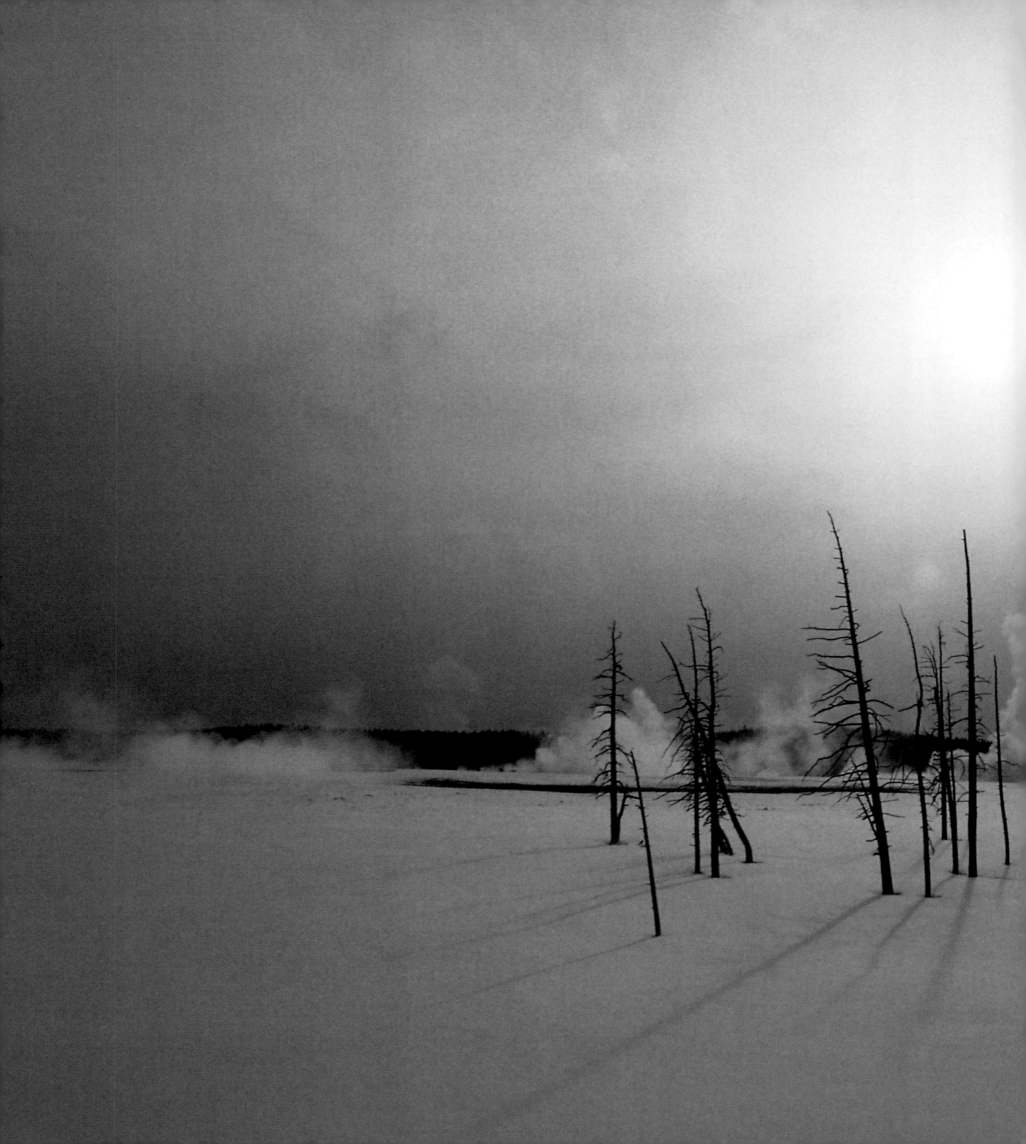

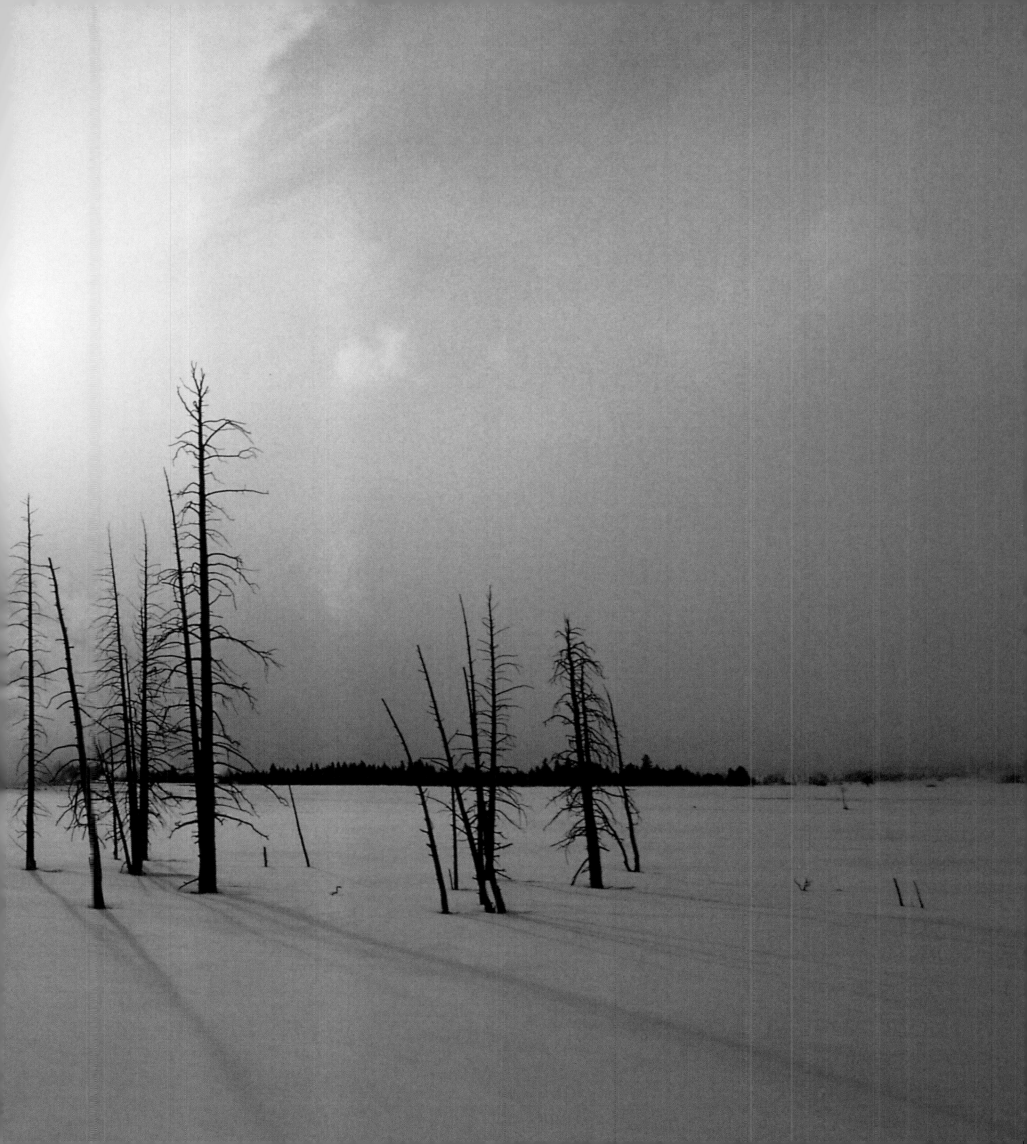

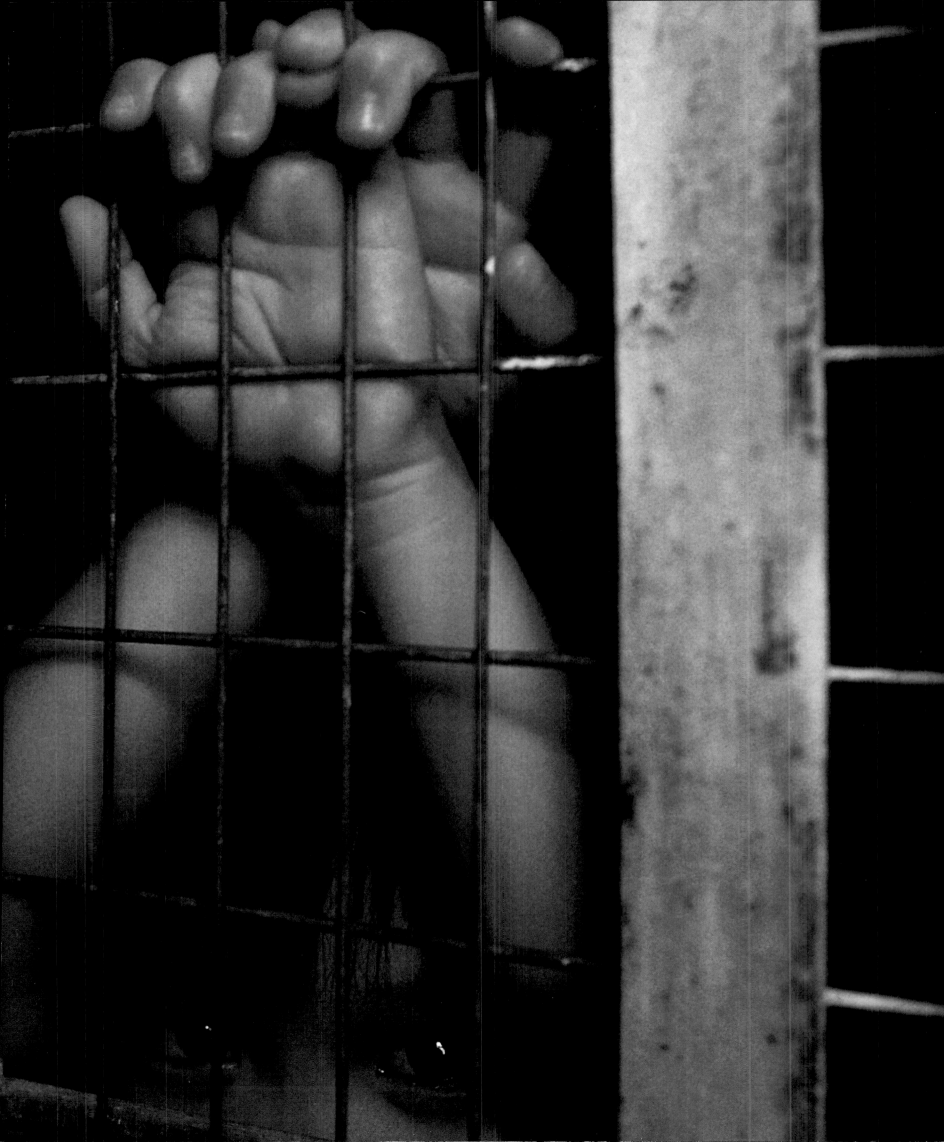

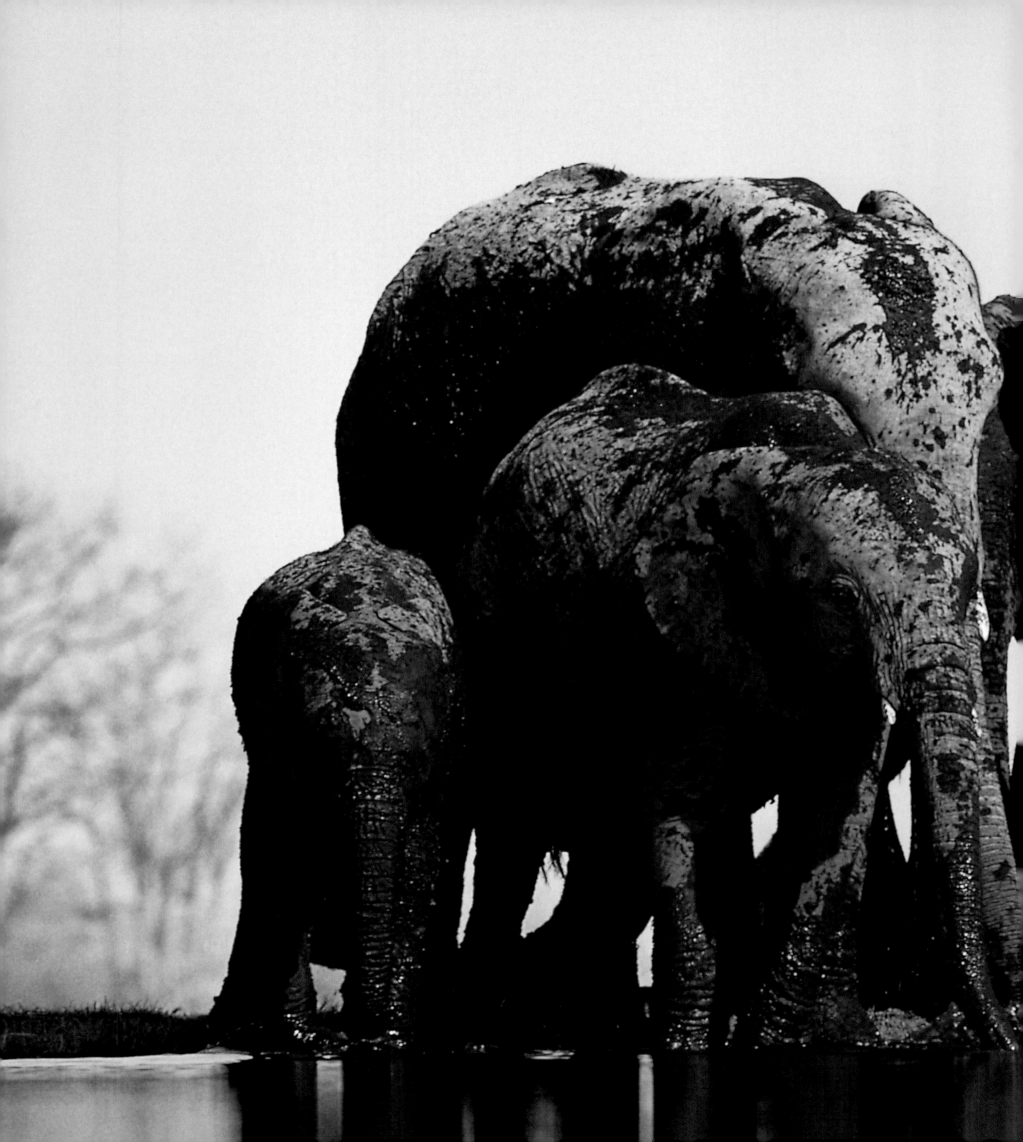

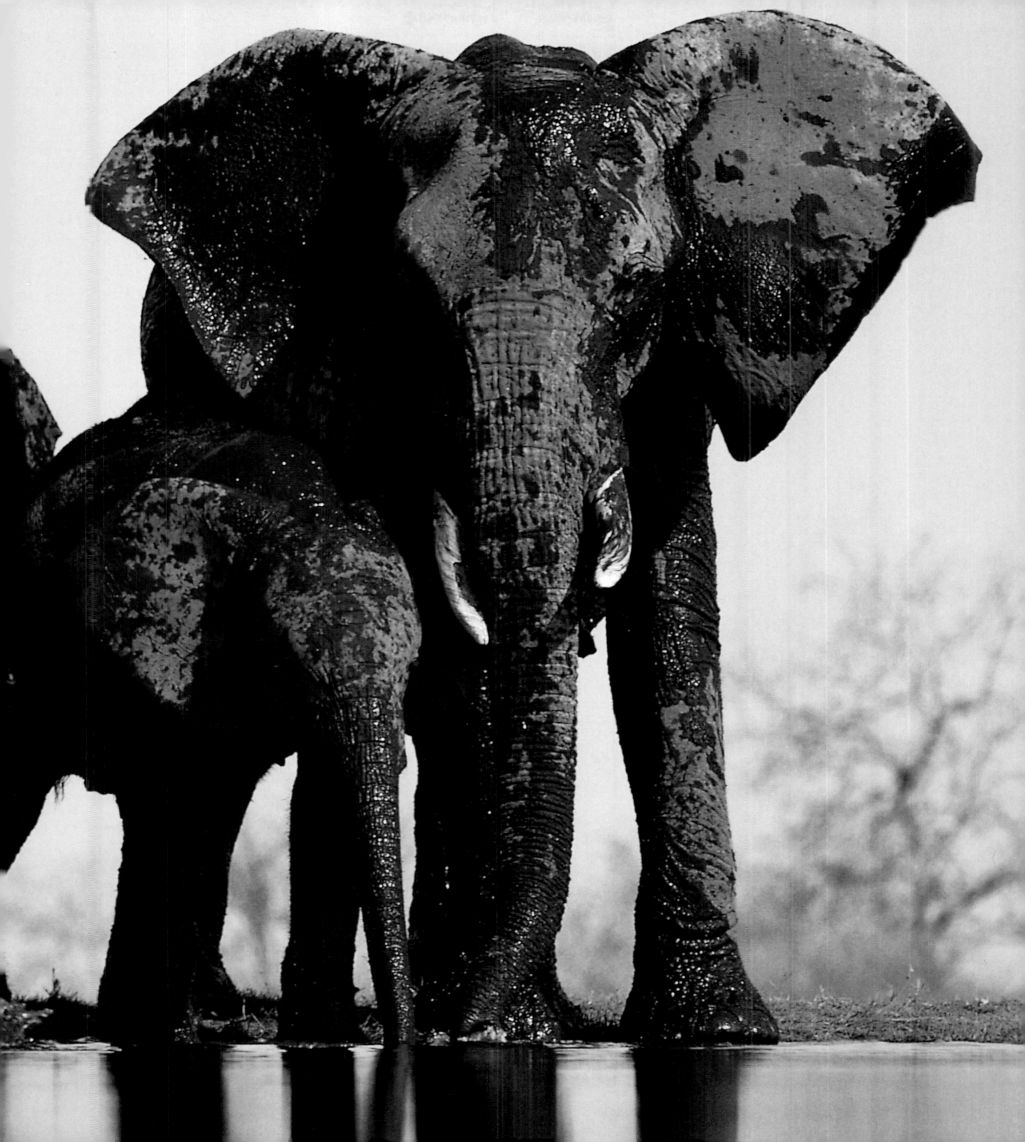

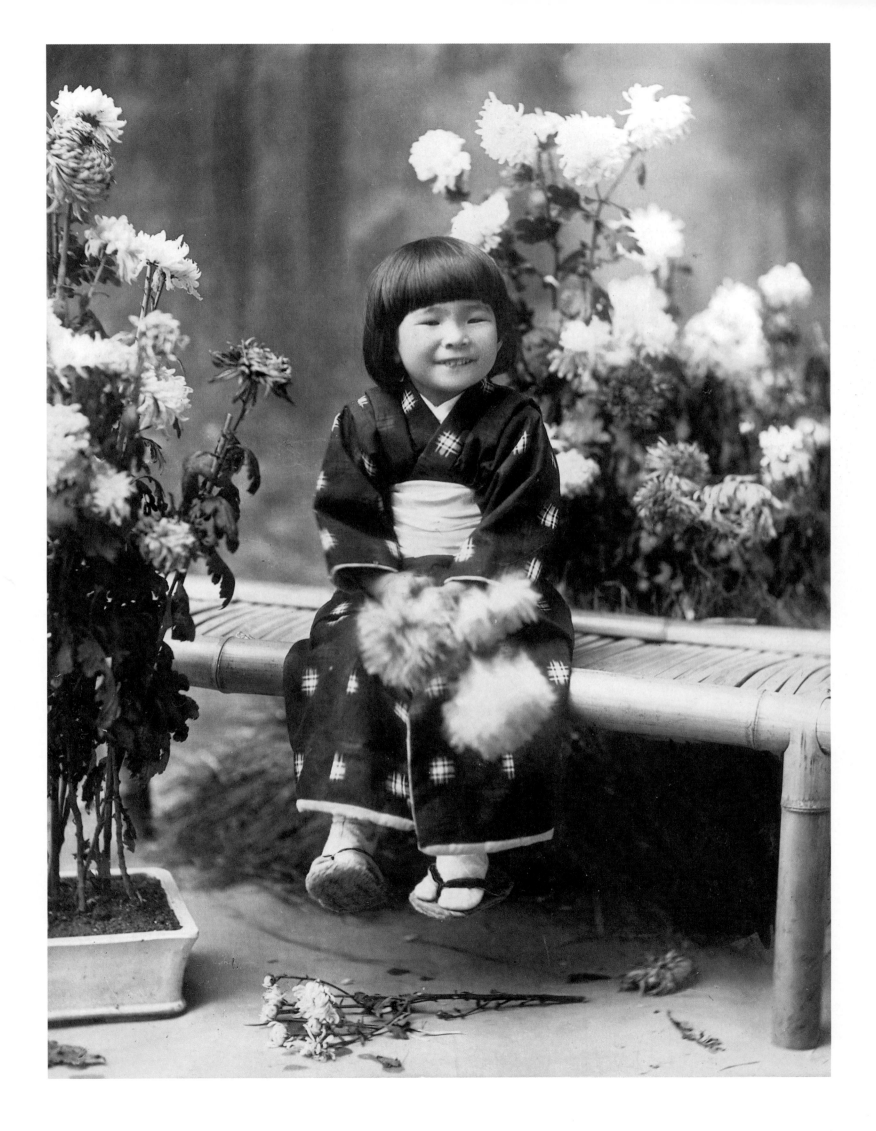

Introduction
by Naomi Rosenblum

IN A PHOTOGRAPH TAKEN IN 1967 and inscribed "greatest photographic team in the world," 25 properly suited men are gathered around the desk of NATIONAL GEOGRAPHIC Editor Melville Bell Grosvenor. The image suggests that the universal language of the photograph upon which this publication (and many others) depended was solely a contribution of the male eye and mind. Such a conclusion would be misleading, in part because women photographers had already been making images for NATIONAL GEOGRAPHIC for more than 50 years, and in part because camera work by professional women had become increasingly visible in exhibitions and magazines. Some 30 years earlier, the photographs for the cover and for a feature article in the first issue of *Life* had been taken by a woman—the then renowned Margaret Bourke-White.

American women had become actively involved with making camera pictures in the late 1880s, but long before that a few women were devotees to the medium. Of the two processes that were announced almost simultaneously in 1839, one—the negative-positive process (first using paper for negative and print, and later glass for the negative and albumen-coated paper for the print)—appealed especially to upper-class British women. These "ladies" had the leisure time and, one presumes, the interest in both art and science to occupy themselves with what then was a messy and untried picture-making technique. Despite the fact that photographic chemicals stained clothing and flesh, the women used the new medium to record family, friends, and landscapes. One, Julia Margaret Cameron, was renowned in her own time, and today is considered among the most gifted of the 19th-century practitioners of the medium. Her exploration of the aesthetic dimensions of photography by staging scenes and controlling focus and lighting still resonates in contemporary photographic practice.

The other discovery, the short-lived French daguerreotype process, resulted in a fine-toned image on a silver-coated metal plate. It was attractive for its commercial possibilities in portraiture. Women in Canada, Denmark, Germany, France, and America, with spouses or on their own, opened studios or traveled as itinerant portraitists, although it is impossible to verify their numbers or to recuperate much of their work.

The daguerreotype also was harnessed to the newly awakened desire among middle-class for pictures of faraway places and monuments, whether natural or built. As a unique image, and one that usually was small and difficult to read, it had to be reproduced (commonly by lithography) to reach this public. The earliest compendium of such imagery, *Excursions daguerriennes: Vues et monuments le plus remarquable du globe,* issued in the 1840s, comprised images by a number of photographers, all male. However, in 1845, Franziska Möllinger undertook a similar although far less ambitious project when she traveled throughout her native Switzerland daguerreotyping its monuments and scenery, which she turned into an album of lithographed views.

Despite such activity, women held a minor place in professional and leisure photography until the late 19th century. Then, in the late 1880s, new equipment and different processing methods allowed them a greater role as recreational camera-users and, soon, as professionals. The portable, fixed-focus camera, notably the Kodak, and the fact that the chemical aspects of the medium—developing and printing—could be done elsewhere and by others attracted amateurs of both genders. But it was to women that the Eastman Company directed much of its advertising of their Kodak in the hope that the simplified apparatus would widely be used to record domestic life. Having jumped the initial technological hurdle, women soon progressed to more complex equipment. Noted one commentator, "The woman who began with the Kodak . . . is seldom satisfied until she is mistress of larger boxes and expensive lenses."

Of course, advances in camera technology would have had little effect had not other changes occurred at the same time. In the last decades of the 19th century, American middle-class women in particular were experiencing new situations, both physical and psychological. Factory-produced foods and clothing and immigrant household help meant more time could be spent in non-domestic pursuits such as bicycling and photography—sometimes in tandem. The claims made by suffragists that besides being the caretakers of families, women also had "duties to themselves," had considerable resonance. Furthermore, numbers of women had had some training in the arts, with little prospect of being able to devote themselves to both raising a family and pursuing an all-encompassing career as artist.

Photography, it appeared, might be a substitute artistic enterprise. As a visual medium that was less rigorously inscribed, it was not all-consuming in terms of committing large blocks of time to its pursuit, an important consideration for women with domestic obligations. Photography could be taken up with seriousness or only practiced on occasion. It could be aesthetically challenging and commercially viable.

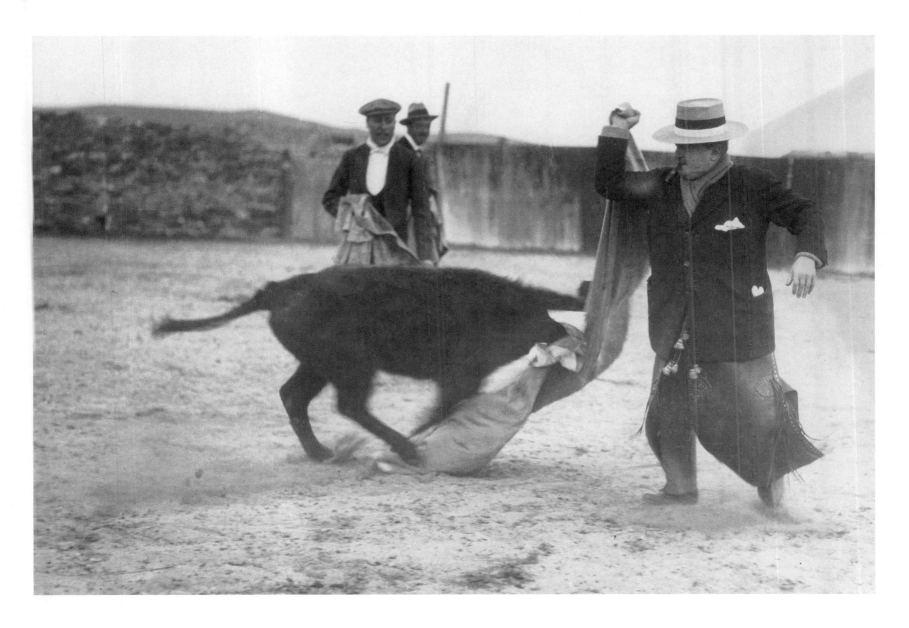

HARRIET CHALMERS ADAMS • SPAIN 1924

A cow is tested for aggressiveness to determine whether it should join the breeding stock for bulls bred for the ring.

PREV OUS PAGE

ELIZA SCIDMORE • JAPAN 1914

A young Japanese girl sits on a bench in a hand-tinted black-and-white photograph made by Scidmore,
probably the first woman to have photographs published in NATIONAL GEOGRAPHIC.

It allowed its user broad social latitude, enabling women to photograph in the home,
in studios, and in urban and rural settings. For women who looked upon it as a source
of income, it had the advantage of not being markedly competitive in monetary terms
with male-dominated professions. As a writer in *The Woman's Book* noted, photography
should appeal to women "content with a small income."

By the first decade of the new century, American women had become
acknowledged as important participants in applied and recreational photography.

21

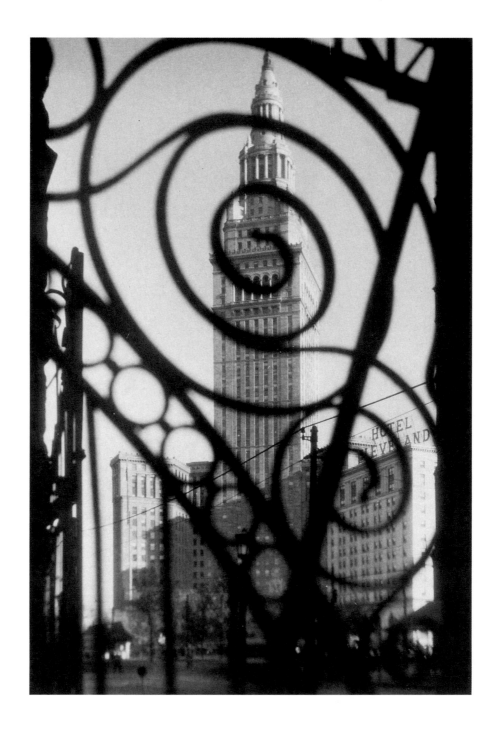

MARGARET BOURKE-WHITE • CLEVELAND 1933

A view of Union Station Tower taken from across the public square. Although
acquired for the magazine's archives, this picture was never published.

Gertrude Käsebier, who took up photography after her children were grown, and Eva
Watson-Schutze were among the women who kept classy portrait salons catering to the
carriage trade, with women and children as the main clients. They were acclaimed for
raising standards in a business notable for dreary facial mapping rather than artistry.
Portraying motherhood and the young was considered suitable for women because only
they were believed able to capture familial love on the light-sensitive plate. In a society
dedicated to the proper upbringing of children, this was deemed an important gift.

This feminine sensitivity, which turn-of-the-century America believed to be intrinsic to women, led a number of them to consider photography a medium capable of personal expression, like etching or painting. Some who embarked on creating photographic art patterned their choice of subject and their treatment on the works of late 19th century genre painters; others chose to photograph flowers and religious themes; still others looked to more up-to-date themes and treatment. One who believed that photographs could evoke transcendent emotions was West Coast photographer Annie W. Brigman, a member of the avant-garde Photo-Secession group. Her images, often softly focused and with applied handwork, were meant to express her deepest feelings about the interrelationship of nature and womanhood.

With the discovery near the end of the 19th century of the half-tone printing process, the camera image for the first time could be printed directly on the page along with the text. As a result, photographs began to displace hand-drawn illustrations in periodicals, books of verse, travel stories, and social instruction. By 1908, more than half the illustrated pages of NATIONAL GEOGRAPHIC comprised photographs; by 1910, the magazine included 24 pages of color photographs, achieved by hand tinting original black-and-white images; a group similarly colored by Eliza Ruhamah Scidmore, the first woman on the Society's Board of Managers, appeared in 1914.

One of the first to specialize in this genre was a woman. Frances Benjamin Johnston, whose work appeared in magazines before 1900, described herself as "making a business of photographic illustration . . . for magazines, illustrated weeklies and newspapers." She focused on working people in mining communities and shoe factories, documented life aboard Navy ships sailing to the Caribbean, and portrayed Hampton Institute and the Washington, D.C., public schools. In some ways, these commissions, which required commitments of time as well as photographic ability, forecast the kinds of assignments that would be given women working for NATIONAL GEOGRAPHIC.

Johnston's choice of documentation as a genre was unusual but not unique. Women throughout the United States began to venture out of their homes with cameras to document life for pleasure or profit. In the early 1900s, Chansonetta Stanley Emmons in Maine, Frances and Mary Allen in Massachusetts, Nancy Ford Cones in Ohio, and Evelyn Cameron in Montana, among others, photographed life in their communities, to sell either as reproductions in print media or as individual prints in platinum or silver. A rare few peered beyond their immediate surroundings. E. Alice Austen, who photographed the genteel activities of her upper-class precincts in Staten Island, also traveled across New York Bay on the new ferry service to capture street life

clarification is helpful because there has never been a clear distinction between the different kinds of work done on assignment for magazines and newspapers, whether it be travel photography, cultural documentation, or the portrayal of newsworthy events.

Photographers working on timely news stories are expected to cover their assignments expeditiously and to capture the scenes that best evoke the essence of the happening. Those working for magazines such as NATIONAL GEOGRAPHIC may also be

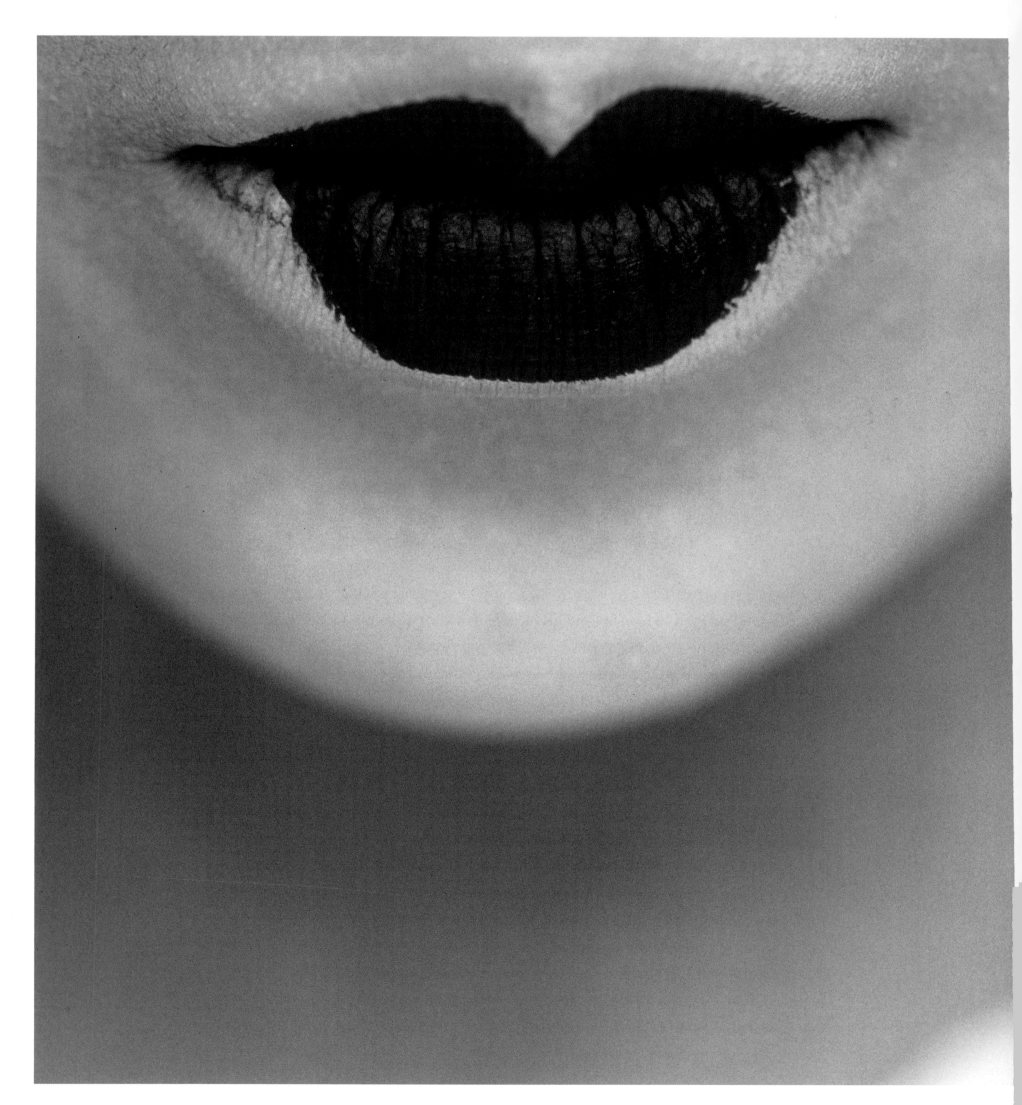

INSIGHT

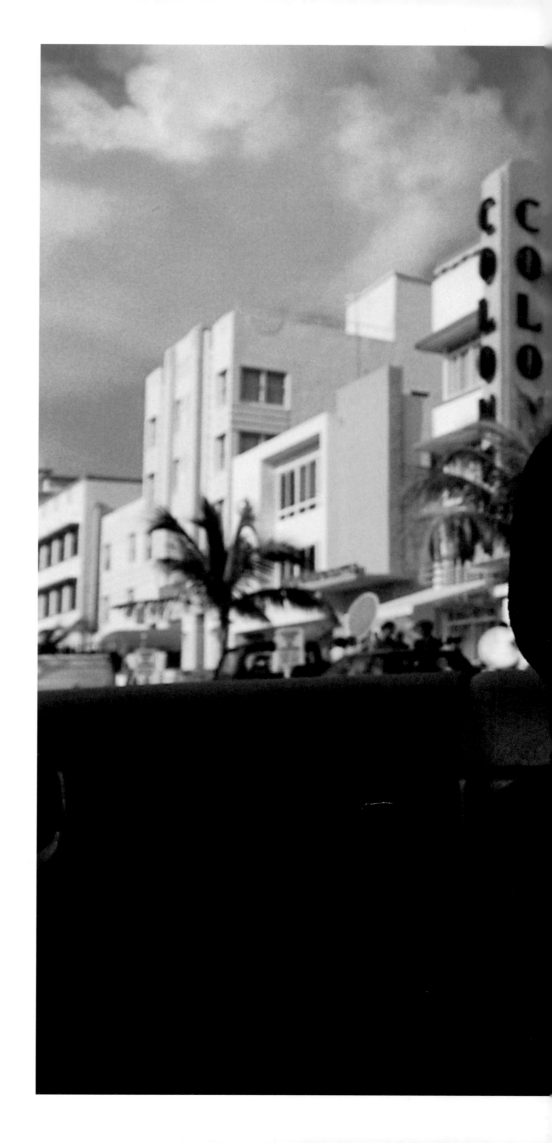

MAGGIE STEBER • MIAMI BEACH 1992

With an exuberance as sassy as her convertible, artist Laura De Pasquale glories in the sun-soaked scene along Ocean Drive in South Beach.

PREVIOUS PAGE

JODI COBB • JAPAN 1995

Sealed lips symbolize the enigmatic beauty of the Japanese geisha. The art of the geisha has been practiced for 250 years; today they number no more than a thousand.

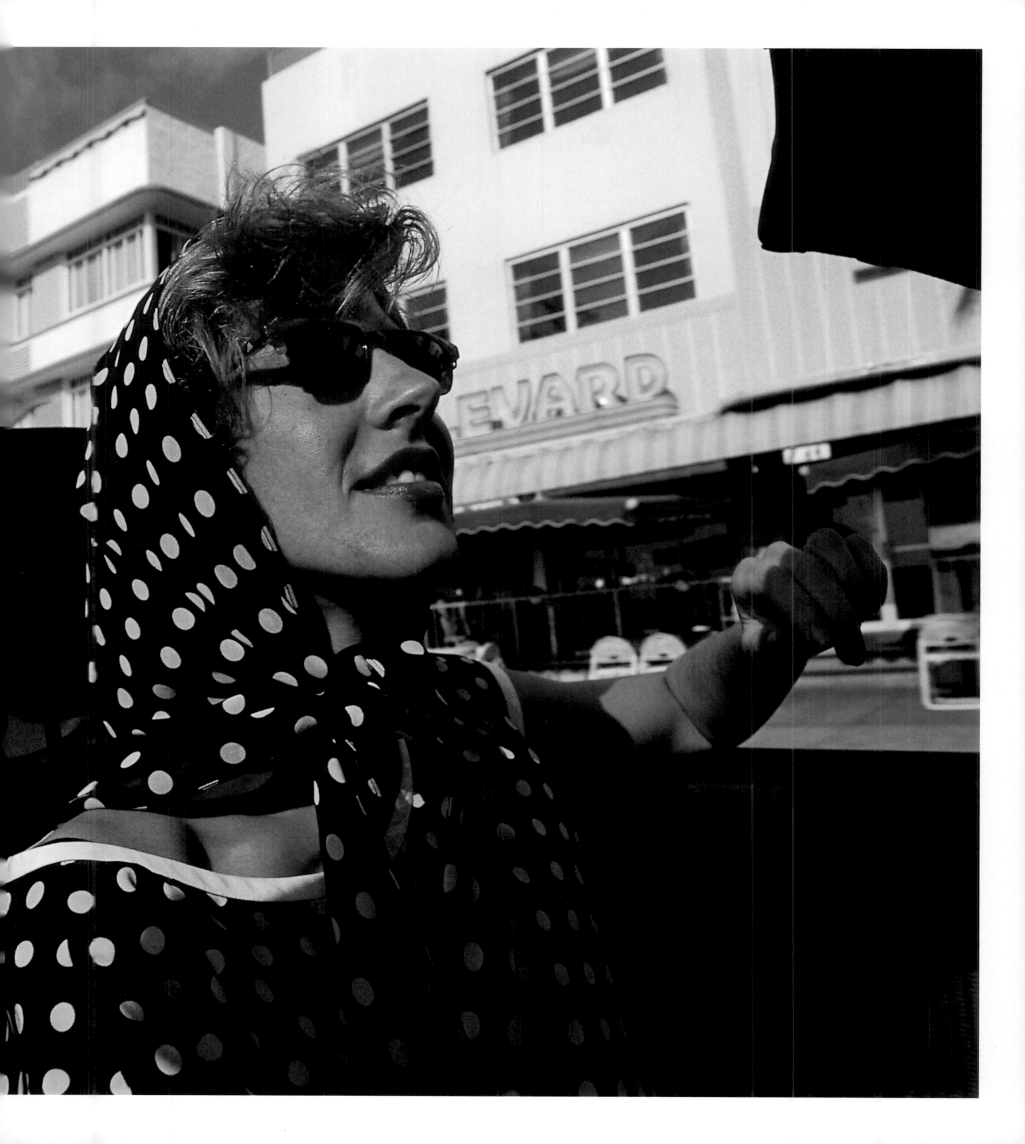

LYNN ABERCROMBIE • NORTH YEMEN 1985

Designs traced in henna decorate a woman's
hand. To preserve the woman's anonymity,
Abercrombie asked her to remove her rings.

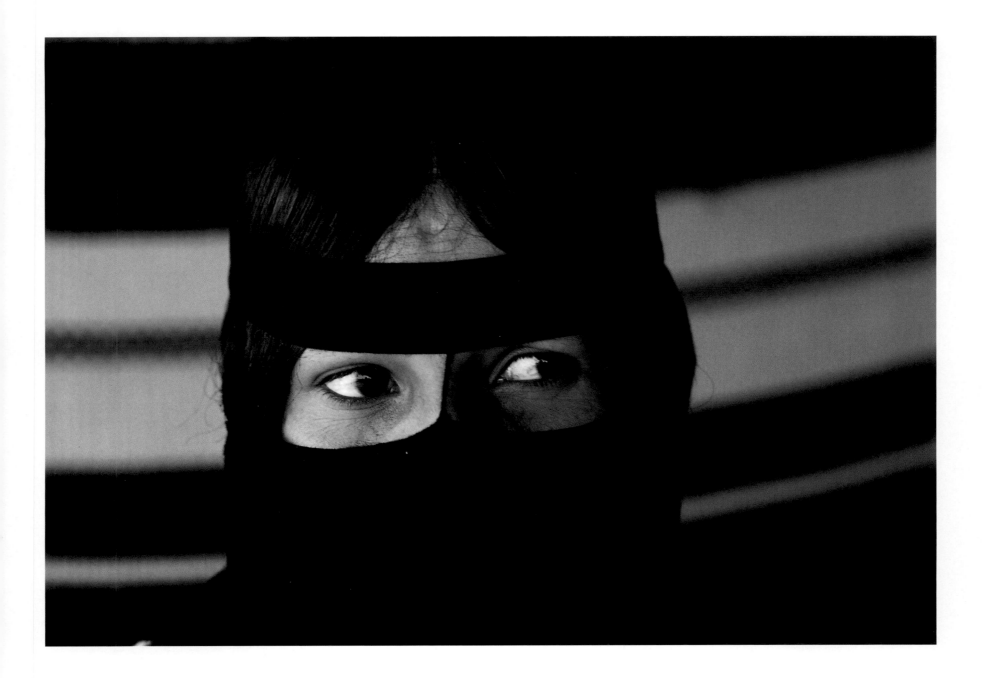

JODI COBB • SAUDI ARABIA 1987

Metaphor of the hidden world of Islamic women,
a veil betrays only its wearer's eyes. She will
remain covered to men outside her family.

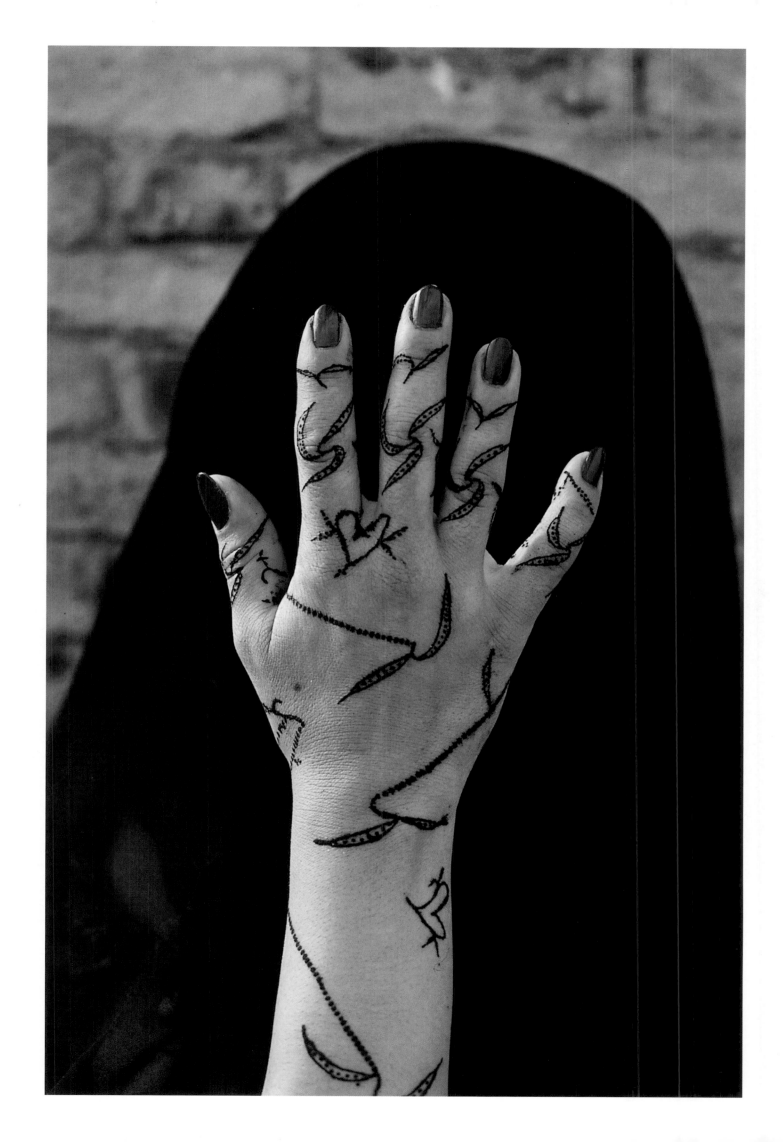

ALEXANDRA AVAKIAN is a tall, striking woman with an aquiline nose and a face made only more arresting by the distinctive gap between her teeth. She has the calm self-assurance of more than a decade at the top of a brutally competitive profession—photojournalism. She has stunning images from such pivotal world events as the fall of the Berlin Wall, the *intifada* in the West Bank and Gaza, and the collapse of the Soviet Union, as well as stories on Iran, the Gaza Strip, and Romania in NATIONAL GEOGRAPHIC.

But 18 years ago, as a graduate of Sarah Lawrence College, she still had a long way to go. In putting together a portfolio of her work for her agent to send around, she edited a selection of her pictures and carefully stamped on it the name "Alex Avakian."

"I didn't want gender to be an issue," she explains. "I didn't want them to say, 'We can't send her to cover that—she's a girl.'"

Of course, the portfolio spoke for itself loud and clear. Here was a fresh and undeniable talent. But the point is this: It is a struggle for anyone to be taken seriously in the early days of a career. It is even more so for a woman. Consider George Eliot (Mary Ann Evans) and George Sand (Aurore Dudevant), who, wishing to be taken seriously as artists and to avoid the condescending "Not bad for a woman," chose to cloak themselves under the nom de plume of a man.

For Avakian, the issue of gender never quite disappeared.

Once, on assignment for a newsmagazine, Avakian walked into the office of a sullen, over-decorated Soviet general to make a portrait. "He looked me up and down and sneered, 'You must be the secretary,' then glowered at me during the session," she recalls.

At the start of her career, as a preemptive strike against such dismissal, Avakian dressed boyishly. "I downplayed my femininity," she concedes. "I didn't want to be seen as too feminine to handle a tough job." She smiles wryly and rearranges the folds of a skirt as voluminous as a gypsy dancer's.

"Later I realized I didn't have to do that. I could just be myself."

To be a photographer—to be any photographer—is to struggle with camera and film and shutter speeds and being in the right place at the right time with the right piece of equipment. To be a photographer for NATIONAL GEOGRAPHIC raises the bar. The GEOGRAPHIC and photographic excellence are synonymous. In its infancy, the magazine, founded in 1888 as the official journal of the National Geographic Society, was austere-looking, technical, and drab. It was Alexander Graham Bell, the second President of the Society, who instinctively articulated the true mandate of the magazine when he directed Gilbert H. Grosvenor, then Managing Editor, to go to Martinique following the eruption of Mount Pelée in 1902 and return with "details of living interest beautifully illustrated by photographs." GHG understood the power of photographs in advancing the Society's mission to "increase and diffuse geographic knowledge." By the end of his own 25-year-long reign as President, GHG had transformed the GEOGRAPHIC into a popular magazine that opened the wonder of the world to millions through its lush photography. "The magazine's life depends on getting better and better pictures," GHG once explained to a staffer. For more than a century, the magazine's photographers have done just that.

To get the picture, first you must get to your assignment—by trekking up the Himalaya or sinking to the bottom of the ocean in a submersible or sailing to Antarctica on an icebreaker.

Then the real work begins. The picture must be technically perfect. It must be riveting beyond belief. It must, above all, tell a story. There are, along with unusual locales, unusual risks. There are dangers large: charging hippos and great white sharks. There are dangers small: poisonous snakes and killer bees. There are dangers you can't even see, like deadly parasites and radiation, not to mention the more mundane perils of fires, floods, mobs, and government bureaucrats. There is the intense, protracted nature of the work. An assignment can devour your life. A photographer for NATIONAL GEOGRAPHIC may be away from friends and family for months. It is a lonely existence that can strain these bonds to the breaking point.

To be a woman photographer for the NATIONAL GEOGRAPHIC is to complicate the complicated. For one thing, there are not that many. Of 70 photographers who regularly shoot for the magazine, 14 are women. Most of these women are freelance—that is to say, they work on a story-by-story basis. Seven photographers on the magazine hold coveted slots as staff photographers; there is only one woman, Jodi Cobb, among them.

Women with families who shoot for NATIONAL GEOGRAPHIC are even more few and far between. They are the true rarities, tightrope walkers in heels. There is no template for how to choreograph the balance between job, spouse, and most difficult of all, children. Those—and there are less than a handful—who steer their way through the process write their own instruction manual as they go.

The history of women at the Society has traditionally been one of exception rather than rule. Until the 1970s (and some might say beyond) the National Geographic was the publishing equivalent of a private men's club. Women worked at the Society, but nearly always as secretaries or clerks. Men and women ate in separate dining rooms. In an unspoken but tacitly acknowledged code of behavior, ladies wore dresses and stockings, never pants, and gentlemen never dreamed of shucking their coats and ties. Nameplates were always prefaced with Miss, Mrs., or Mr. "The Society was considered by many of Washington's best families as a fine, safe place for a postdebutante daughter to put in a few years dabbling in secretarial work before marriage," wrote Anne Chamberlin in *Esquire* magazine in 1963.

Amidst the air of gentility that prevailed during the first six decades of the magazine's existence, the work of women sometimes came in over the transom and was published, but a woman would not be put on the photographic staff until Kathleen Revis (the Editor's sister-in-law, but more about her later) in 1953. It would be 21 years until the next one, Bianca Lavies, made her appearance. Jodi Cobb would follow three years later; then another 18 years would pass until Sisse Brimberg joined the staff. The total number of male staff photographers stands around 50. The all-time total of woman staff photographers is four.

In an ideal world, gender would be irrelevant. It would not matter whether a photograph were taken by a man or a woman. The only thing that would matter would be the photograph. We are not there yet. The discussion continues. "Do Women Photographers See Differently Than Men?" asked *American Photo* in a special issue on women in photography published in March 1998. Answer: It depends on whom you ask. *Cosmopolitan* magazine guru Helen Gurley Brown thought not. The fashion photographer Helmut Newton said women do see differently. Photographer Merry Alpern wondered, "How can you tell?"

At the National Geographic, when the subject of this book was proposed, a number of photographers and editors—several women among them—wondered why women photographers should be written about as if they were a subset species of photographer. Hadn't Laura Gilpin, noted for her photographs of the American Southwest, said: "Either you're a good photographer or you're not"?

"I sometimes hear myself referred to as a "great woman photographer," muses Maggie Steber, whose work for NATIONAL GEOGRAPHIC includes stories on Miami and Quebec. "Would you ever hear anyone referred to as "a great man photographer?"

Said a female illustrations editor, "I don't think of any of them as women photographers. They're just photographers who happen to be women."

Finally, there was the male photographer on the magazine staff who commented, "Women photographers? It'll be a short book."

Hopefully, not. Surely to write about women as photographers is to celebrate them both as photographers and as women. If the eye that frames a picture is as distinctive as the voice of a writer's pen, then the photographer as woman, and her experience and identity as a person, relates to the pictures she creates. Men and women do speak different languages, do see things differently, and do respond to them differently. *Vive la différence.* And yet, along with confusion, exasperation, and, sometimes, hurt, in difference there is abundant joy.

In photography as in life, gender does matter. It matters less in some ways, more in others. Alexandra Avakian seems to agree. "Once I didn't think women as photographers was a topic of discussion," she says, "but now I think we should talk about it."

Okay. Let's talk.

Line up a dozen photographs, half of them taken by women, half taken by men. Can you tell who took which? Probably not, but neither can the experts. Don't expect subject matter to reveal any clues. Karen Kasmauski has covered stories on nuclear waste, radiation, and the Alaska oil spill for NATIONAL GEOGRAPHIC. Staff photographer Sam Abell's subjects are softer: hedgerows, gardens, Lewis Carroll. Both create striking and beautiful images.

On the other hand, gender can affect the story a woman photographer gets by virtue of access. Closed cultures are an example of a story where assigning a woman, in the words of Kent Kobersteen, director of photography at NATIONAL GEOGRAPHIC, can sometimes be a "no-brainer." Jodi Cobb's coverages on geisha and Saudi women, and Karen Kasmauski's story on Japanese women probably could not have been done by a man, or at least, in all probability, not with the same degree of intimacy. Or take Doranne Wilson Jacobson's 1977 NATIONAL GEOGRAPHIC article "Purdah in India," about the centuries-old Hindu custom of secluding women from men. "You'd never get a man to do that one," points out Mary Smith, a retired senior assistant editor and picture editor. The culture would never allow it. Suggests another illustrations editor: some of the most powerful images in the magazine are pictures of women taken by women. Which doesn't surprise Kasmauski at all. "They're female; we're female. We can more easily bond."

The door often opens more readily to a woman. Rules fall away. Sometimes in a foreign culture, says Sisse Brimberg, who has photographed more than three dozen stories for the magazine, it's as if you are forgiven for being female—if only for a short time. Brimberg, whose English bears the

lyrical lilt of her native Denmark, recalls a trip to Gaza and a visit to a Bedouin camp where she sat on carpets in a tent and was served tea together with the men. "I could see the women outside the tent," she says. "Their eyes followed every move I made, and I knew I was in a special situation, because of my profession." In circumstances like that, observes a colleague, the men just don't know what to do with you. Your status as a woman is temporarily suspended.

Sometimes the culture itself conspires to help. In Africa, people want to protect and safeguard you, says Carol Beckwith, who with collaborator Angela Fisher has photographed the people of that astonishing continent for 25 years. The Masai, she explains, originated in the Nile River Basin, and swept southward killing every male enemy in sight, absorbing the women and children. "You're entering a society where the idea that women are to be protected is embedded in peoples' genes," she says. "Working there was like having parents, and being told, 'you can't move without our permission, or at least we have to come with you if you want to get in your Jeep and go to another area.'"

Sometimes the door doesn't open at all. An assignment in Cairo turned out to be an exercise in frustration for staff photographer Jodi Cobb. Under normal circumstances, Cobb has a knack for getting people to cooperate. Some years ago while doing a story on Jordan, she somehow convinced the late King Hussein to take her up in his helicopter. She is likeable and enthusiastic about the work, which appeals to her subjects. And she is gutsy. She may appear vulnerable, a colleague says, but watch out. She keeps shooting, even when it gets uncomfortable for her subjects and for herself.

But Cairo, being in a Muslim country, wasn't a normal circumstance for any woman, let alone one trying to do photography. Subjected to incessant verbal and physical abuse while trying to shoot on the streets, Cobb finally, and reluctantly, realized it wasn't going to work. "It was intolerable," she recounted, "—people rubbing up against me, sticking me with needles, grabbing me in the street." For the first time in 20 years of shooting, she asked to be taken off a story. The next photographer assigned to the story, a man, did no better, and quit. A third try with an Arabic-speaking photographer who could melt into the culture finally met with success.

Sometimes you enter through a side door. While shooting a story in Israel about the Sea of Galilee, Annie Griffiths Belt hoped to photograph a Hasidic holiday in which everyone lights bonfires and fathers bring their three-year-old sons for their first haircut. But women were not allowed at the Orthodox Jewish ceremony.

Belt was stubborn and refused to be deterred, so set herself the task of getting around the simple fact of gender. If women weren't allowed to attend, well, then, why not go as a man? she wondered.

"I love this idea," her advisor, an Orthodox Jew, responded.

Belt, who has a slender frame anyway, dressed boyishly, cut her hair short, tucked the rest of it under a baseball cap, and got the pictures that way. Was such a gender-bending ploy kosher? "My goal was not to deceive or disturb," she responds. "It was to do my job without being noticed."

There are many ways of doing the job of photography. Street shooting is one. The photographer walks down the street, hoping for what the famous French photographer Henri Cartier-Bresson called "the decisive moment." There is no interaction with the subject; the photographer waits and watches and hangs out, hoping that subject, light, and composition will coalesce in a single wonderful instant. Jodi Cobb's evocative photograph of a steam-and-fog shrouded Broadway at night,

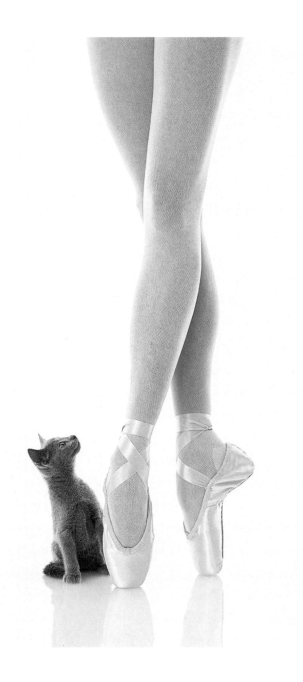

KAREN KUEHN • NEW YORK 1997

Grace defers to grace as a Russian blue kitten evokes choreographer George Balanchine's
directive to his dancers: "Land like a pussycat."

Alexandra Avakian's haunting image of a nun patiently sweeping the stone pavement of her convent in Romania, and Annie Griffiths Belt's image of a young Hasidic boy sneaking a cigarette on a Jerusalem street are all examples of where magic happened and the camera caught it.

All photography is more or less voyeuristic; street photography is more so. Not surprisingly, many women find that uncomfortable. "I'm not at ease doing street shooting," says Karen Kasmauski. "As a single woman, particularly in a foreign country, I feel I'm too noticeable, too vulnerable." Kasmauski, who is intrinsically shy, hates being the center of attention. After a day in the field, she would rather order room service than go out for a meal by herself. "Street shooting just grates too much against my personality," she says. "It feels like I'm barging in."

Not everyone agrees. Although she is equally comfortable shooting pictures in the

intimate setting of a family home, Maggie Steber revels in street photography, as evinced by her photograph of two young Hispanic brothers standing on a scruffy stretch of Miami's Biscayne Boulevard as a homeless man wheels his cart of possessions in the background. "To me it's sheer theater," she says. Perhaps it helps that Steber is unreservedly outgoing and whimsical in addition to being dead serious in how she approaches her work.

Kasmauski, by contrast, is only truly comfortable working stories from the inside. She'll spend time with a family, then, by winning their trust, be able to get the intimate, behind-closed-door shots that help define her work in stories with subjects such as Japanese women or viruses. Melissa Farlow, who has published photographic coverage of the Okefenokee Swamp and the New Jersey meadowlands, has a similar approach. "My stronger images come when I'm comfortable with the people I'm with. I need to understand them. I'm not as comfortable just photographing a stranger on the street."

Adds Farlow's husband, Randy Olson, who also shoots for NATIONAL GEOGRAPHIC: "It's like getting into a swimming pool. I dive right in. I'm afraid things are going to disappear, so I tend to move faster. Melissa puts her toe in. Then her foot. Eventually she's in the pool. By that time, I'm kind of exhausted, whereas Melissa's in for the long haul. Everyone in this pool of people has to understand what she's doing and why. And then she works."

There is a flip side to the equation of street shooting. "Certainly, on the street it helps being male," says staff photographer David Alan Harvey. Males are less likely to be harassed. "However, the minute you walk in the door and into a family situation, you're better off being a woman. In certain villages, if you're a single man, you're the biggest threat going. When I go to see a family in that kind of a situation, I often have a woman as an assistant just for that reason." He pauses and adds, "We all would like to be able to flip a switch sometime."

Even in a post-feminist, politically-correct era of women astronauts, Supreme Court justices, and women's World Cup soccer, being a woman photographer is not unrelated to how others define your role as a woman. The stereotype of the "second sex" persists.

"And when will your photographer arrive?" Sisse Brimberg has been asked, after lugging a half a dozen or so cases full of lighting equipment through a museum door in preparation for shooting artifacts.

"She *has* arrived," is Brimberg's stock reply.

Is the bar set higher for women? "I know it is tougher for my female colleagues," says David Alan Harvey. He and Jodi Cobb started as staff photographers on the same day in 1977. ("I said to myself, 'That gal can shoot people,'" says Bob Gilka, the retired director of photography who hired her.) The women's movement was in full bloom, and Cobb was exquisitely aware of being in the "only woman" slot. "I never had the luxury of taking a chance that could result in failure," says Cobb. "I had to play it safe in so many ways. I had to do a lot of jobs that didn't interest me just to prove I could do the stuff that the guys did. I could hang out of a helicopter; I could go underwater; I could go by horseback or whitewater raft. I could do that if that's what the job took. It wasn't where I was as a photographer, but I felt I couldn't stand up and say, 'I don't want to do that,' because I felt that would limit more women's chances."

To be sure, patronizing behavior and speech are not the exclusive domain of men.

Women can claim equality there as well. In a *Ladies' Home Journal* article published in the late 19th century entitled "What a Woman Can Do With a Camera," Frances Benjamin Johnston, best known for her work as a documentary photographer, wrote: "Even a person of average intelligence can produce a photograph." Presumably some are even men.

"Can a Woman Photograph Women?" *Modern Photography* asked in a 1953 article. According to a female fashion photographer who went by the name of Sharland and who worked in the 1950s, "It takes a woman to do justice to another woman." A man, she went on to proclaim, "experiences an emotional reaction when he first sees a woman he has been assigned to photograph. If he finds her unattractive, he can seldom develop enough interest to discover why she was selected by an editor to be photographed."

Such cliches aside, women really are less threatening, suggests Lynn Johnson, who has covered such subjects as the Russian poet Alexander Pushkin and the Dutch painter Vincent Van Gogh for NATIONAL GEOGRAPHIC. "People take you for granted. They take you lightly, and I am happy as a clam to take advantage of that. I understand it is not necessary to go into a scene and announce your presence." Johnson, one of the most thoughtful and introspective photographers working for the magazine, wears her shyness like camouflage.

Zen and the art of covering a story. It's about holding still and melding into the scene. It's about pulling on the mantle of camouflage and becoming part of the foliage. It's not always that way. There are instances when the photographer is most definitely present. But often, not being there while being there is better.

"I'm a small person, and I carry a Leica, which is a small camera," Johnson says. "I really can melt into the background." The key, she says, is to move within an environment, particularly a family situation, almost without being present.

Is stillness the birthright of women? Of course it's not. It's the stock in trade of any photographer. Photography has everything to do with watching and waiting. But perhaps, suggests Rich Clarkson, a former director of photography at NATIONAL GEOGRAPHIC, women have a bit more patience; they take a little more time; they're a bit more Debussy than Wagner.

What happens after the film gets shipped back to headquarters in Washington to be reviewed by the illustrations editor who helps direct the coverage? Again, generalizations are to be taken with a grain of skepticism; there are no absolutes. On the other hand….

"Women agonize more," observes Susan Welchman, an illustrations editor for the magazine. "'This is the picture,' they'll say. 'It's not as good as it should be.' They'll let their vulnerability show. Men often bring their pictures in, slapping each other on the back. Women seem to be more isolated, more independent. It could be maybe that women are so divided with so many things to do, they haven't got time for schmoozing. Women will say, 'Well, I've got that picture. I've got to go take care of my child or clean the house.'"

"It's not a matter of self-confidence," adds Elizabeth Krist, another illustrations editor. "Anyone who works at NATIONAL GEOGRAPHIC has to be titanium-tough.

"Women tend to find more fault in themselves," Krist says. "They are more willing to blame themselves, whereas men seem to go through every twist and turn to rationalize. The men also tend to objectify and intellectualize their work more, whereas the women seem to want to talk more

about the experience and the relationship with their subjects."

Biology may or may not be destiny, but the issue remains a topic of discussion. Perhaps, a woman photographer suggests, if there were enough women in the profession, the stereotypes would disappear. Instead of women photographers and men photographers, there would just be photographers who take pictures.

"Where I was born and where and how I have lived is unimportant," the American painter Georgia O'Keeffe once wrote. "It is what I have done with where I have been that should be of interest."

It is the picture that should captivate us, nothing else, O'Keeffe seems to be saying. Take no notice of the young girl who grew up on the long, flat expanse of the prairie, or the old woman's preference for isolation. Ignore the artist's love for the burnt red hills of New Mexico and don't even think about the fact that a tough, blunt woman created these tough, blunt paintings.

One might say the same of the work of women photographers at NATIONAL GEOGRAPHIC. The work—by turns, stunning, exciting, and often moving—speaks for itself. Why look beyond the frame?

Because to know the woman behind the work—to know how she thinks, what she feels, why she photographs, can only deepen our appreciation, that's why. The stories these photographers have to tell can teach. They may even inspire.

"I wanted to be in the human heart," Jodi Cobb says in explaining why she became a photographer. In an image from her story "The Enigma of Beauty," a young girl with anorexia sits in front of a white plate on which rests a solitary green apple. Shadows fill the room. It is a still life of sadness. The girl's face is dark with fatigue and despair that may or may not turn into hope in the setting of the clinic where she is being treated. It is a heart-bruising photograph, full of quiet pain.

"One time in Buenos Aires I had to do something in a hurry. I had to take pictures of a poor woman in her house in a barrio," says Joanna Pinneo in speaking about the emotional complexities of shooting a picture in haste. "I ran in, shot the picture, and ran out. I felt bad. I thought, 'She didn't know me; I didn't know her.'" It is years later and Pinneo is still haunted by remorse at the contact too rushed to ripen into a relationship. Ideally, it is otherwise. In a photograph from her story on the Basques, a father and son share a moment of affection. The son wraps an arm around the older man's shoulder. The father's face radiates happiness. It is a tender image, full of love and connection between father and son and between the photographer and her subjects. It is the result of spending days—not minutes—with the family.

How richer we are for knowing these things. The images made by the women who work for NATIONAL GEOGRAPHIC are to be admired on many levels. Though looking is its own reward, to understand the photographer is to better understand the photograph. Character is style. Experience is point of view. It is also hopefully, and most of all, insight. ■

ALEXANDRA AVAKIAN • GAZA 1996

The family of a newly married bride
in Gaza carries its joy to the streets,
a sign of hope in a landscape otherwise
marked by violence and fear.

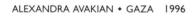
FOLLOWING PAGES

JODI COBB • NEW YORK 1998

Pencil-sharp high heel shoes punctuate
the fashion statement made by designer
Isabel Toledo at a runway show during
designer week in New York City.

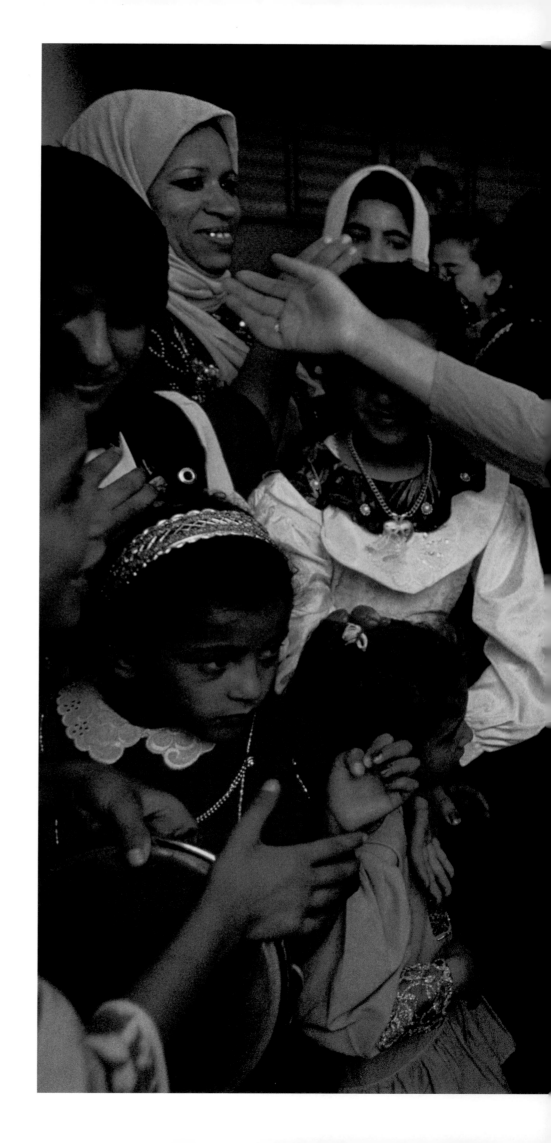

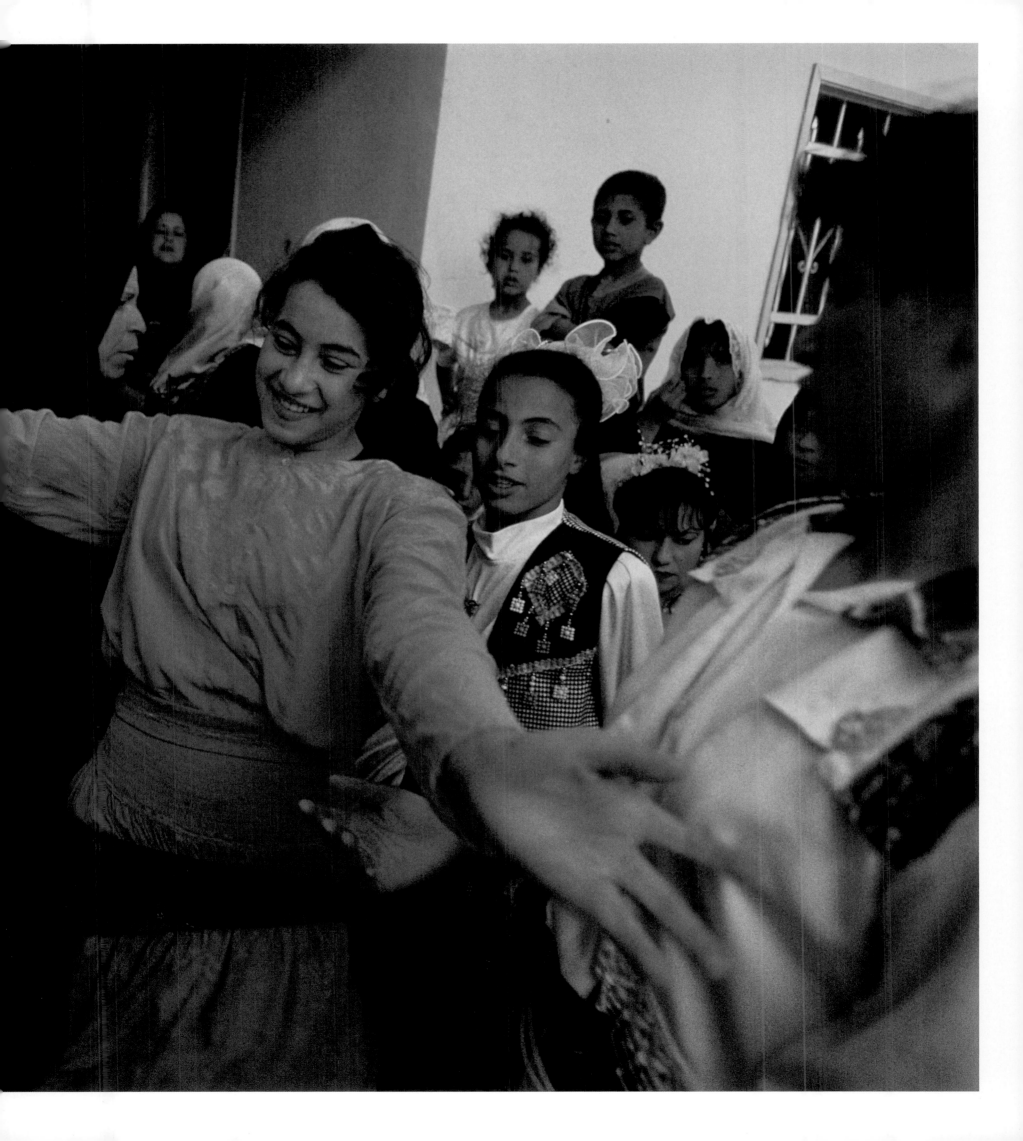

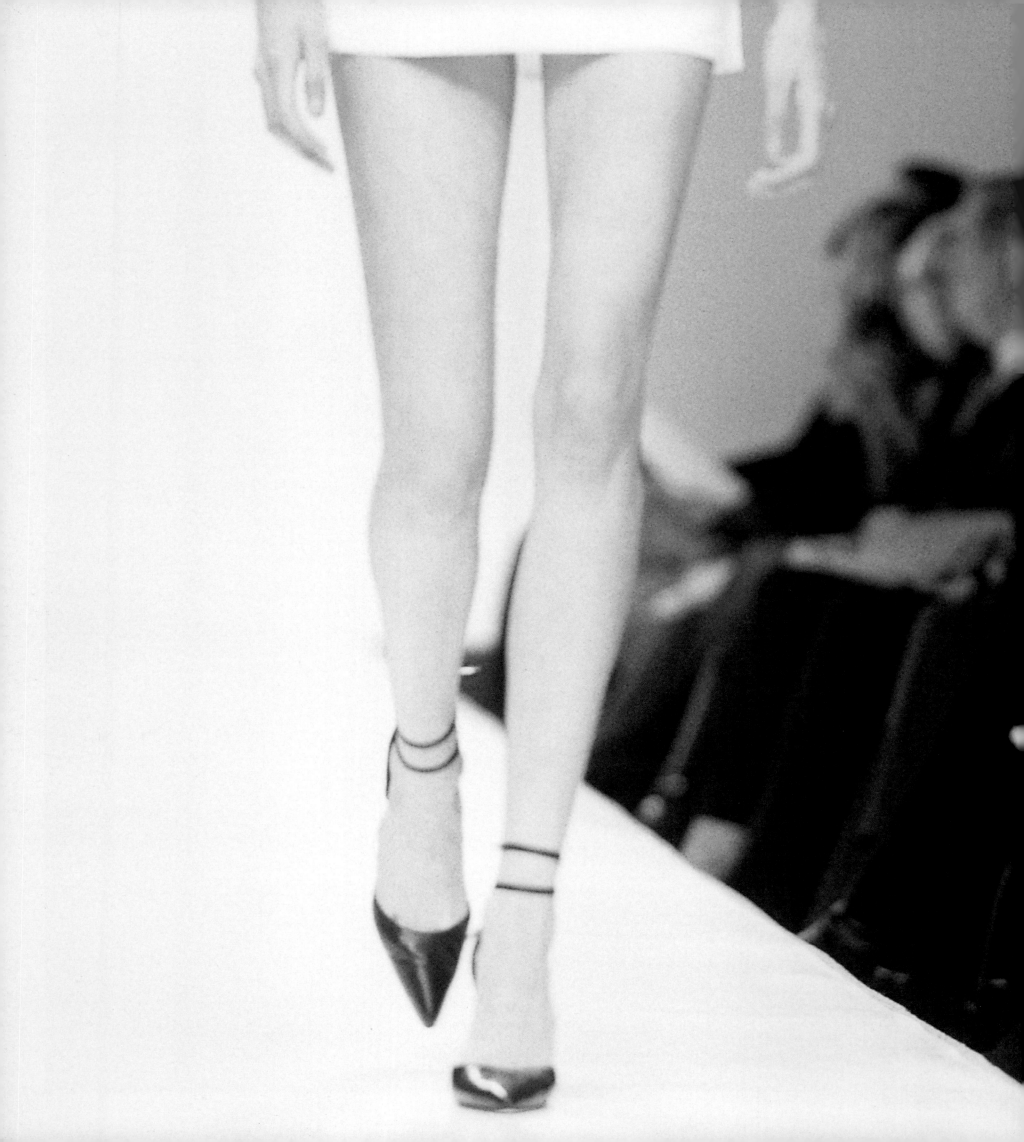

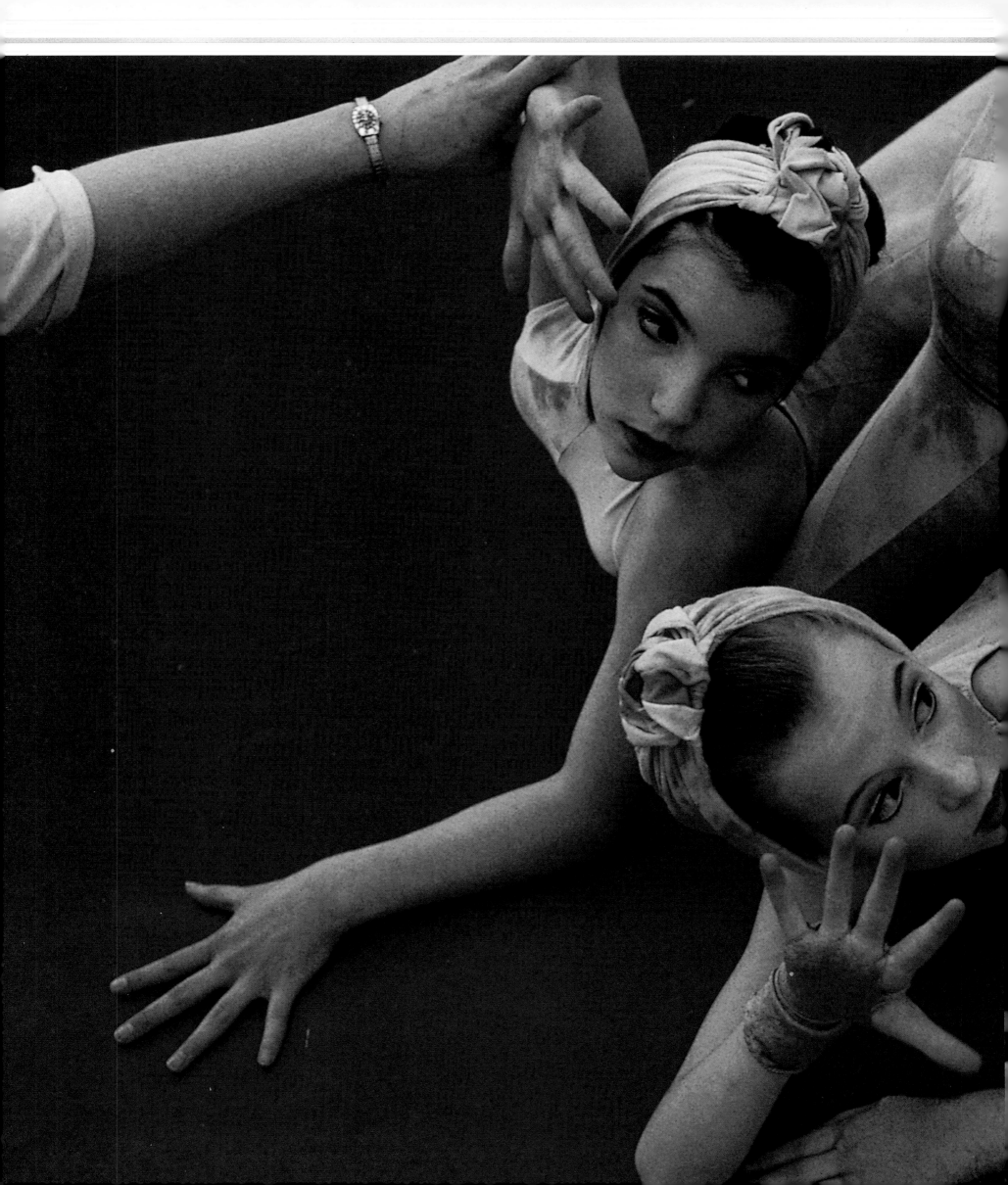

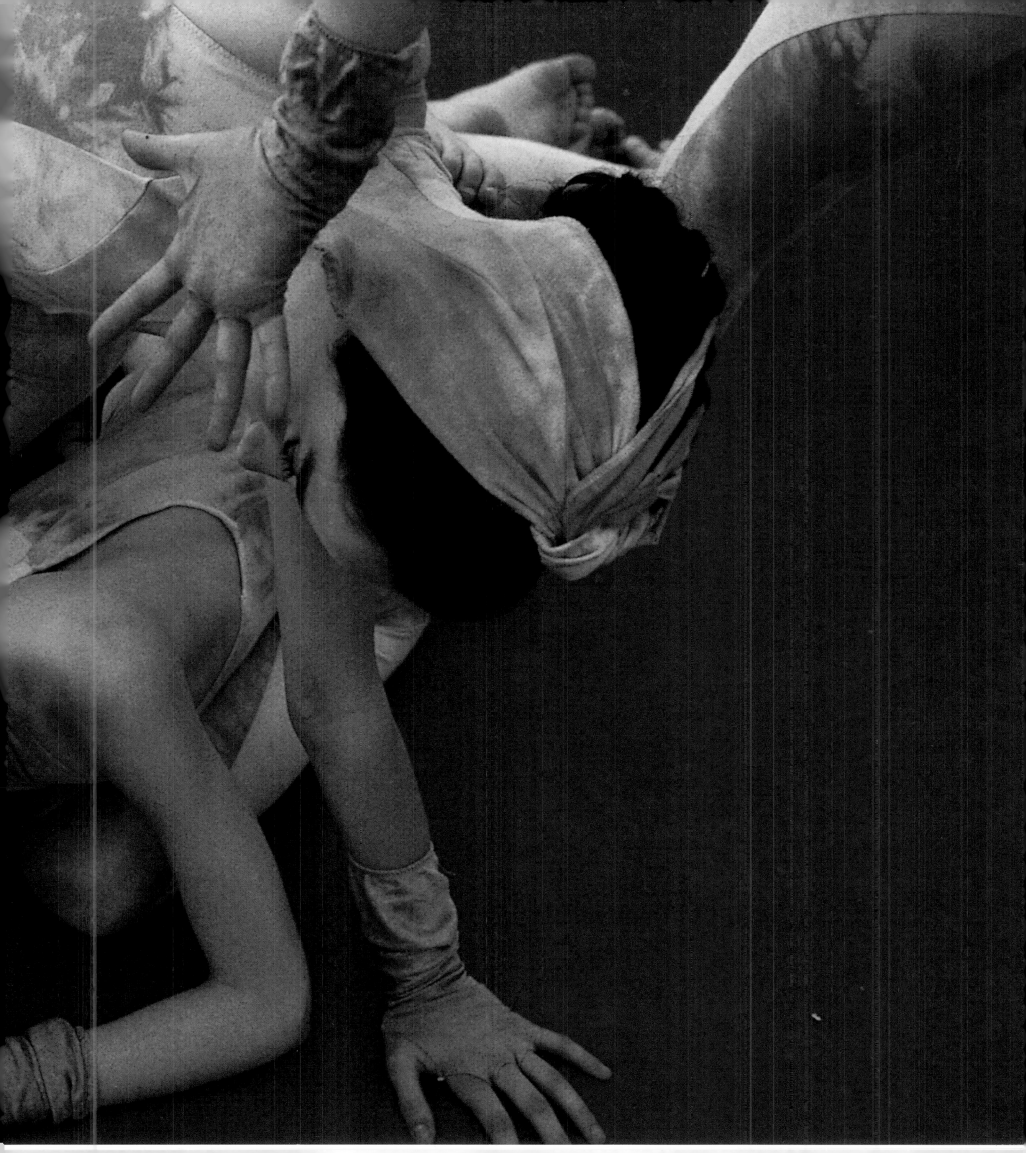

Jodi Cobb

WOMEN ON WOMEN

JODI COBB IS A MASTER of the telling detail—the clock on the wall above the aging actress; the solitary apple on the plate of an anorexic girl; the red tricycle at the foot of a red-carpeted set of steps that belongs to a toddler member of the Jordanian royal family. Such exquisiteness twists the heart and speaks to the mix of tears and laughter in life. "She has a homing device for the extraordinary situation," says Susan Welchman, an illustrations editor. "She has a more artful eye, a more cerebral eye; she's always dwelling in that part of the mind." She also has an appreciation for irony—an aspect of life difficult to show visually. Perhaps, suggests Tom Kennedy, a former director of photography, you could argue that women have better antennae for those complexities. "I love the element of surprise in a photograph," Cobb says. "I want to surprise the viewer. For that to happen, I need to be surprised, too. How to do that? I keep moving. I look at things in different angles, in different light." Some of Cobb's most powerful work has been of women. Her coverages of Saudi women and the geisha lift the curtain on otherwise inaccessible worlds. "The two cultures are different as can be," she observes, "but in their souls, women want the same things: dignity, respect, love, freedom." Cobb is one of seven photographers who hold coveted positions on the National Geographic staff and the only woman. Her strengths—artistry combined with intelligence, wit, and tenacity—enabled her to get images such as these from "The Enigma of Beauty" published in the magazine in January 2000.

HAWAII 1998 Hours before being crowned Miss Universe 1998, Wendy Fitzwilliam, a law student from Trinidad, puts the finishing touches on her national costume.

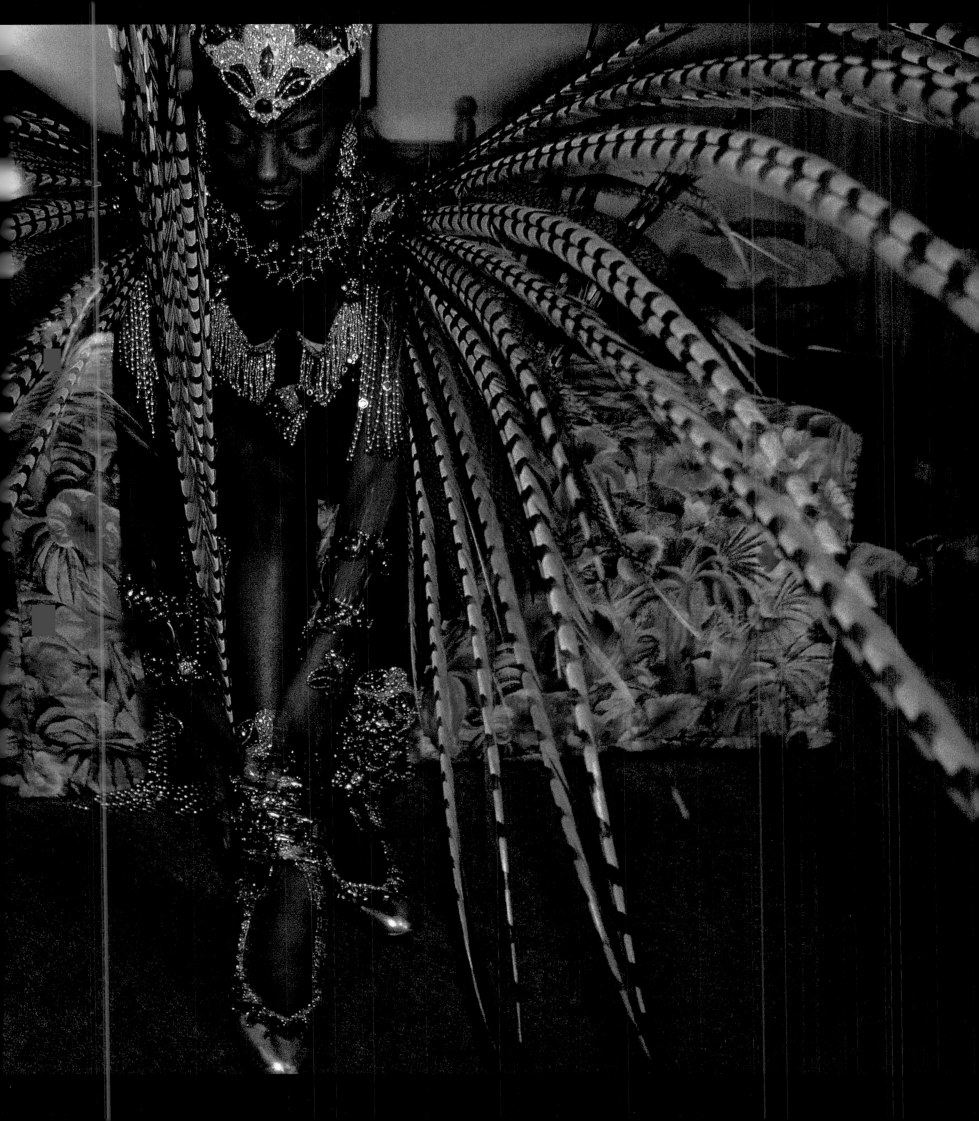

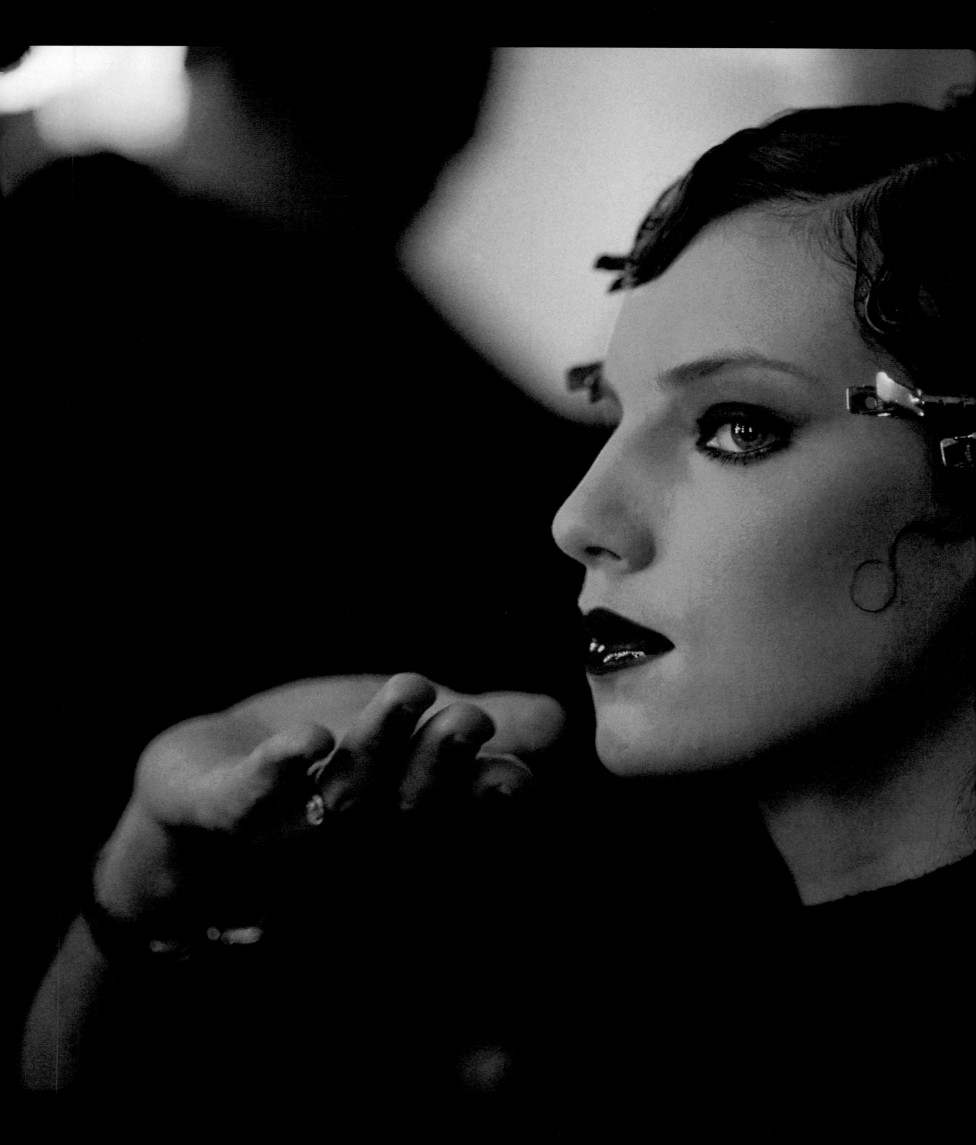

NEW YORK 1998

A model sits through the time-consuming tedium of having her hair done prior to a runway walk that will be over in minutes.

FOLLOWING PAGES

LONDON 1993

Graduates from London fashion colleges dress for a runway show featuring the evening wear of New York designer Carmen Marc Valvo.

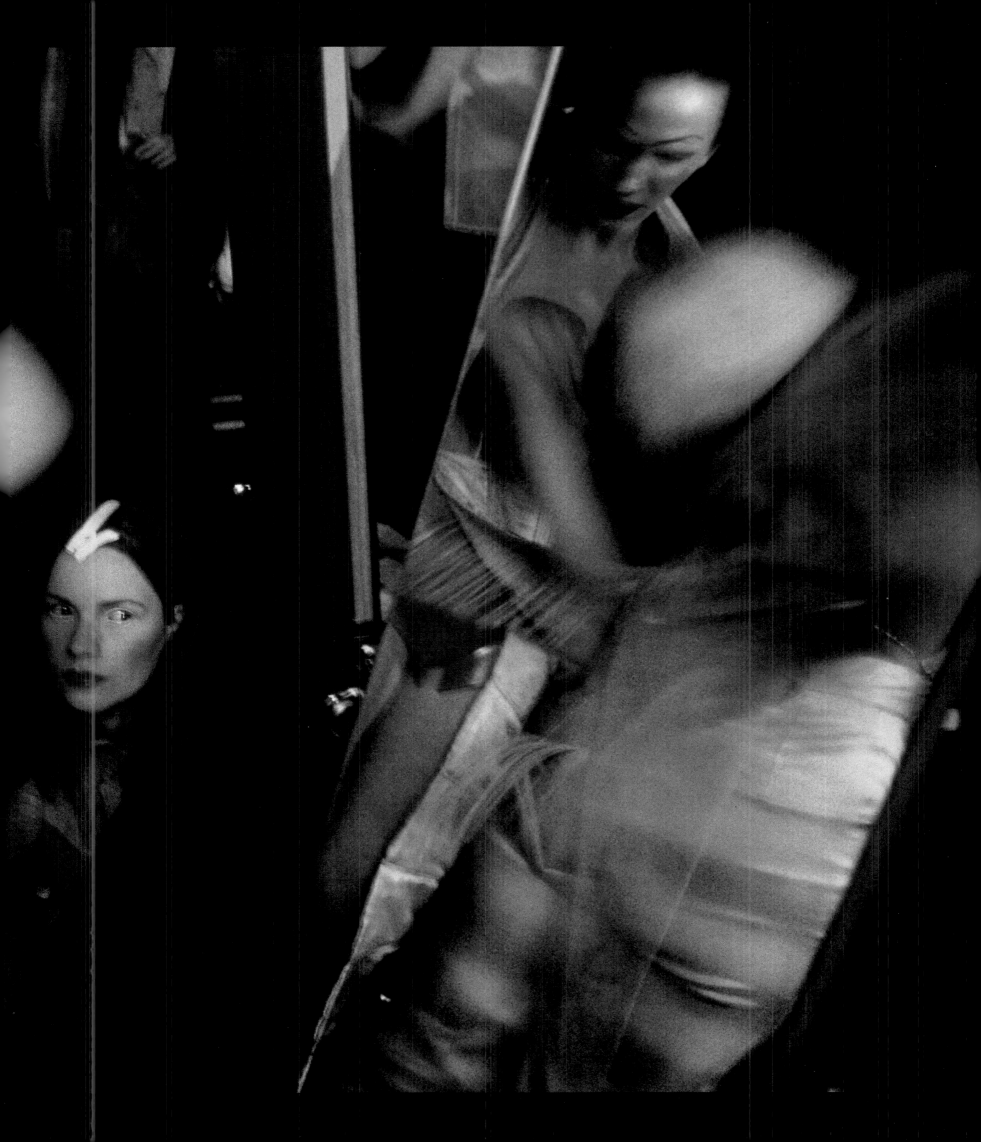

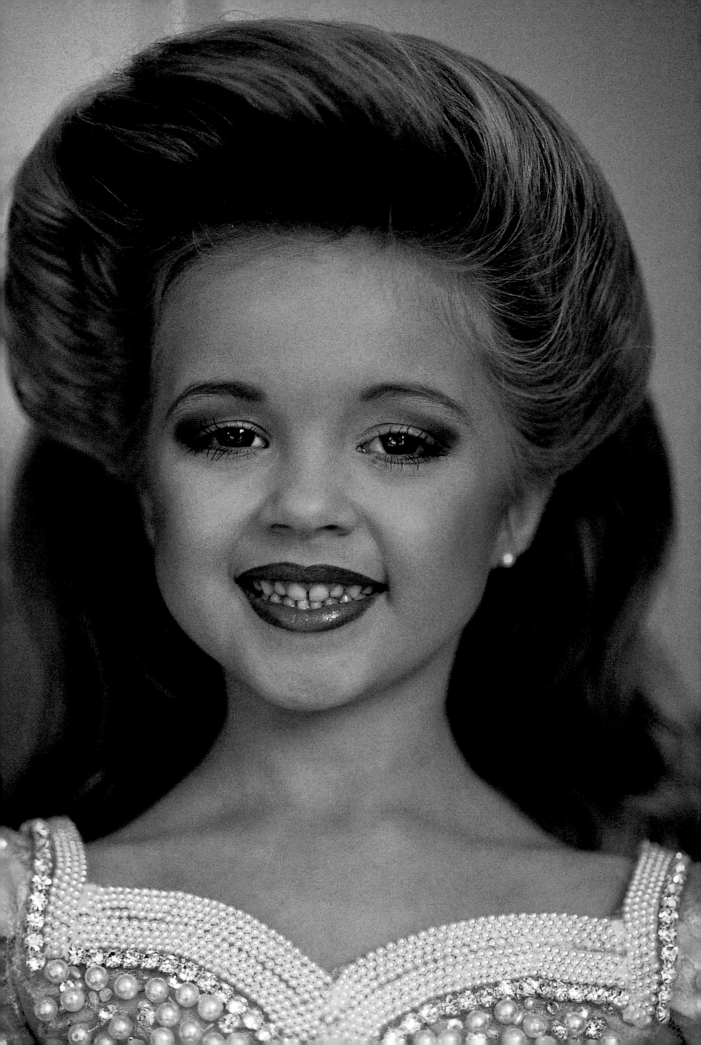

Hoping to be crowned queen, a five-year-
old, opposite, competes in the Regal Miss
pageant. "The trophies and crowns were
bigger than some contestants," says Cobb.

JEKYLL ISLAND, GEORGIA 1999

While her mother curls her sister's hair,
Regal Miss competitor Nicole Moore
gives the same attention to her doll.

77

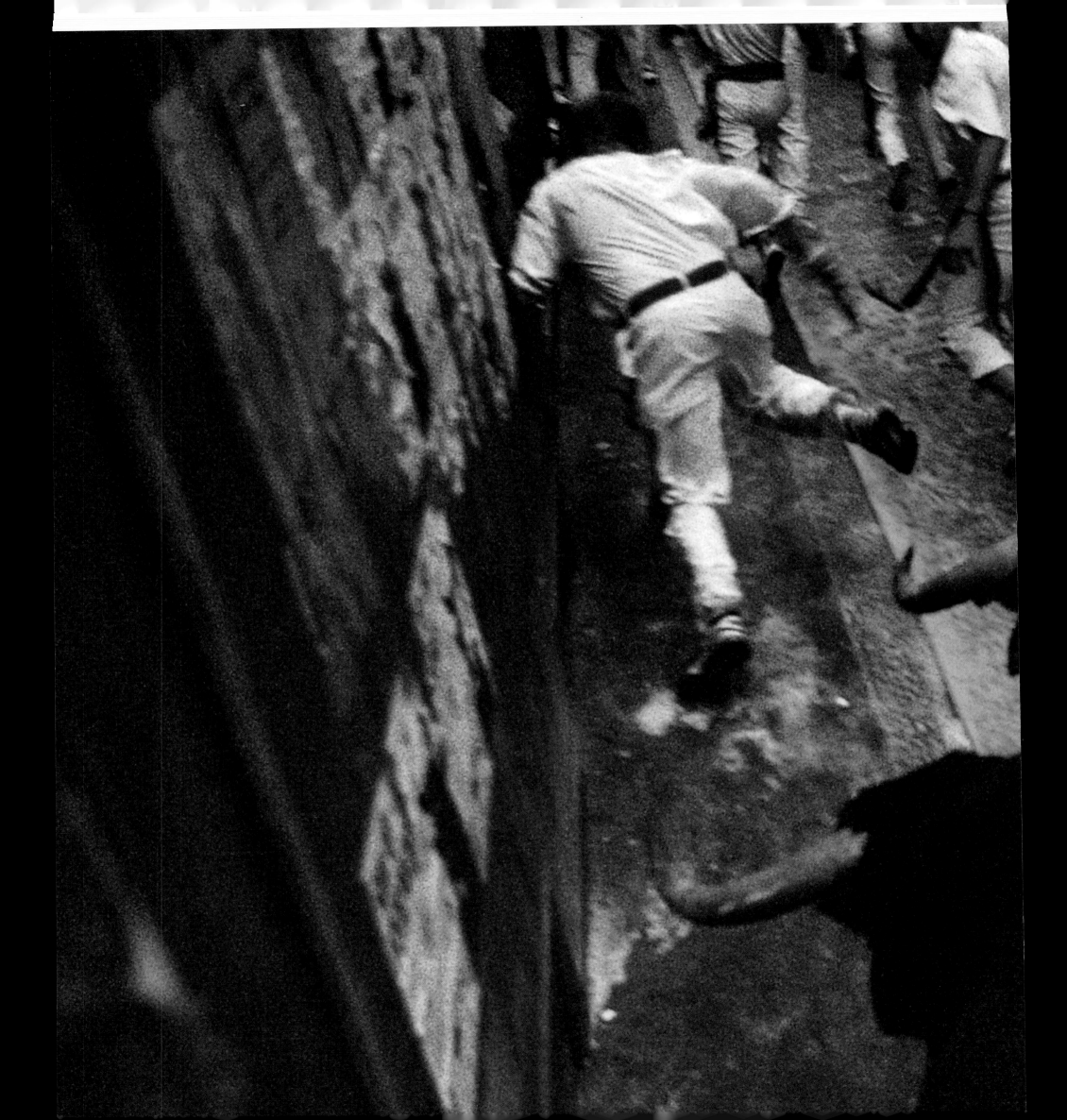

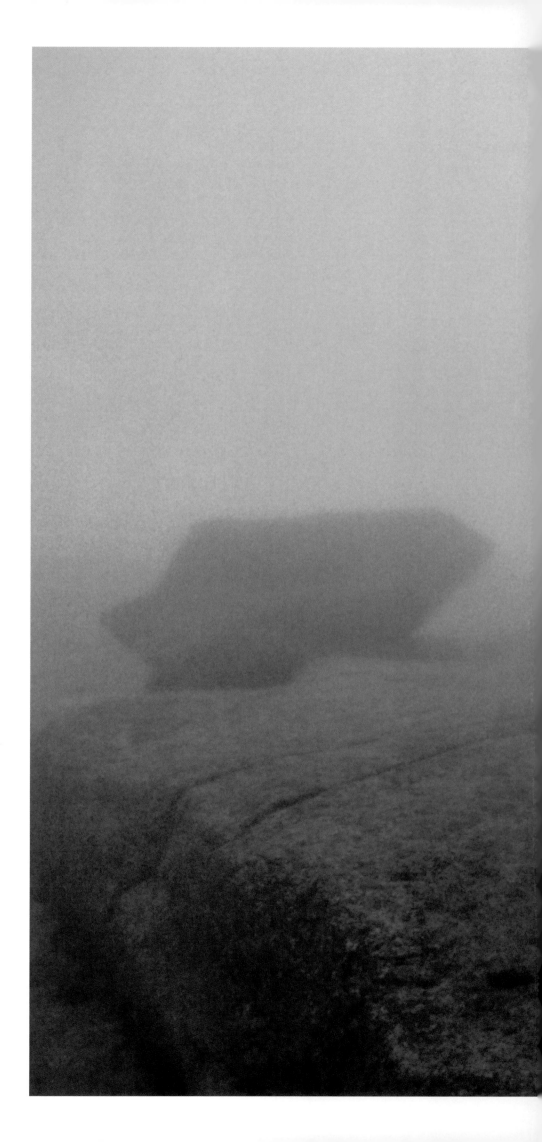

MARIA STENZEL • ADIRONDACKS 1998

Kevin Burns, an Adirondack guide,
leans into the 50-mile-an-hour winds
on the summit of Algonquin, the second
highest peak in the chain.

FOLLOWING PAGES

LAURA GILPIN • COLORADO 1932
Gilpin, a noted photographer of the
Southwest landscape, captured the
tracks of a lone walker in the desert
of Great Sand Dunes monument.

JINX RODGER • ALGERIA 1958
George Rodger is credited as author
of the story with this photograph; but
this image of him groping through a
sandstorm is clearly the work of Jinx.

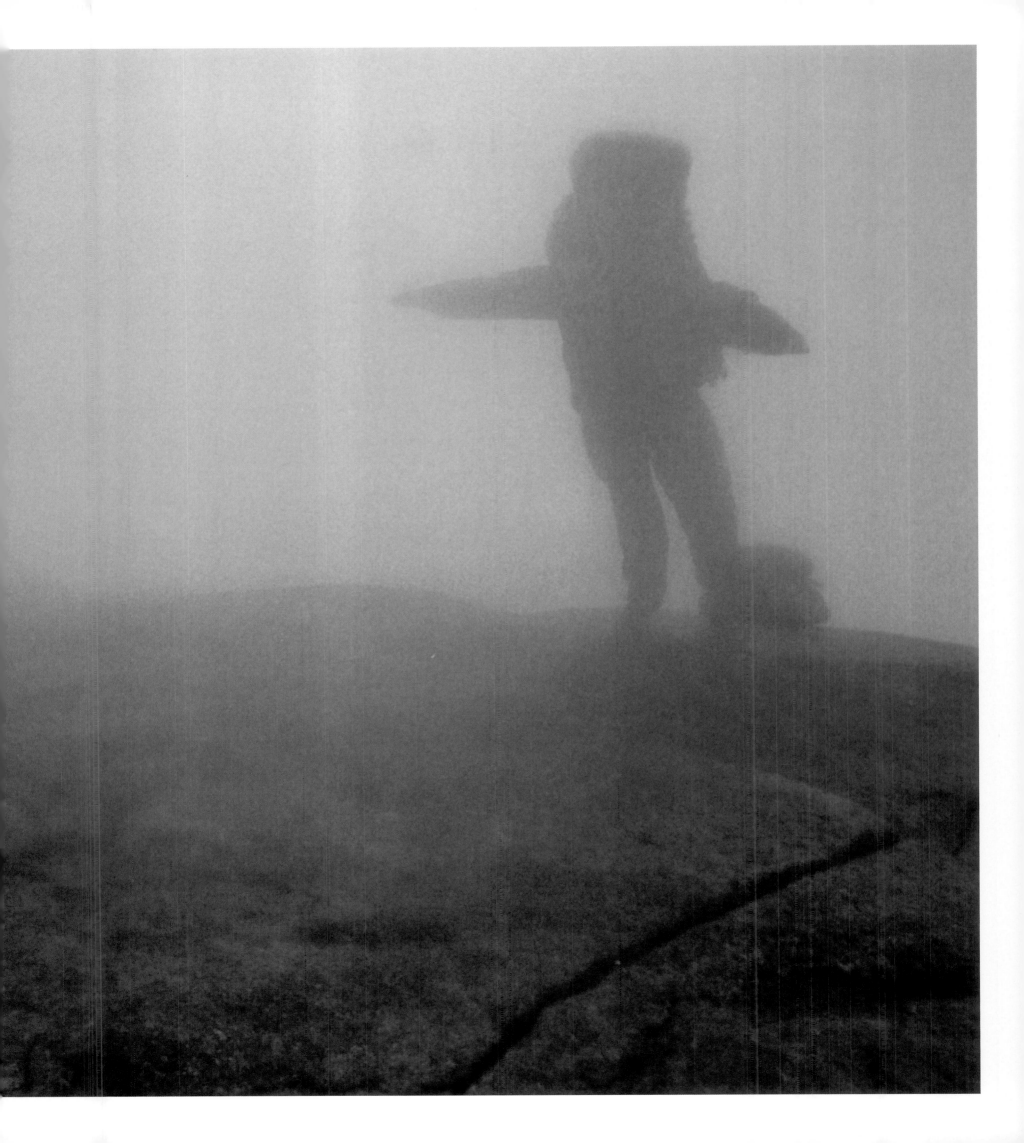

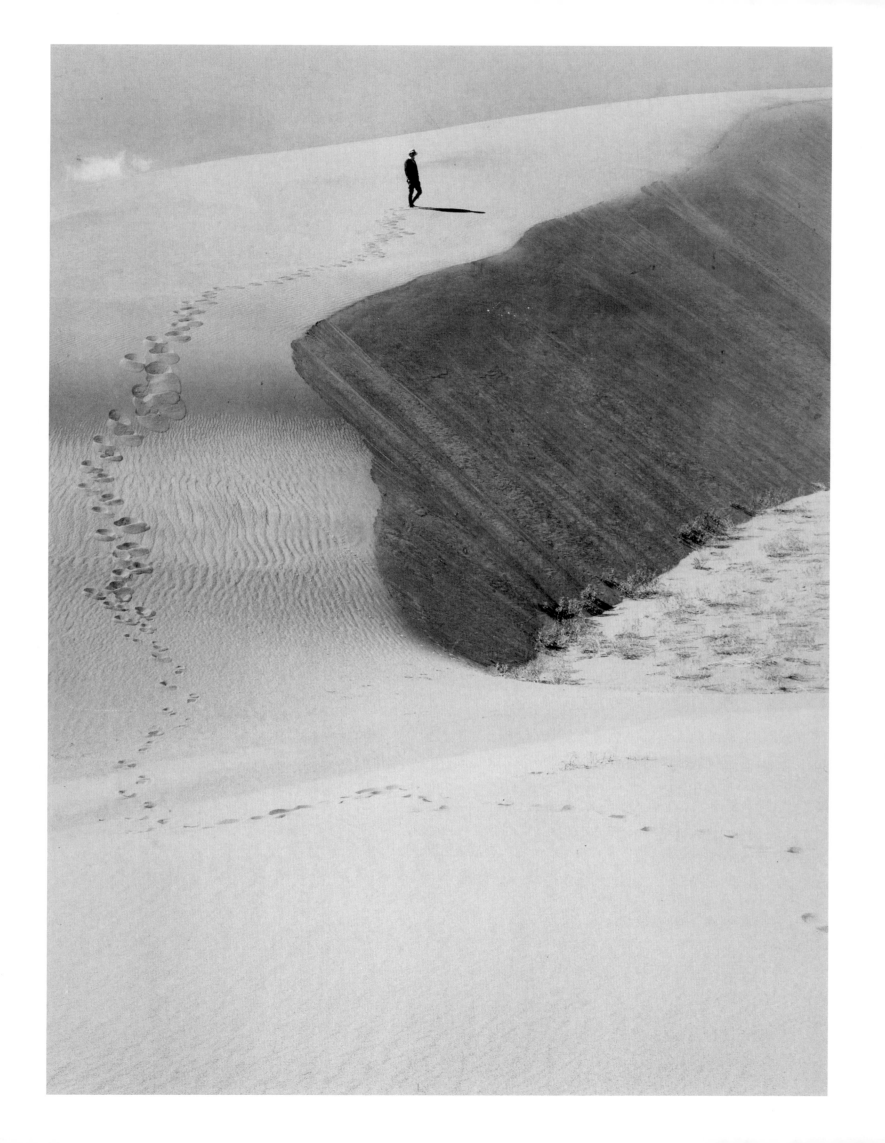

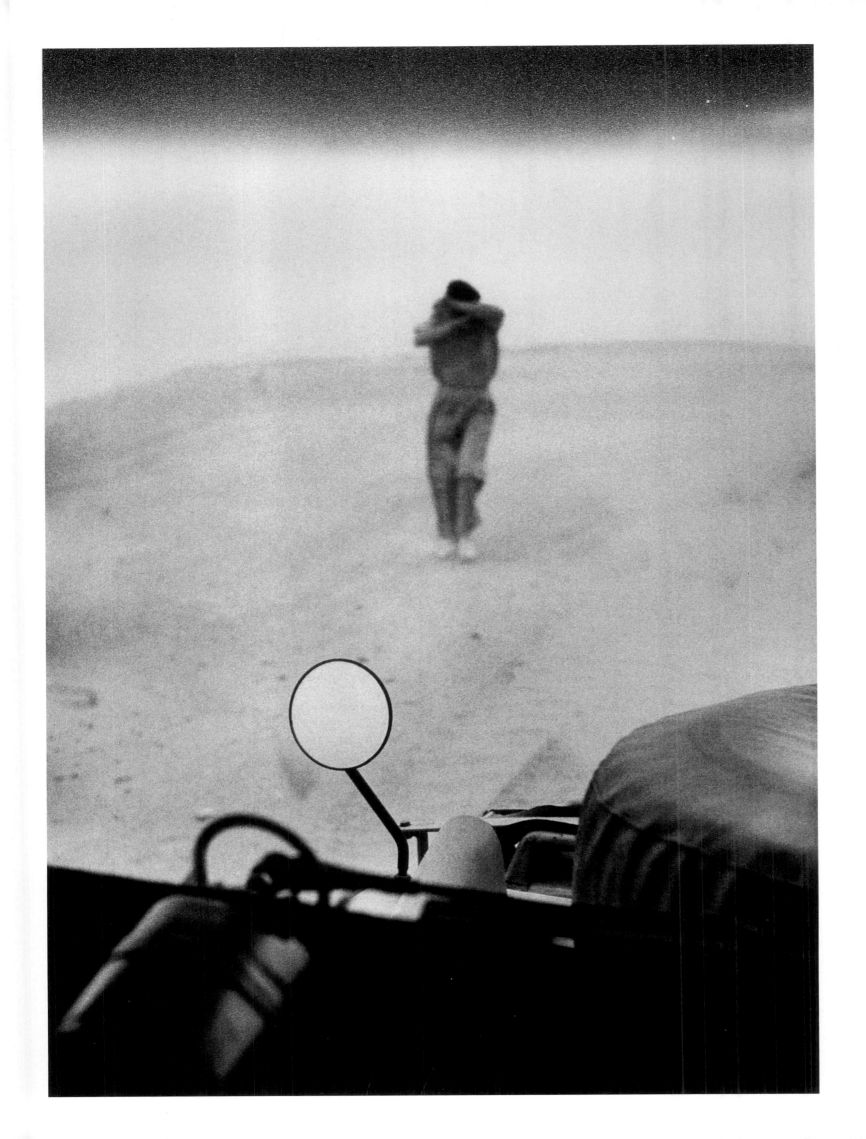

ALICE SCHALEK • INDIA 1928

Schalek, an Austrian correspondent,
traveled widely through Asia, Africa,
South America, and the Pacific. She
submitted hundreds of photographs
to the magazine, including this one
of the main street in Udaipur, India.

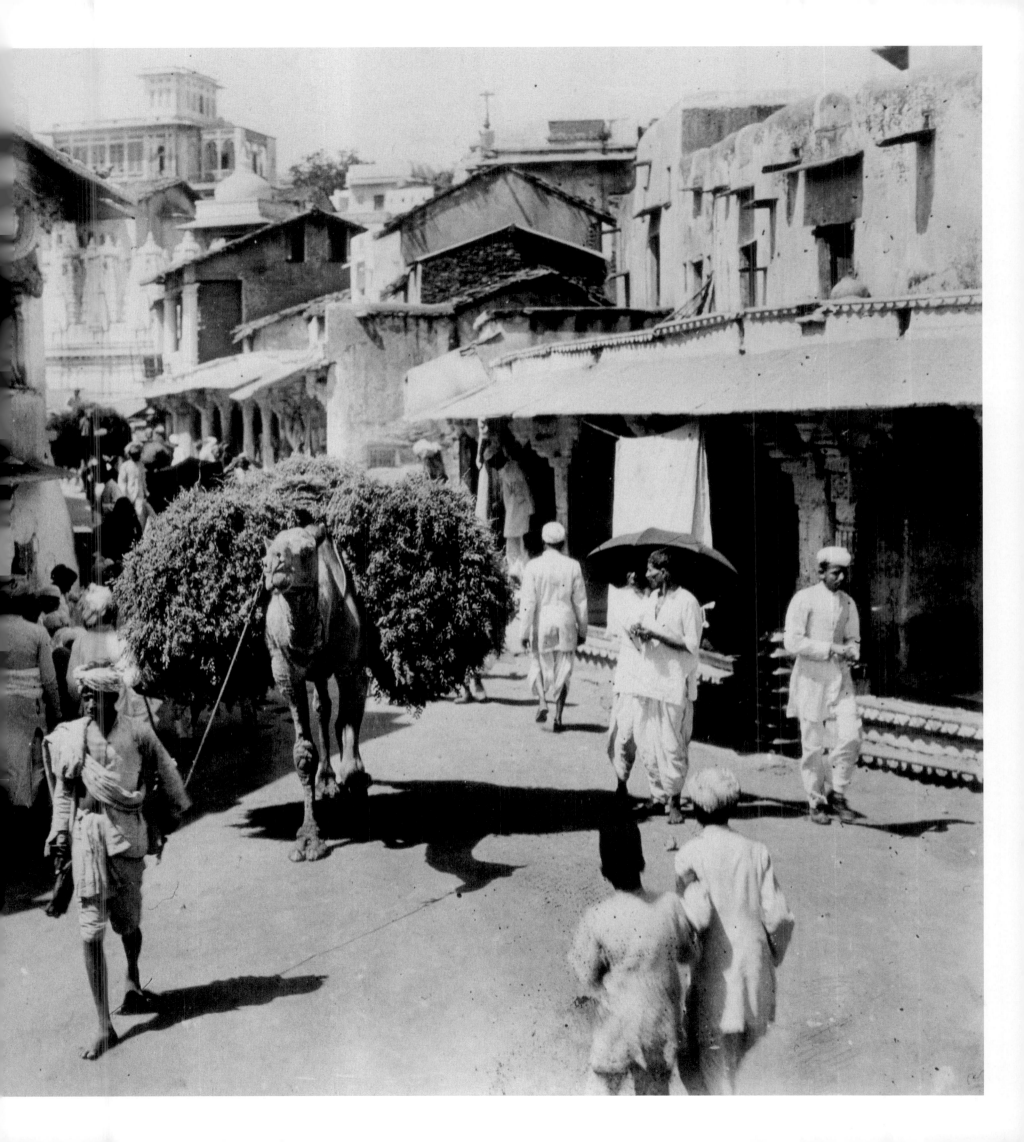

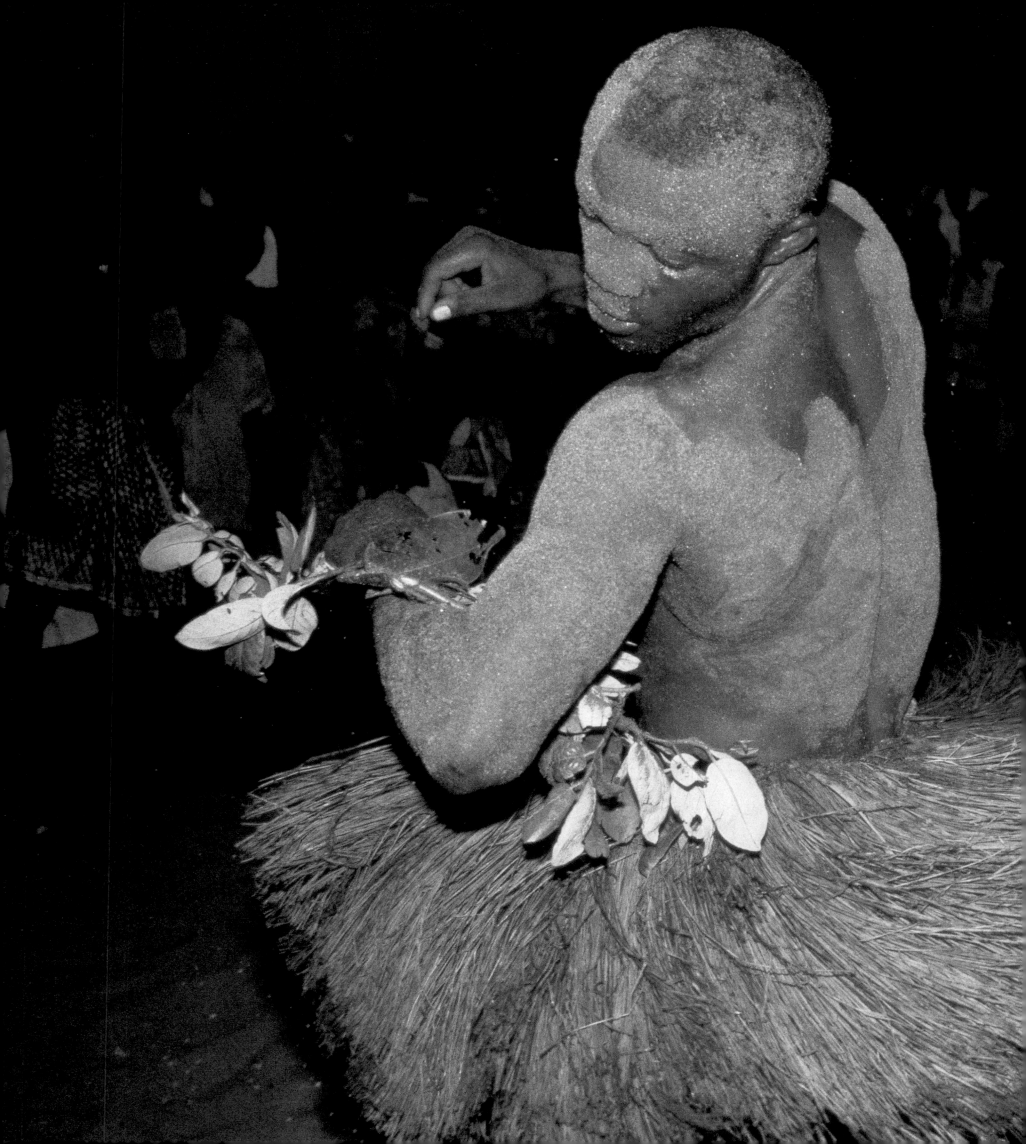

Maria Stenzel

ADVENTURE

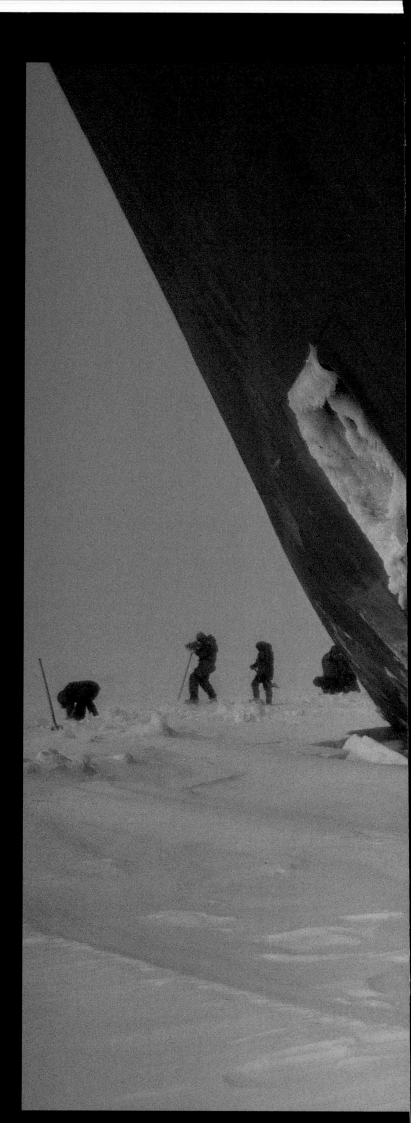

"I LIKE THE IDEA of distance," Maria Stenzel says. "I like
being alone on an icebreaker in a sea of ice the size of Europe or in
the Adirondacks or driving across the Arctic tundra on a sled pulled
by reindeer." As a photographer specializing in adventure, she has
been there and done it all. Stenzel went to work for NATIONAL
GEOGRAPHIC in 1980 after graduating from the University of Virginia.
Her first job was in Film Review, sticking labels on film cans. By 1989,
she was head of the department. "I had worked for the college newspa-
per, but didn't want to be a photographer," she says. "Coming here
changed my mind; I realized there was a wide world out there."
With the guidance of staff photographers Sam Abell and Jim Amos,
she started shooting for local publications. Her break came in 1990,
ironically, with downsizing and the loss of her job. Stenzel, who didn't
enjoy managing people anyway, met the news philosophically. Sensing
her talent, Susan Smith, assistant director of photography, gave her
small, inhouse jobs, such as retirement parties. In 1991 she got her
first assignment: "The Catskills." She never looked back. "Migratory
Beekeepers" followed, then physically tough stories like "David
Thompson," the "Dry Valleys of Antarctica," and "Sea Ice," shown
here. Although colleagues teased her about the assignment, which
entailed 50 days on an Antarctic icebreaker ("You'll have time to write
Christmas cards," said one); she found it exhilarating. Where others see
hardship and discomfort, Stenzel sees tranquil beauty. "I've always pre-
ferred a tent to a hotel room," she says. "I find solace in landscape."

ANTARCTICA 1996 Stopped by sea ice 1,300 miles from the South Pole, the *Nathaniel
B. Palmer* grinds to a halt. From here scientists embarked on their studies.

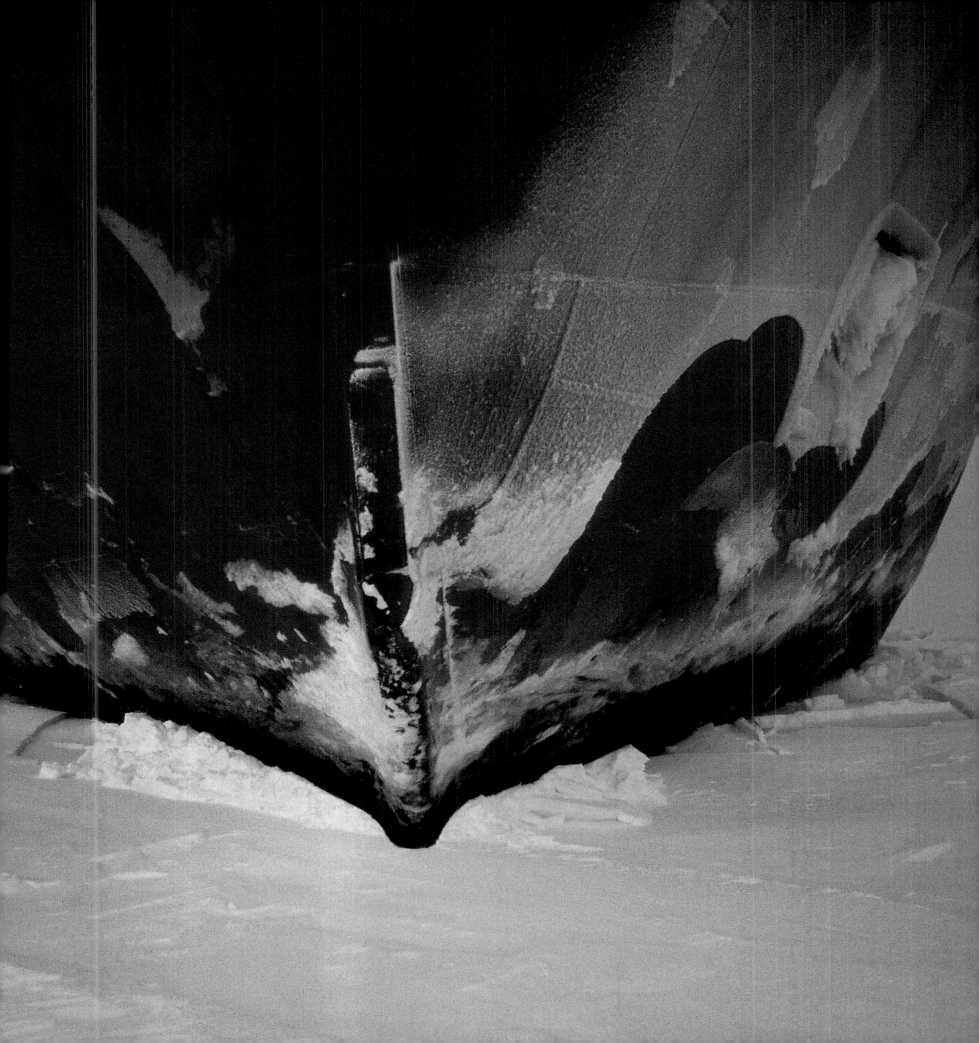

ANTARCTICA 1996

It took five days sailing on a roiling sea
to get to the sea ice—"I was sick all the
way," says Stenzel of this dubious start
to her 50-day trip out of New Zealand.

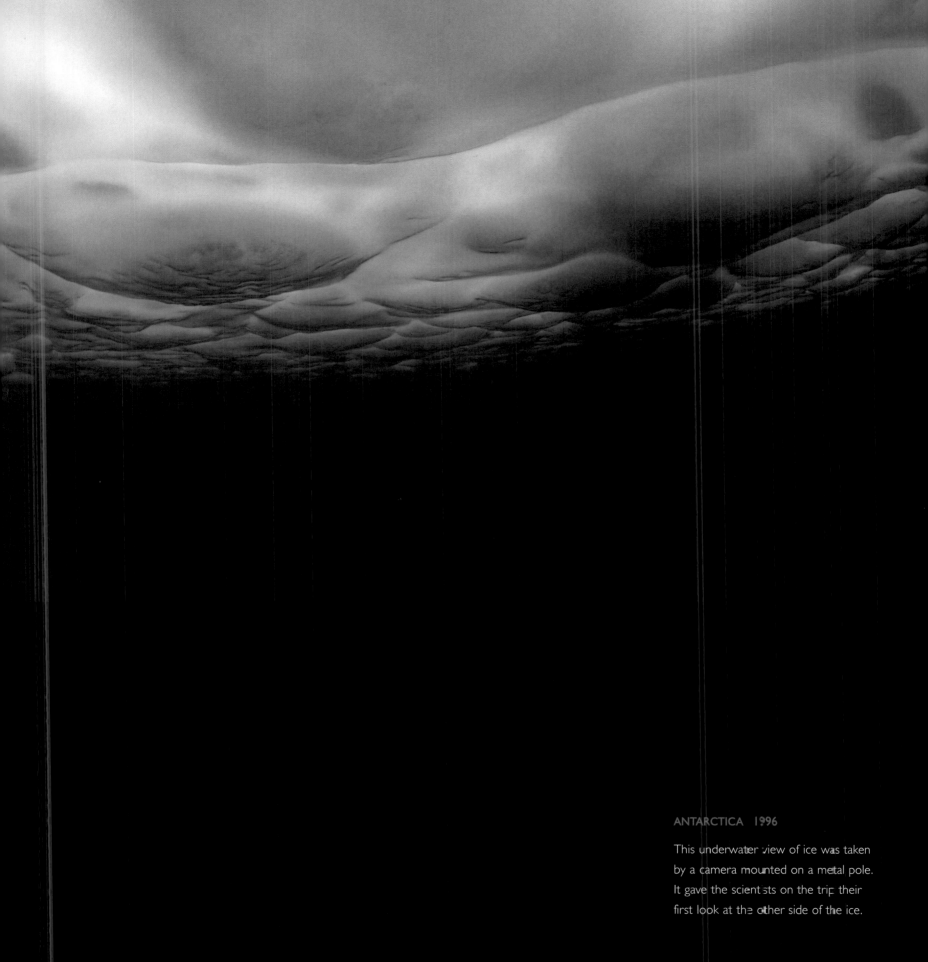

ANTARCTICA 1996

This underwater view of ice was taken
by a camera mounted on a metal pole.
It gave the scientists on the trip their
first look at the other side of the ice.

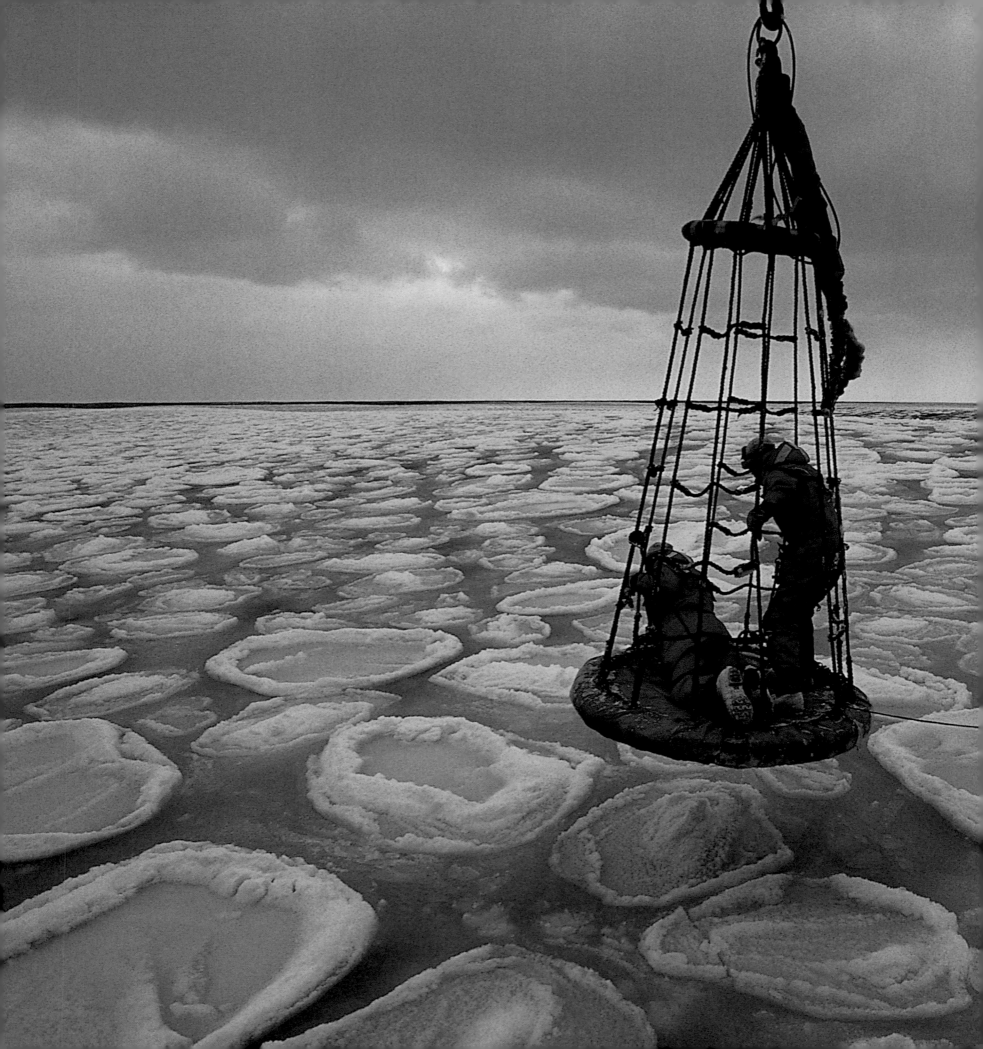

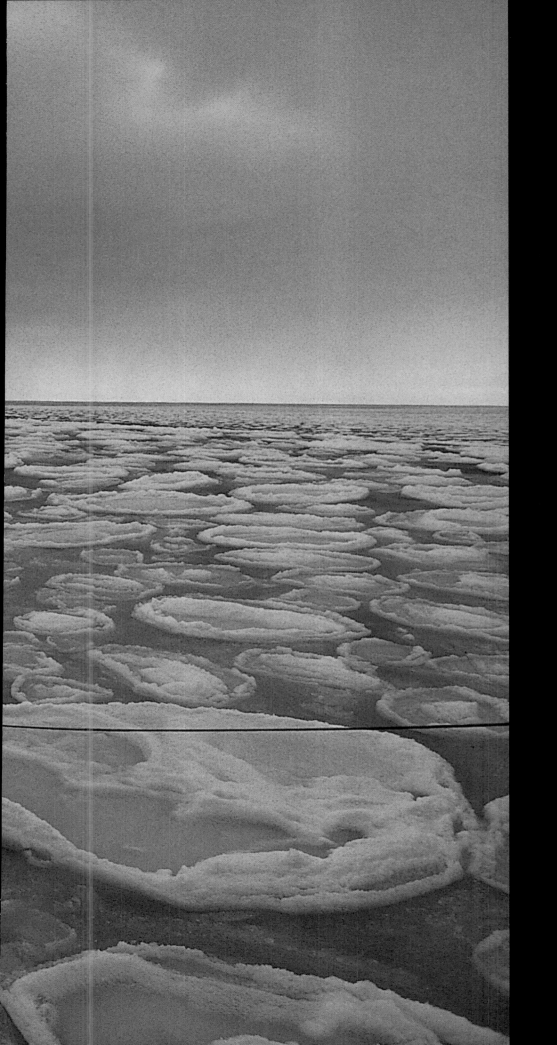

ANTARCTICA 1996

Scientists fish for secrets locked inside
the winter sea, here frozen into pancake
ice—the early stage of solidification.

FOLLOWING PAGES

ANTARCTICA 1996

Struck by the beauty of a solitary iceberg
held fast by sea ice, Stenzel convinced the
ship's lead scientist to stop so she could
get the shot. "He gave me three minutes,"
she says, "then the ship moved on."

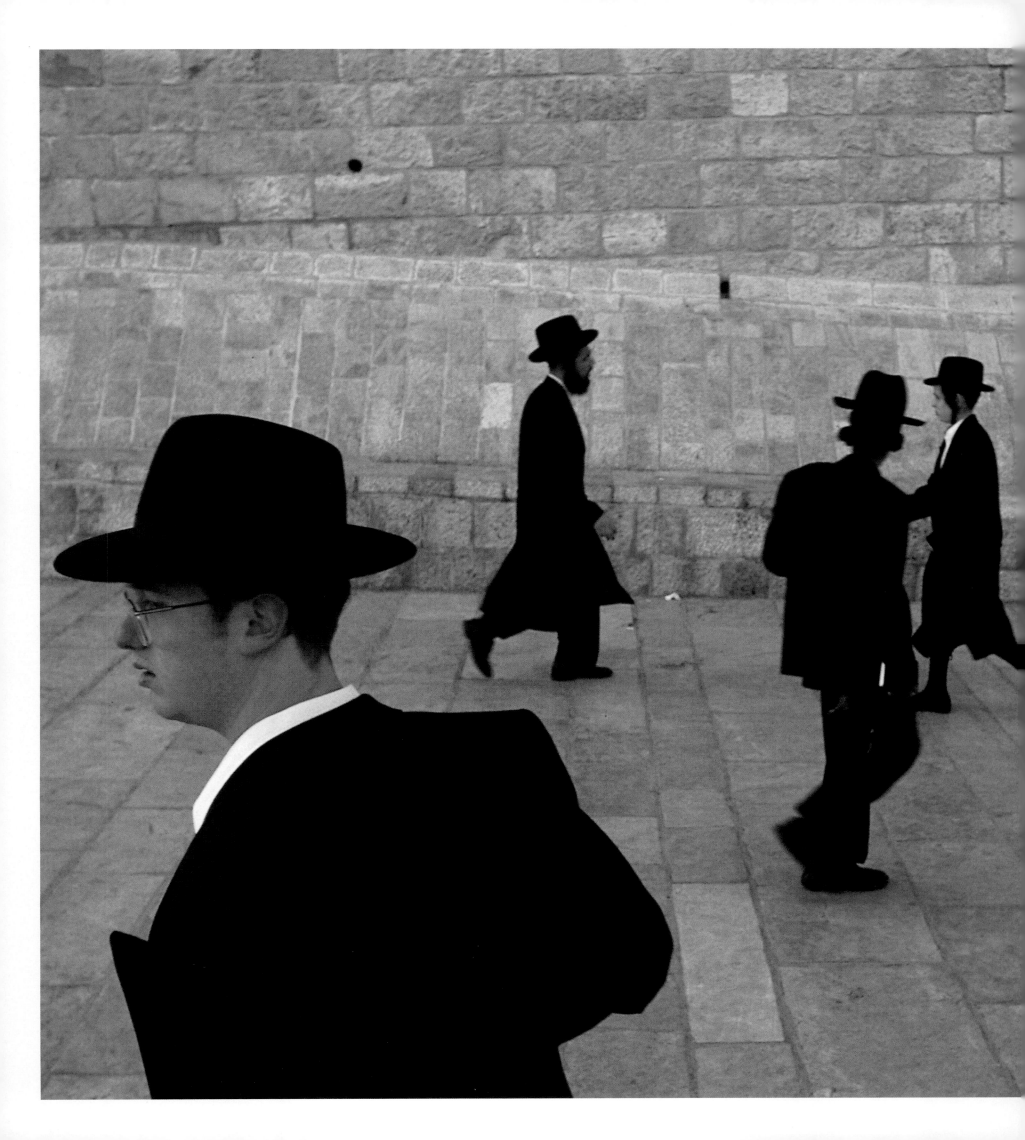

WOMEN'S WORK

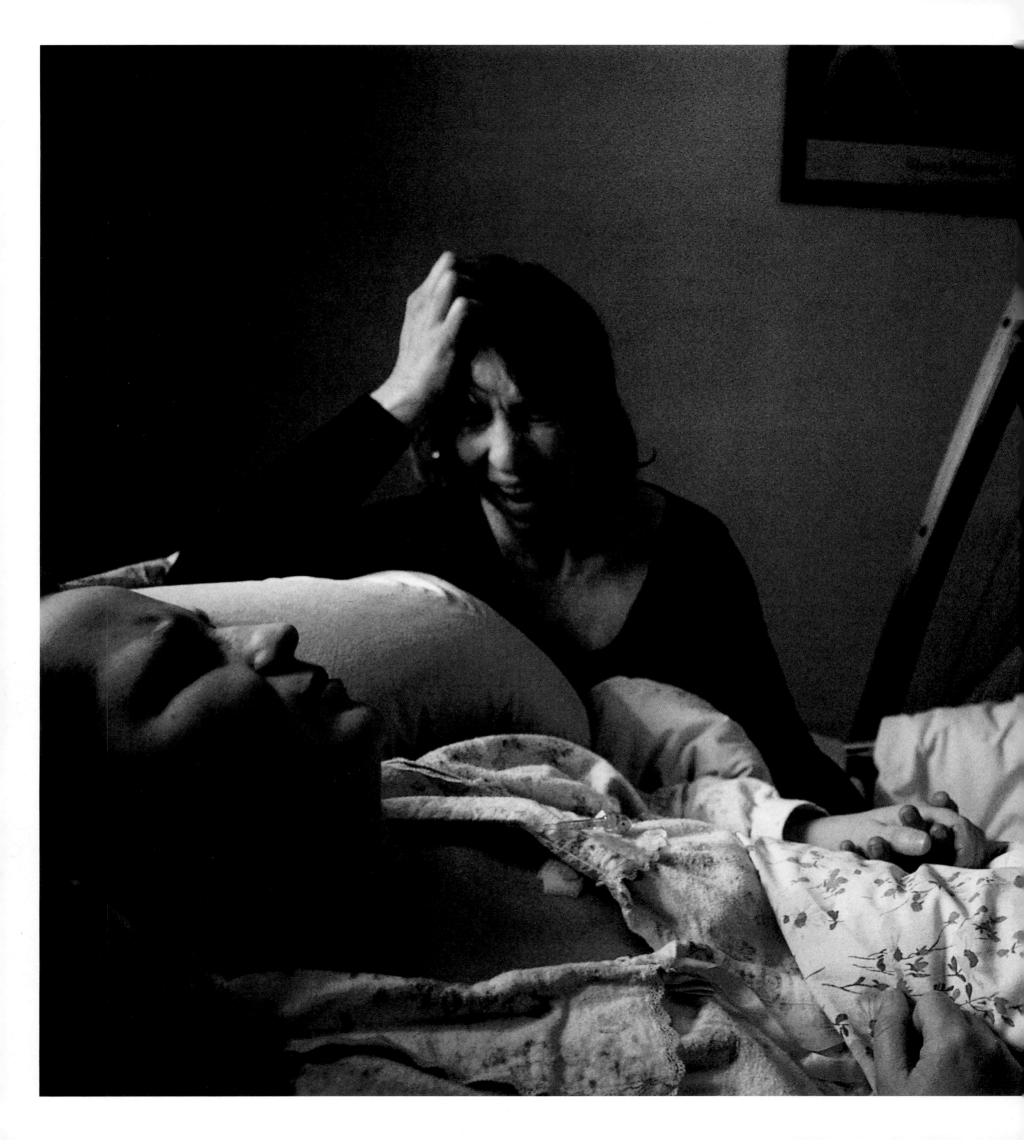

LYNN JOHNSON • MONTANA 1993

A woman sobs in anguish for her
dying friend, stricken by a brain tumor.
A harpist from a group of women in
Missoula dedicated to easing the passage
into death, plays in the background.

PREVIOUS PAGES

ANNIE GRIFFITHS BELT • JERUSALEM 1996

Orthodox Jews pass by the revered
Western Wall, one of many holy shrines
in a city where the faithful of three
religions live worship, and often clash.

131

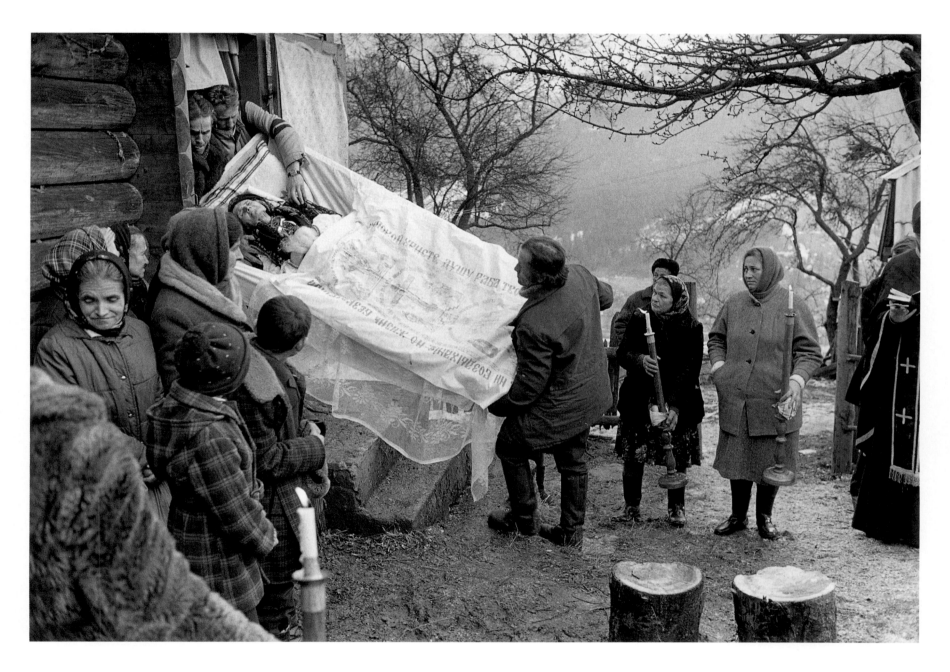

LIDA SUCHÝ• UKRAINE 1997

Hutsul mourners ease a woman's coffin
out her door. Bread loaves tied to candle-
sticks with handkerchiefs honor her soul.

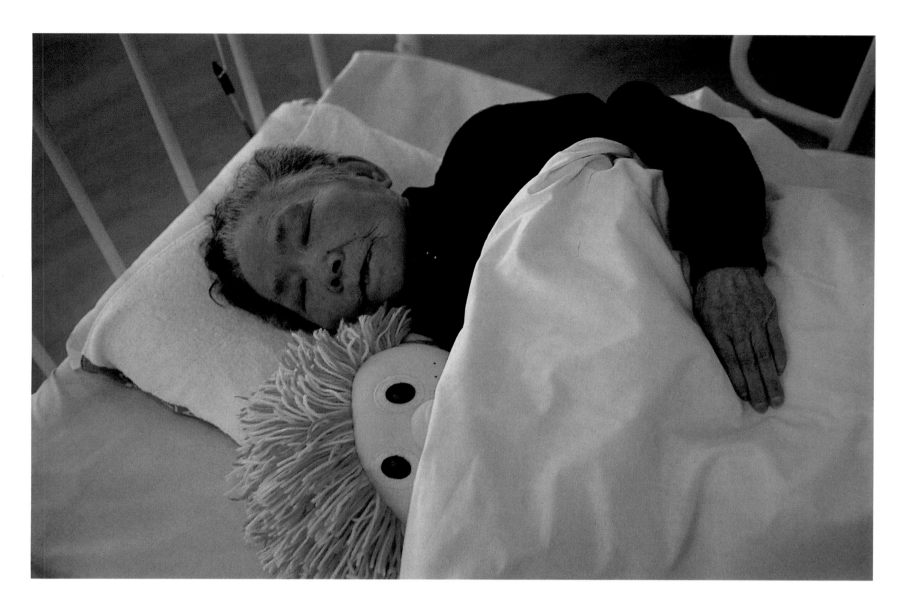

KAREN KASMAUSKI • JAPAN 1997

Yoshi Seki settles into the embrace of sleep in an adult day care center in Yamato, Japan. She comes to the center three days a week, allowing her family time to tend to other duties.

completely crazy. I could never give them the attention they would need.' I was letting her down like everyone else. But she forgave me without saying so and made it easy."

During Kasmauski's last visit, Fanny was clearly overwhelmed by the fatigue of her illness. She was losing the war. "She walked me to my car, and gave me a last hug good-bye," Kasmauski says. "She looked at me with sad eyes. 'Do you think anyone will help me through these last days?' she asked. 'I have given so much to people, will I get anything in return?' I was heavy with sadness. I could not promise that I would be there for her."

Several months after the story ran in the NATIONAL GEOGRAPHIC, Fanny's nurse called Kasmauski to say that Fanny was near death. Kasmauski was torn. Should she fly down and see her? Would she even be alert enough to know if Kasmauski were there?

"I called her," Kasmauski says. "Her nurse answered and said Fanny could not talk. She had left the conscious world. 'If she ever regains consciousness, please tell her that I love her and am praying for her,' I told the nurse. I felt hollow. I had let Fanny down. One of the biggest regrets of my

life was not flying down to be with her when she died; I am certain she would have done that for me."

Fanny's brave gift—allowing Karen into her life as it neared its close—was repaid. Karen's photographs allowed Fanny to share her story with millions. In the end, no one is immune to life's consequences. "We're all responsible for our actions," Fanny said.

In the field, a photographer is enmeshed in the intensity of the moment. The life left behind fades. The experience can be life-changing, liberating, and dangerous. Passion can erupt—for a person, a thing, a place. It is the wild-card factor in every assignment.

"I covered Brazil for six months," recalls Stephanie Maze, who photographed that country for a magazine story in 1987. "I was determined not to miss a thing. I was waking up at four in the morning with howling monkeys in the Amazon. I remember the sensual whirl of Carnival in Rio de Janeiro and of being in the Serra Pelada gold mine with 60,000 miners, all men. I became infatuated with the country. When I returned to Washington, I put my apartment on the market and moved to Rio. I learned the language by watching soap operas. I lived two blocks from Ipanema beach, with a jazz club on the corner. I stayed for two years."

Along with exhilaration, there is risk. The perils of photography come seen and unseen. It is the given of the work. The guiding principle is to avoid carelessness, over which there is some control, and to hope to avoid bad luck, over which there is none.

"The stupidest thing I ever did was when I was photographing a big radio telescope in Chester for the book on Great Britain," remembers Annie Griffiths Belt. The telescope is like a giant dish facing the sky. "I climbed to the rim by ladder, and perched myself on a large bolt so I could shoot down at the dish. Chester was 30 stories below me. A gust of wind hit me, knocking me off balance, and so I grabbed at a rope and glanced back. I wasn't wearing a safety belt, and then I realized that if the wind had been a tiny bit stronger I would have been a grease spot in Chester. I couldn't get down fast enough." Before she did, she got the picture.

The carelessness of others can be just as hazardous. "I'm above Cape Cod," Belt says, talking about her coverage for a TRAVELER magazine piece. "We're ten minutes in the air and the pilot informs me we are out of gas. 'Out of gas!' I said and glanced out to see where we were. 'There's a beach, land on it!' I told him."

The pilot replied he had never landed on a beach.

"Have you got another suggestion?" she snapped.

He didn't. They landed on the beach.

Not unexpectedly, working with wild animals, particularly large animals like elephants, carries great risk. "We have had a few close calls," says Beverly Joubert, who has photographed elephants and lions in collaboration with her husband, Derek, for several NATIONAL GEOGRAPHIC magazine stories and books. "Most of them have been with elephants, although we've been charged by lions while on foot. Once we'd finished filming lions around one in the morning and thought we'd park in an open area and sleep. We'd been dozing 15 minutes when we heard a scuffing sound. It was an elephant cow at the side of the car, her ears flattened. She was hitting us from all sides of the vehicle, then lifted the car up on one side. The car had no top, and next she managed to get her tusks under

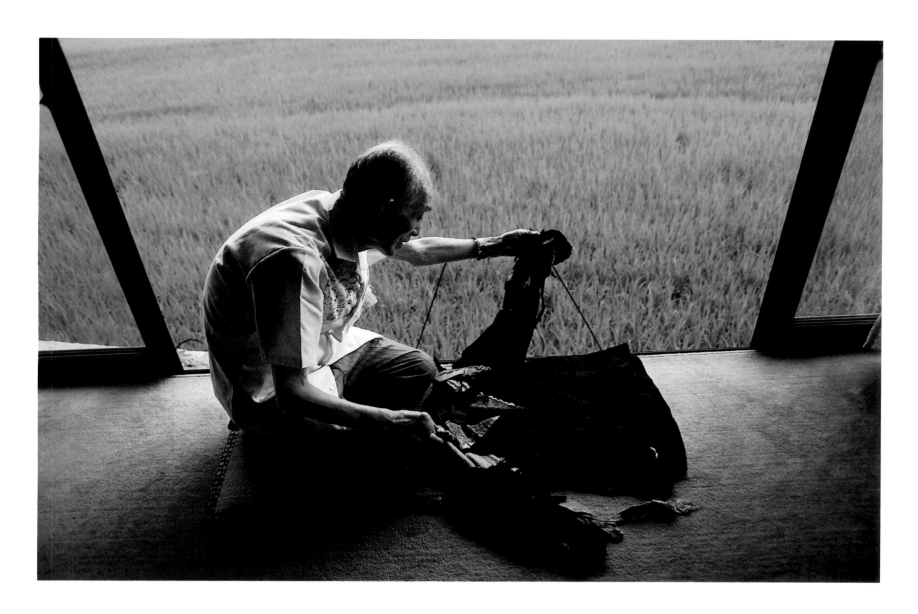

When words fail to describe the horror and pain of Hiroshima, survivor Busuke Shimoe takes out the charred remains of the jacket he was wearing on August 6, 1945, when the atom bomb exploded less than a mile away.

parties and I would hardly talk to anybody," says Joanna Pinneo. "I would just watch. I'd go to some event strictly for pleasure—a ballgame, say—and I would be annoyed because I wasn't up front. I was watching from the bleachers like everyone else. The camera can be a barrier. The camera can isolate."

The line between photographer and subject wavers. It will not stay still. "The older I get, the more I see that there is a permeable boundary between me and the subject," says Lynn Johnson. For Johnson, the classic ideal of distance and the dispassionate observer has been transmuted into a softer, more gentle and malleable approach. "Compassion is nothing without the touch," she says. "If you can't embrace the person on the other side of the camera, there is no exchange. I am a better person for understanding this."

It is an ever-delicate balance: When to pick the camera up. When to put the camera down. "I would love to work with an invisible camera," says Carol Beckwith. "The camera is always in the way to giving full attention to friendship; it also protects you from things you could never see objectively if you didn't have it. There are things difficult to shoot: Voodoo rituals, for example,

in which men and women cut themselves with sharp glass. People go into wild states. At some point you have to engage in order to let them know the bond of trust is still there. When you take 36 pictures of one woman without stopping to interact, it can arouse suspicion and hostility. No one understands why you don't click the camera once and leave."

Getting the picture is what the job is about, but it's also about reaching out to affirm the vulnerability that makes us all part of the human race. If the photographer sees and captures the human spirit on film, does she not show to us something of her own spirit as well?

There was a one-room schoolhouse in McLeod, North Dakota, Annie Griffiths Belt remembers. The story she was shooting highlighted the rural, sparsely populated nature of that state. "The class was down to three students," she says, "and one of the families was about to move away, leaving only two. Of course they were going to close the school. The teacher, Janice Herbranson, was a real trouper. I was there on the last day of school. She was so upbeat with the kids. But when the day had ended and the kids ran out the door, she walked over to the window, watched them running home, and started to sob; as she did, a great sob went through me.

"First I had to take a few pictures. Then I could go over and hug her."

The privilege of photography is its access to the human soul. It is a gift and it is humbling. Perhaps the finest thing a photographer can do is repay the debt in kind. The great American photographer Marion Post Wolcott, who knew the human spirit when she saw it and who photographed women farm workers in the 1930s and '40s for the Farm Security Administration, once addressed a conference entitled Women in Photography: Making Connections. "Speak with your images from your heart and soul," she implored her audience. "Give of yourselves."

If the first rule of photography is to get close to the subject, the second is to keep on shooting. "I get seasick," says Sisse Brimberg, who got tossed around in a small motorboat during a thunderstorm in the San Bernardino Straits between the South China Sea and the Pacific while shooting a story on the Manila galleons. "How do I put this delicately? I can vomit, then turn around and take the picture."

While driving around on assignment to photograph a story on New Zealand, Annie Griffiths Belt was struck from behind by an inattentive motorist in a four-wheel drive. Her own car was demolished. Belt ended up in the hospital with a compression fracture of the spine. Three days later she was in a helicopter shooting a snowfall. "I knew I would pay for it, but that's what I was there for," she shrugs.

What about the photographer whose viewfinder frames the worst that humans can do to one another? How do you keep the camera steady when the tragedy of war fills the lens?

"I always saw it as being like a surgeon," answers Alexandra Avakian, a veteran of shooting uprisings in Eastern Europe, the Middle East, and the Caribbean. "If your hands shake, you shouldn't be there. You want to make a beautiful picture and you want the composition to be perfect. You want the person looking at the picture to stay there transfixed. "

Often in the grim matrix of tragedy and pain, a kind of professional numbness sets in— an instinctual mental self-preservation that enables the photographer to keep shooting. Once someone asked Margaret Bourke-White how she could photograph the horrors of World War II and its ghastly

LYNN JOHNSON • NIGERIA 2000

A woman presses the leaf of a "headache plant" against her forehead to ease pain.

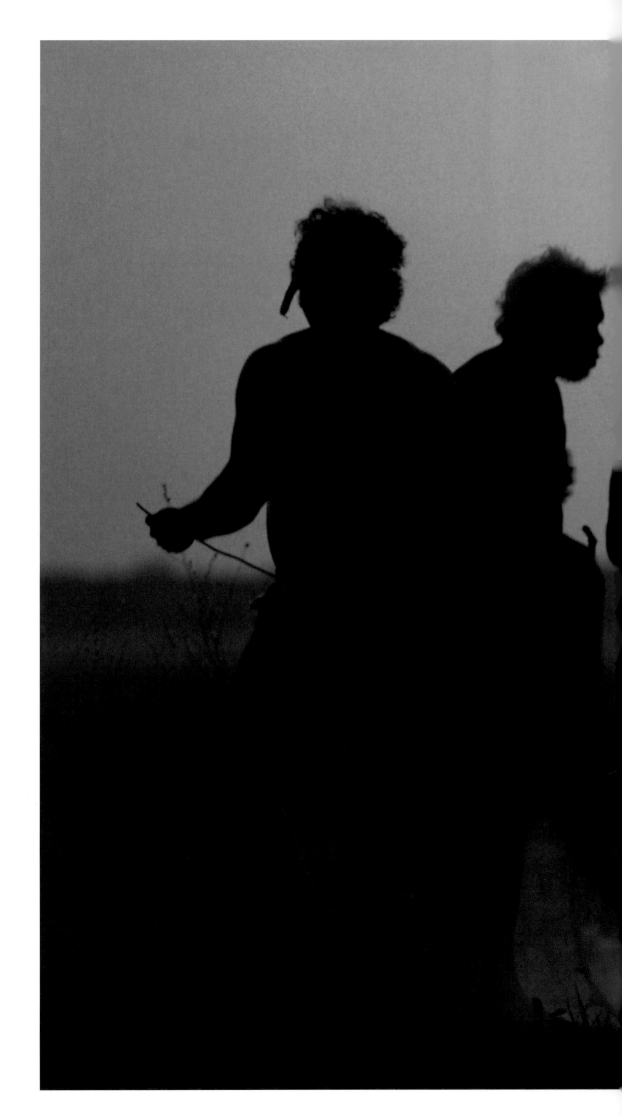

BELINDA WRIGHT • AUSTRALIA 1988

Keepers of the Dreamtime, the Gagudju
and neighboring Aboriginal peoples join
in a ceremonial dance in the Northern
Territory of Australia.

FOLLOWING PAGES

KAREN KASMAUSKI • TOKYO 1991

The energy and movement of humanity
in a hurry give a Japanese citizen much
to ponder in modern-day Tokyo.

148

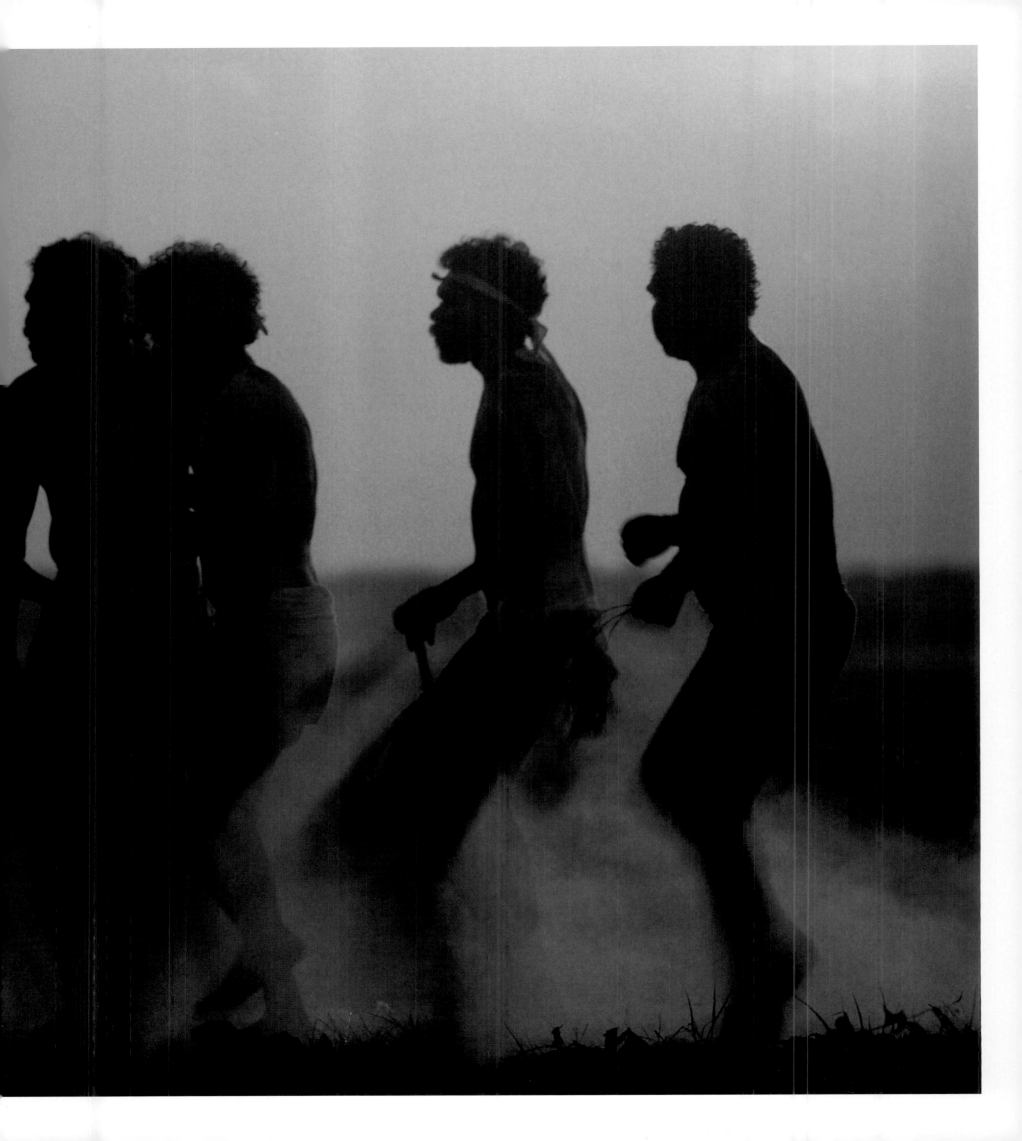

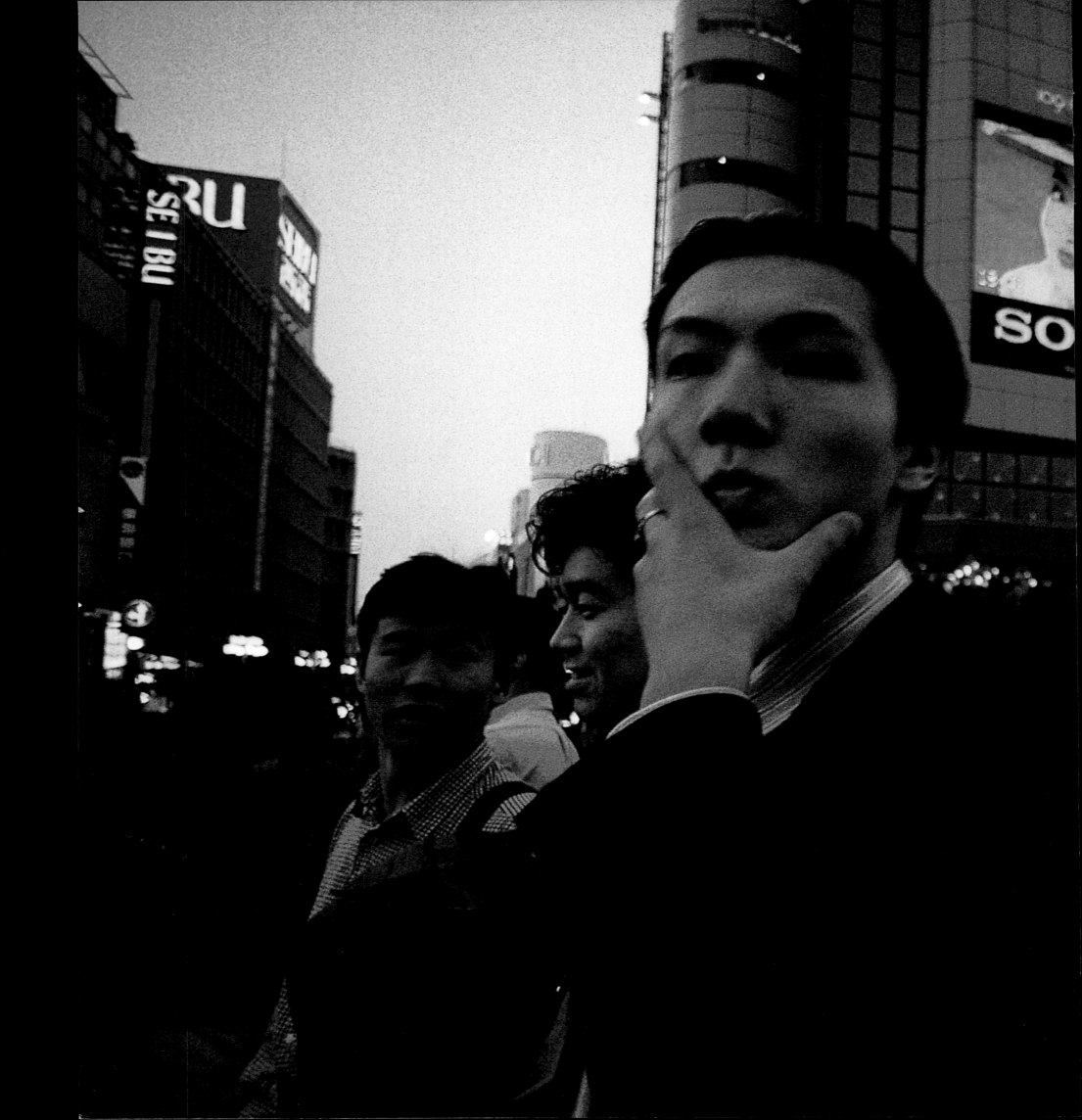

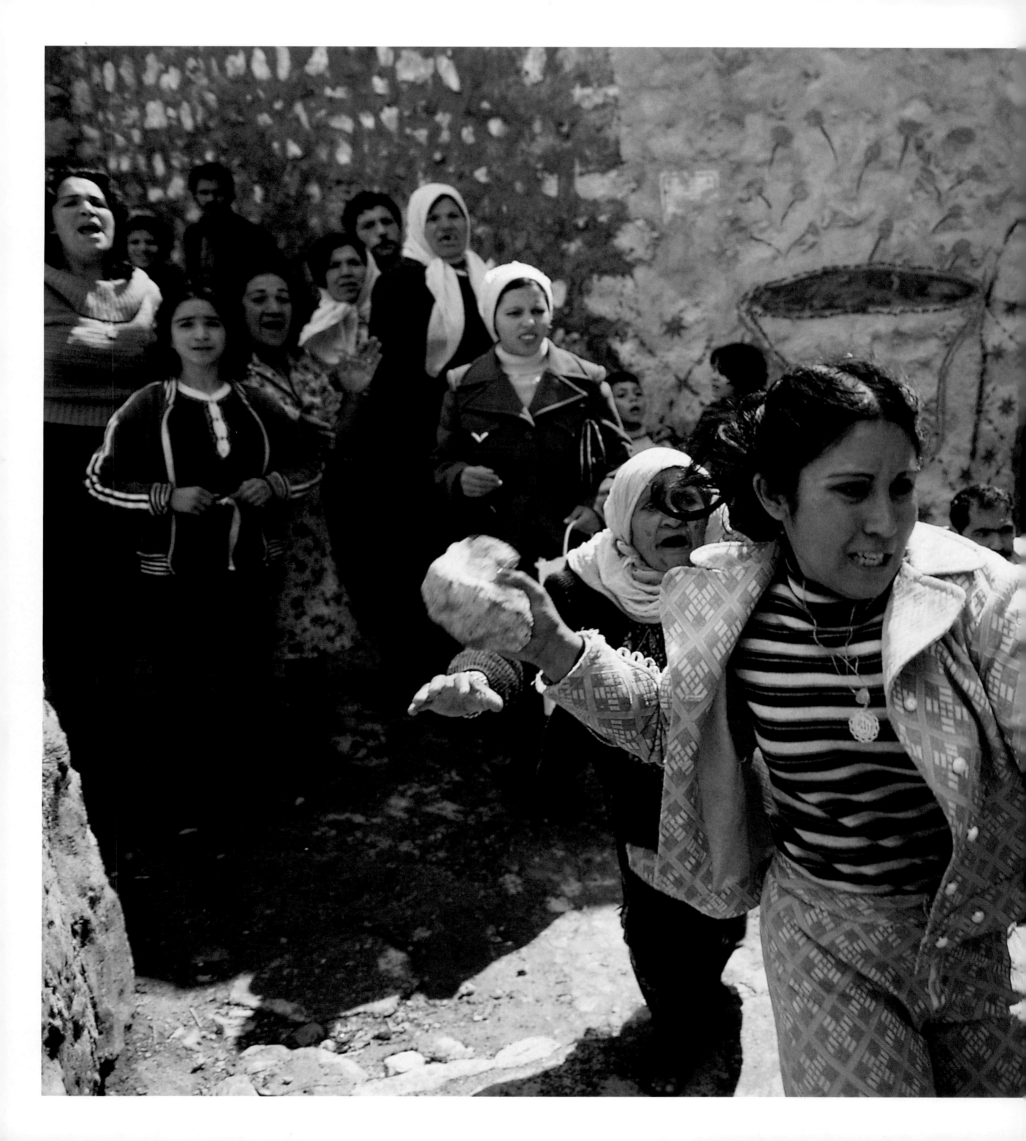

JODI COBB • JERUSALEM 1983

A woman vents her rage at Israeli police
in East Jerusalem during a strike held
by shopkeepers

153

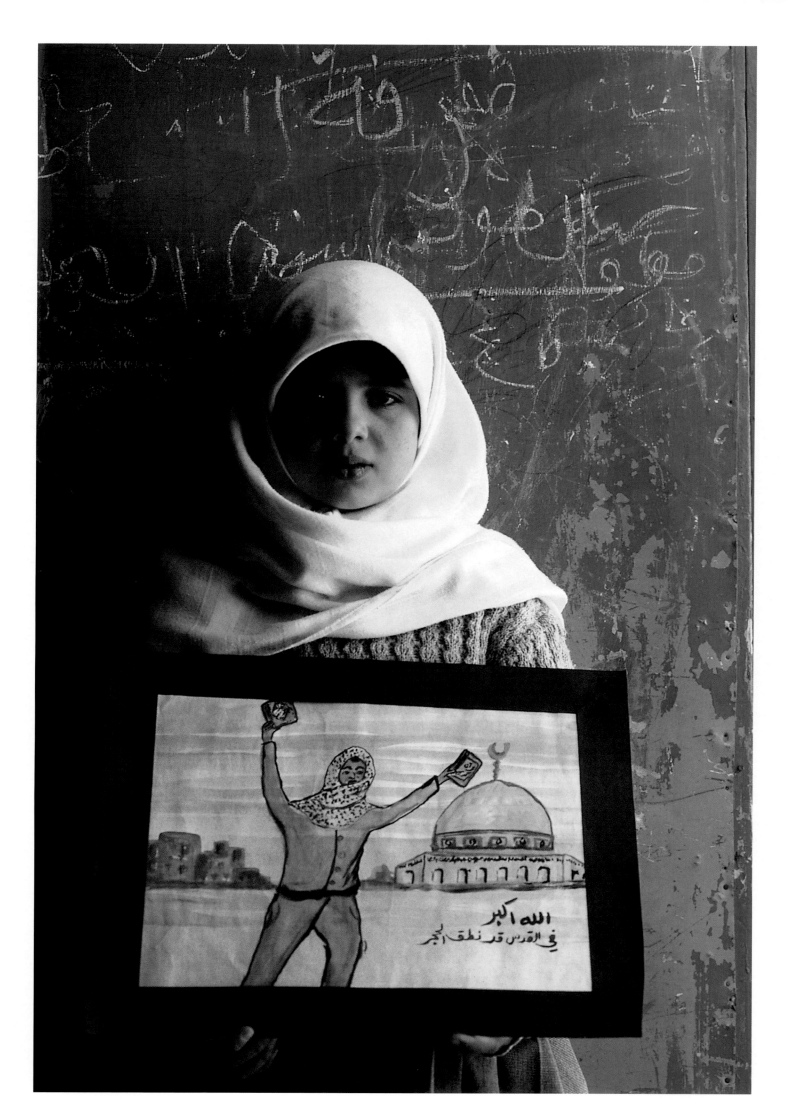

JOANNA PINNEO • JORDAN 1992

Paper creams: a ten-year-old Palestinian holds a drawing of Jerusalem, which she has never seen; but she hopes to live there.

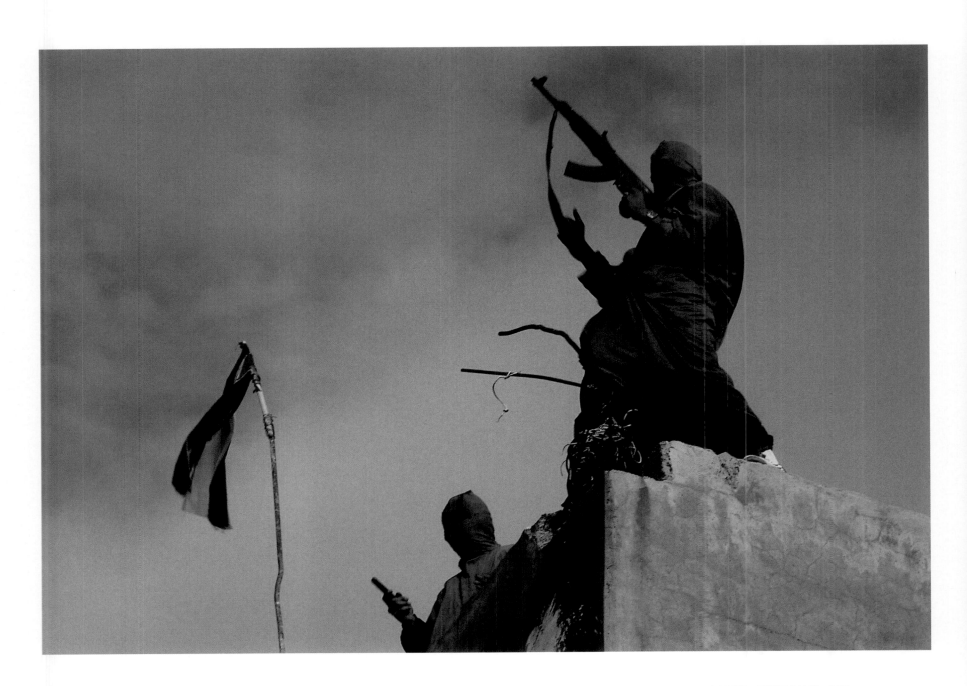

JOANNA PINNEO • WEST BANK 1992

Waving guns and the outlawed Palestinian flag, Black Panther militants demonstrate for national recognition in the West Bank.

ALEXANDRA BOULAT • KOSOVO 2000

Their lives and homes in ruins, ethnic
Albanians survey the wreckage of their
once thriving town destroyed by Serb
forces several days after NATO air
strikes began.

156

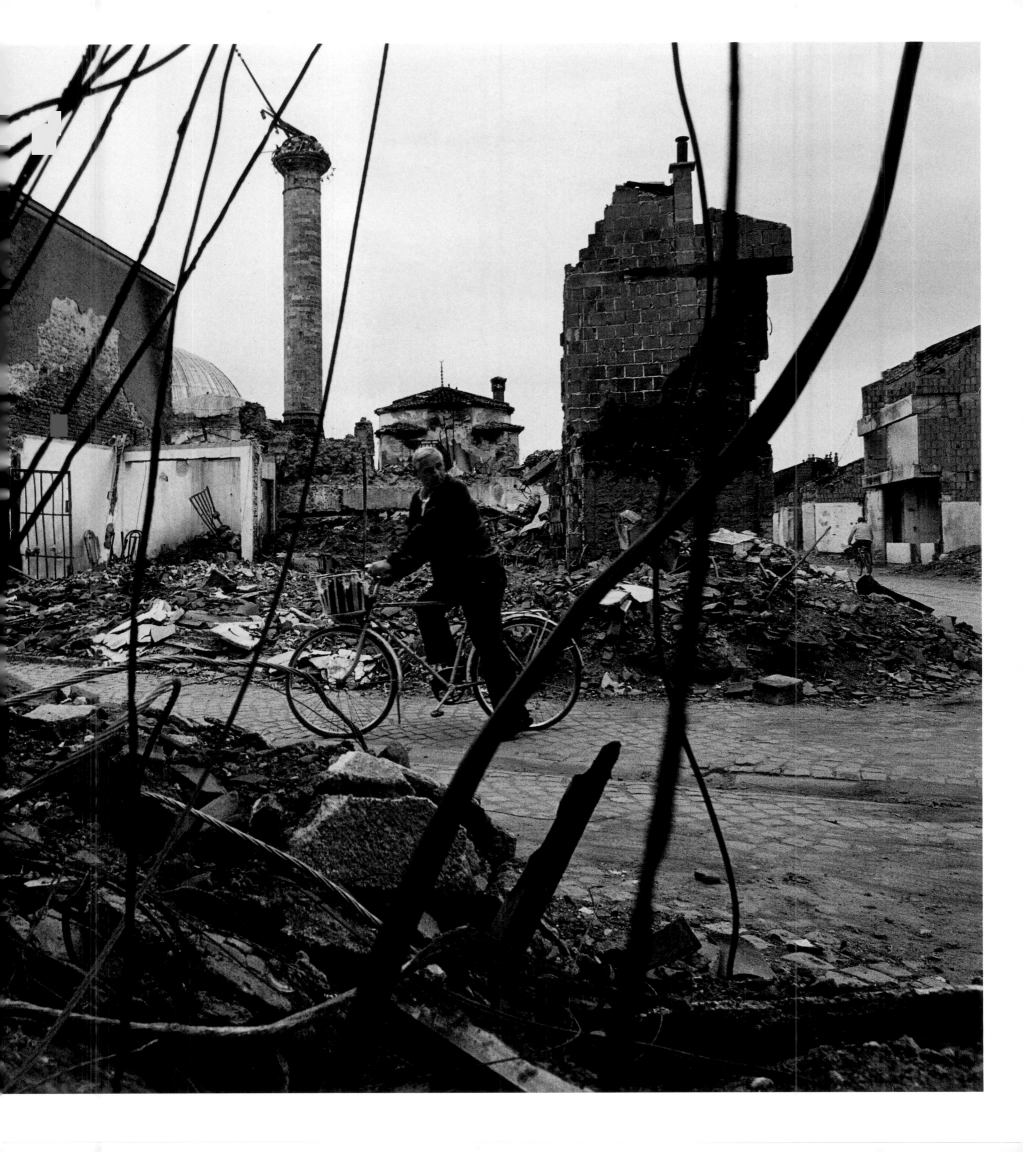

JOANNA PINNEO • SERBIA 1993

A life of sorrow marks the face of
Dragica Kostadinovíc, who fled to Serbia
when her Bosnian village was shelled.
In World War II, her entire family died
in a Croatian work camp.

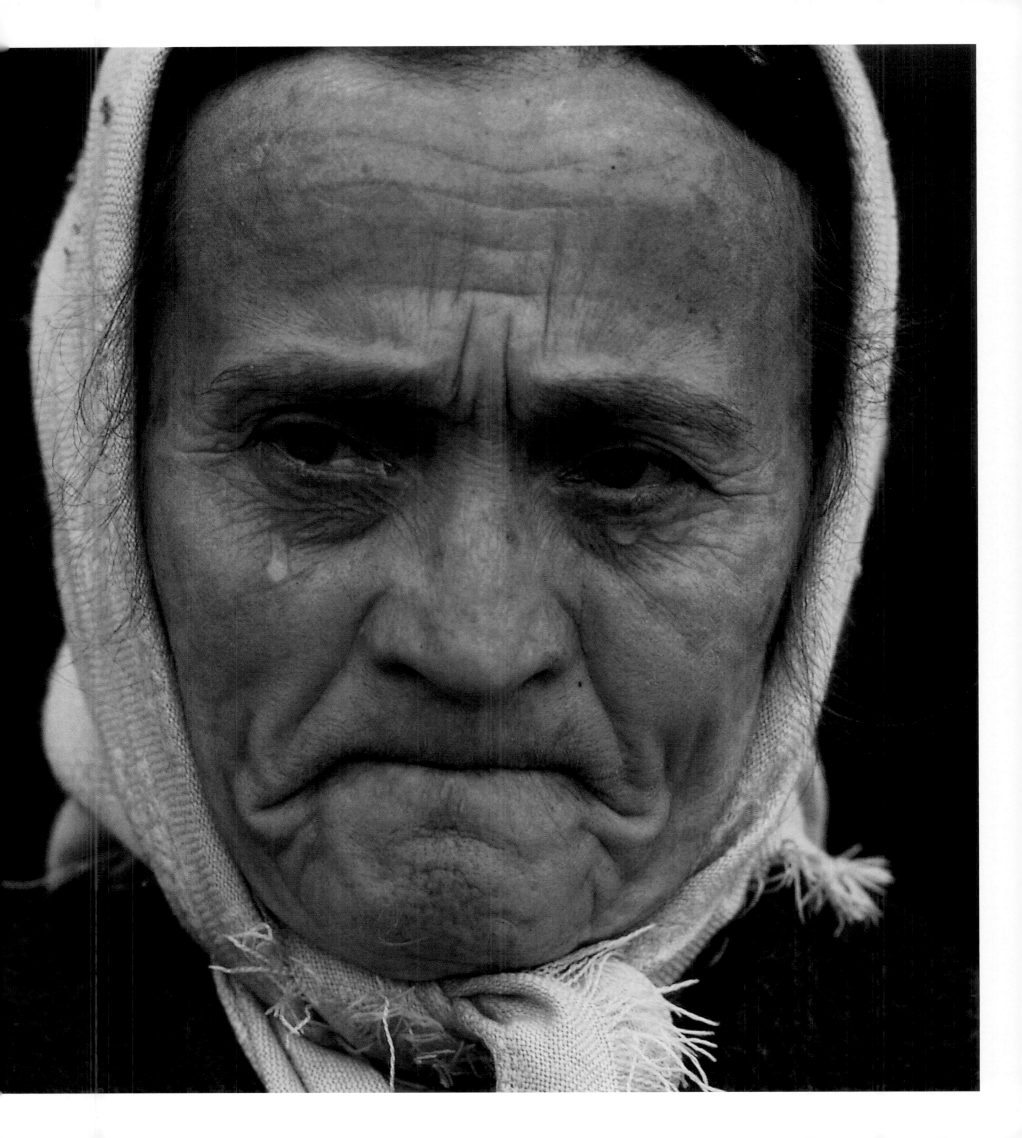

JOANNA PINNEO • GERMANY 1993

His face to the wall, a Nigerian who
illegally slipped into Germany from
Poland is arrested by police in the
town of Guben.

FOLLOWING PAGES

LYNN JOHNSON • NIGERIA 1991

In the arms of her mother, a young
girl suffering from malnutrition receives
syringefuls of soy milk at the Kersey
Home for Children in Ogbomosho.

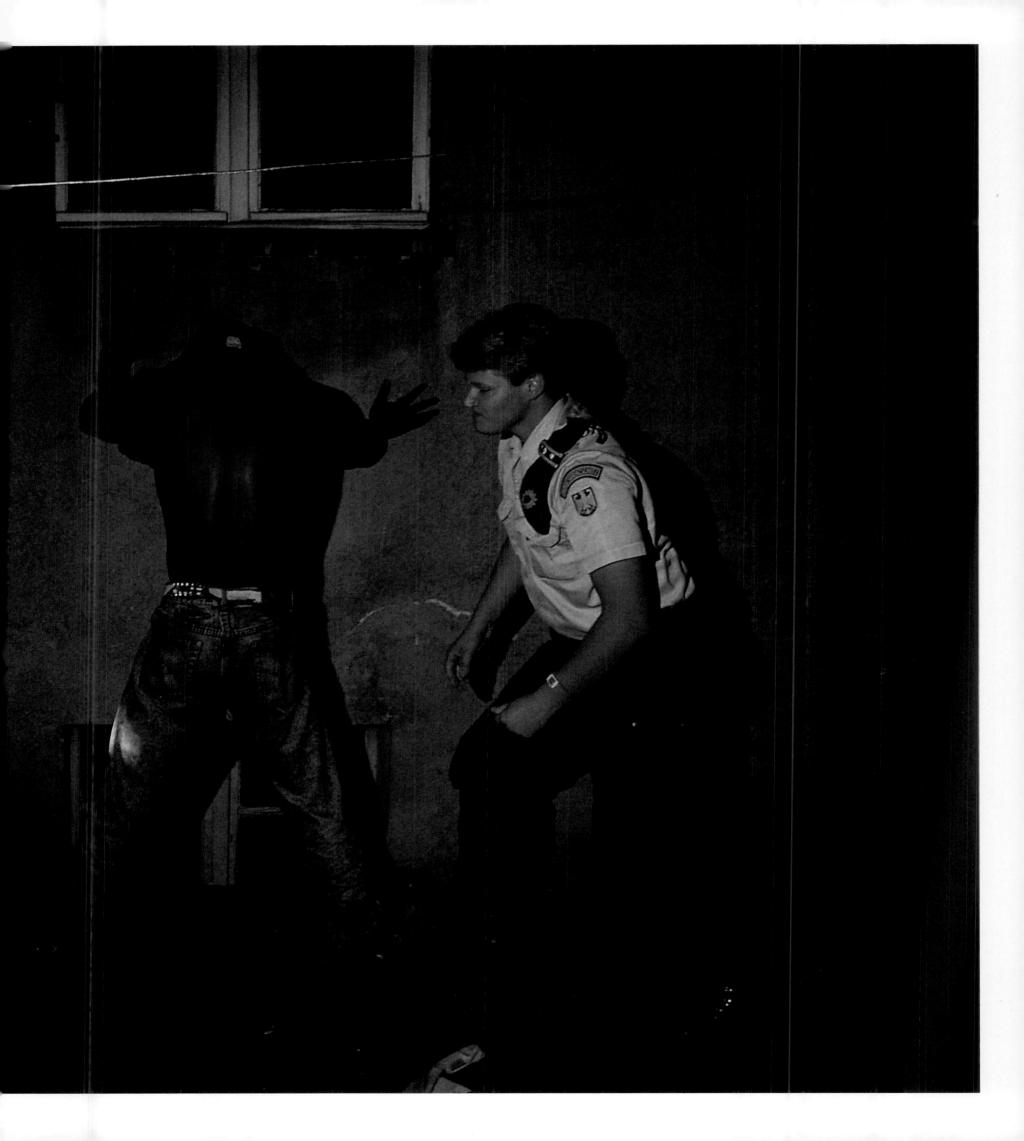

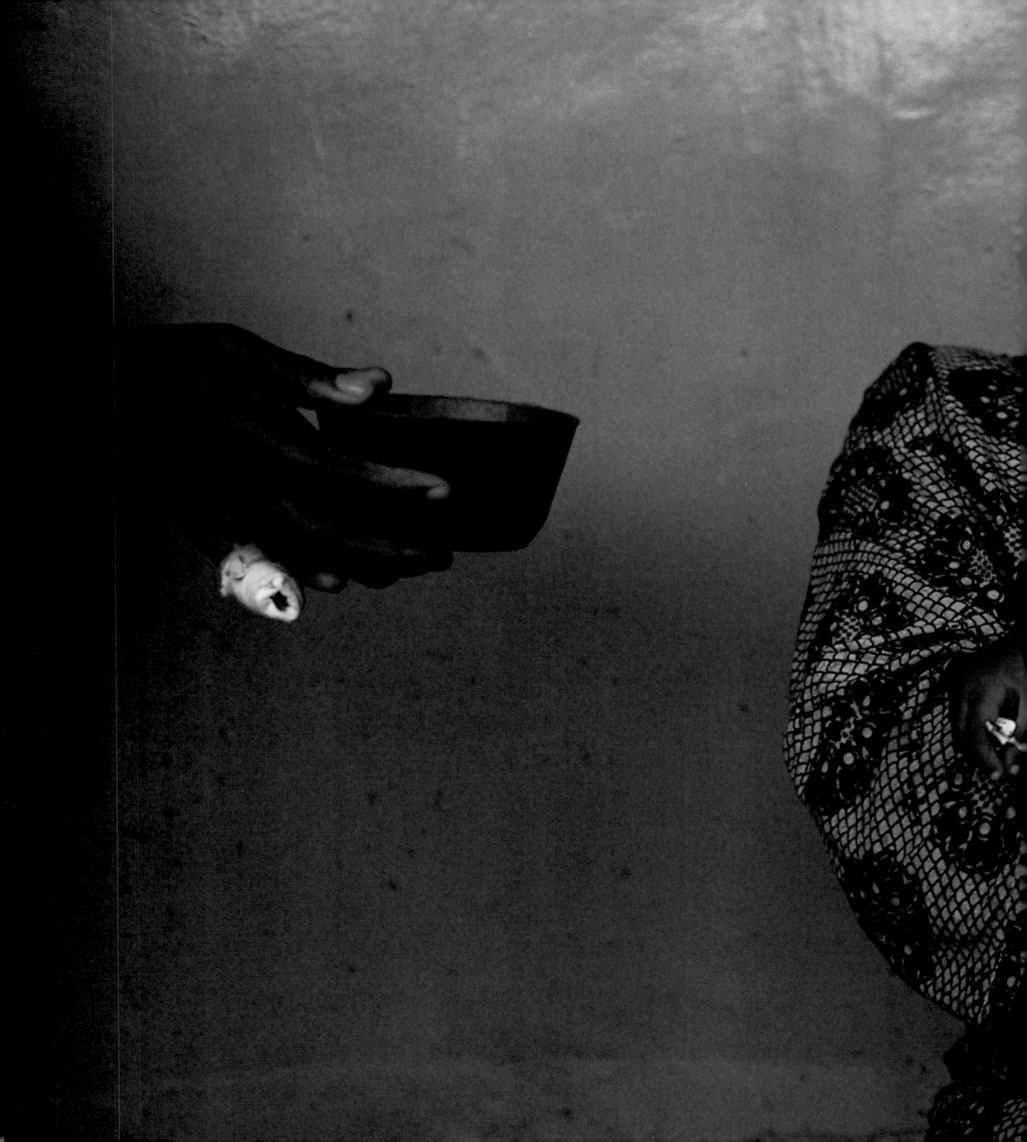

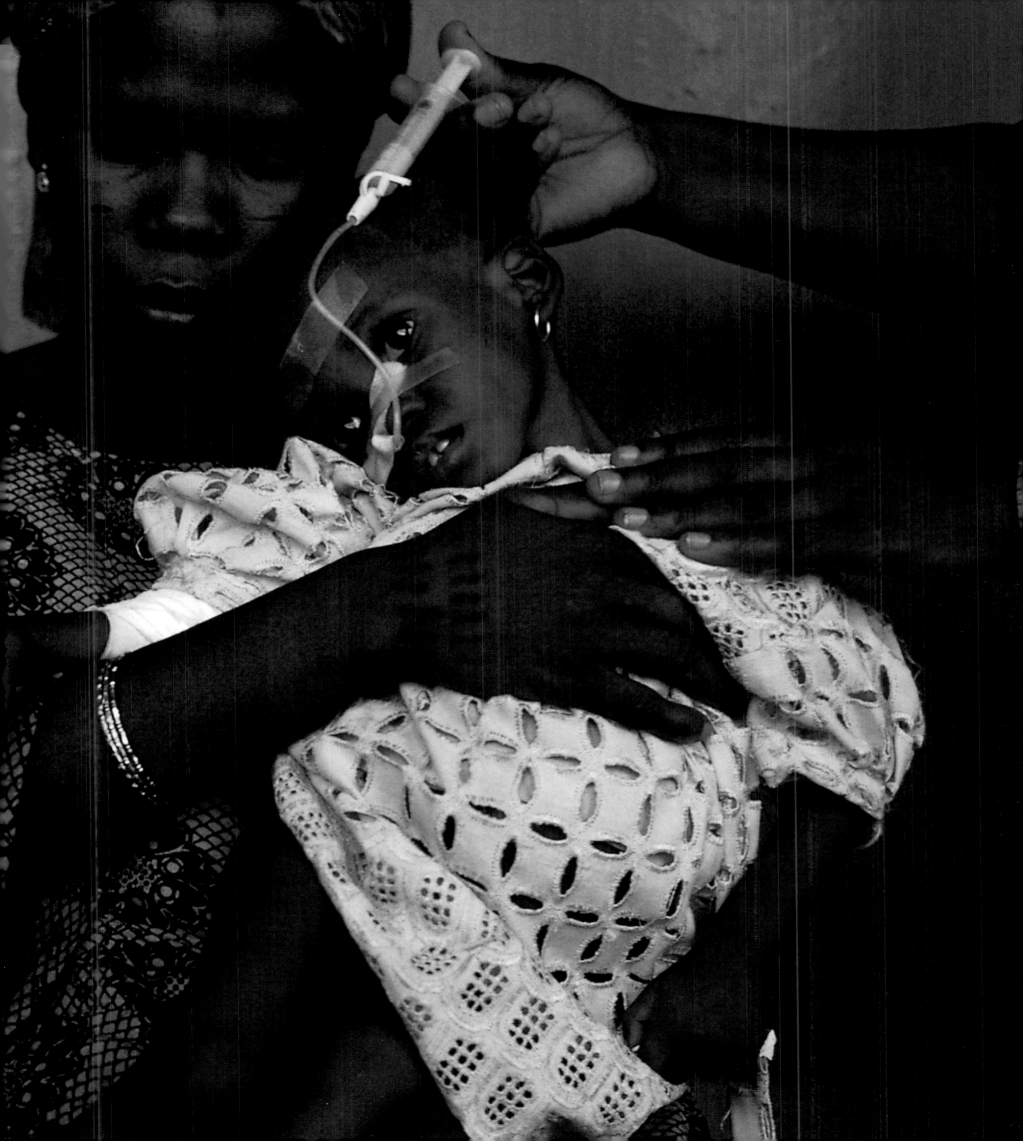

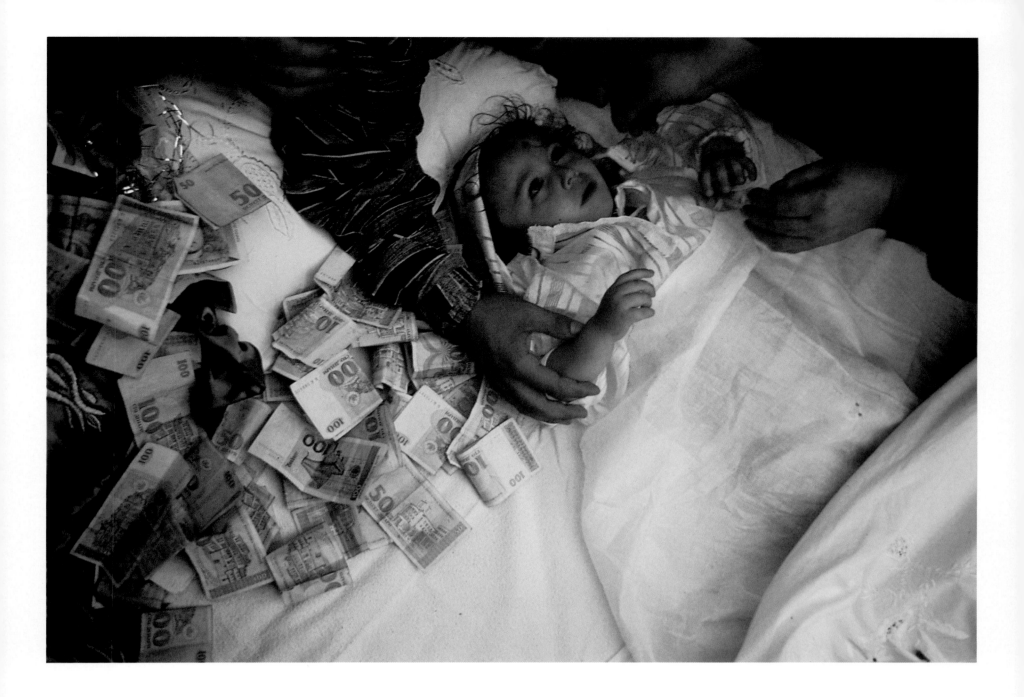

SARAH LEEN • MACEDONIA 1996

Amid money and comforting hands,
a young boy is circumcised in a Muslim
sunset ceremony.

MARIA STENZEL • KENYA 1999

A newly circumcised Ariaal bride, at left, lies in her mother's hut, accompanied by her best friend.

ALEXANDRA AVAKIAN • GAZA STRIP 1996

Fatima al-Abed holds one of her birds, a symbol of peace and hope in a narrow sliver of land that has endured military occupation, terrorism, and despair.

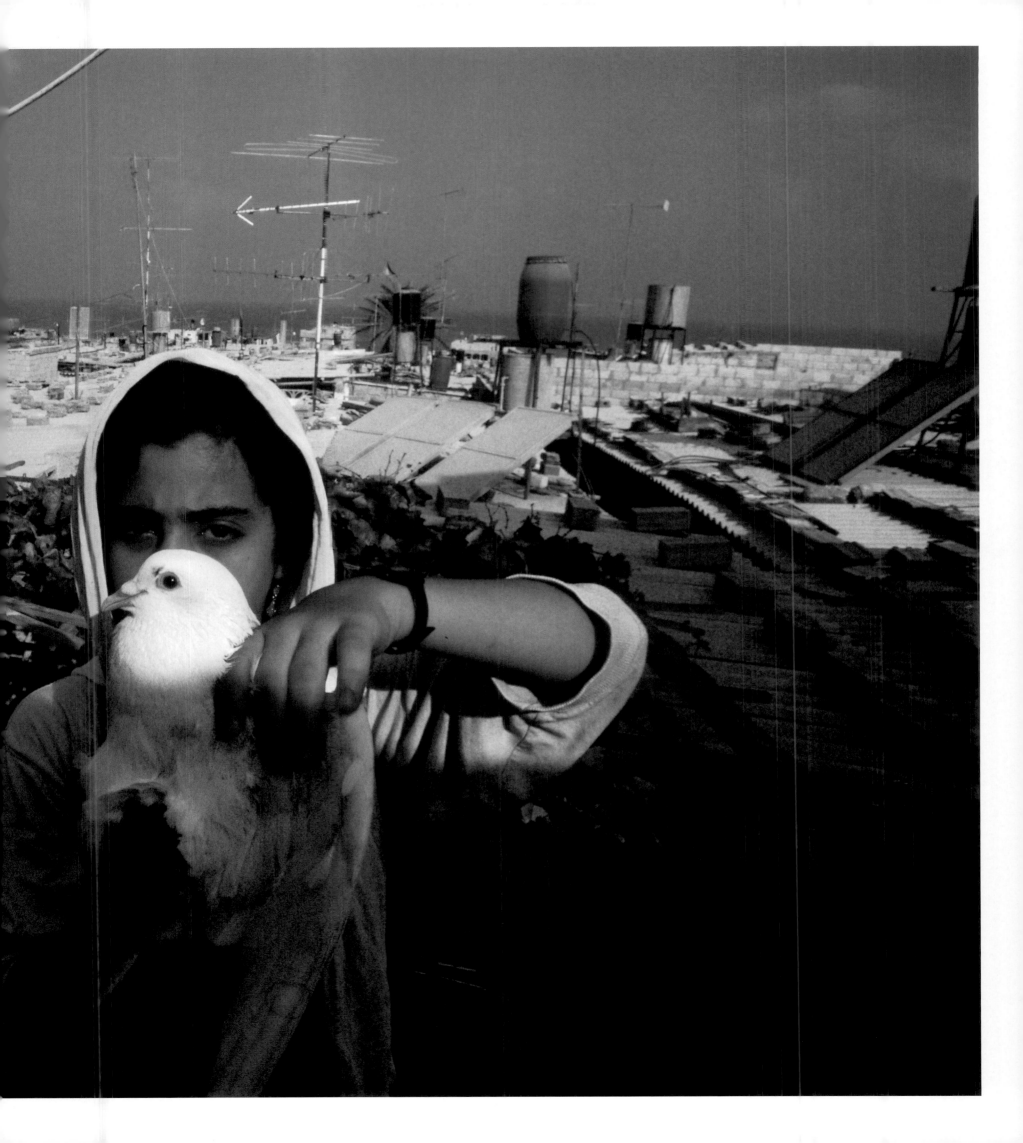

SAN FRANCISCO 1994

A workshop run by the owner of a local
club for gay men teaches safe sex to stem
the wave of illness and death from AIDS.

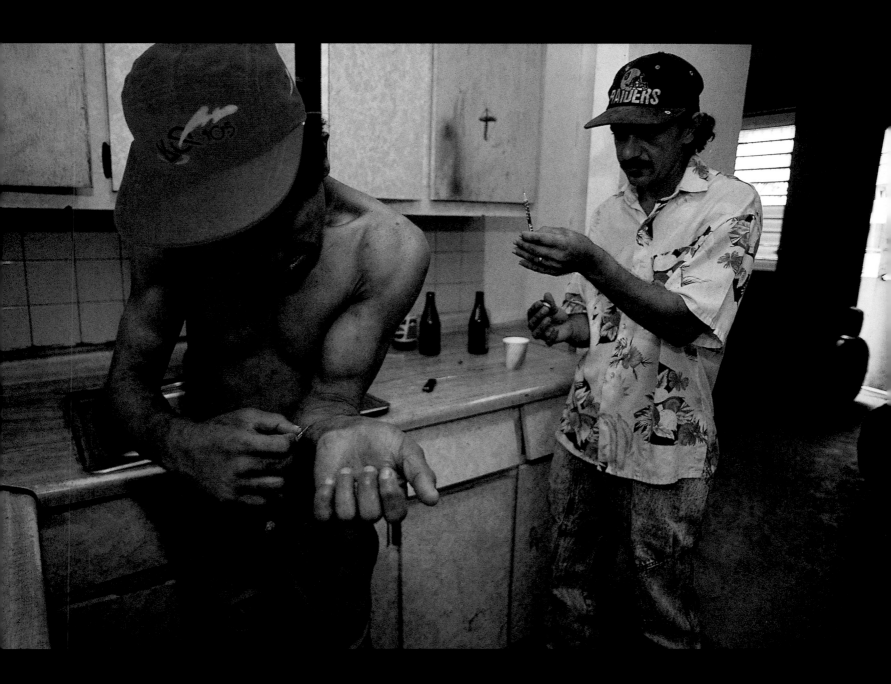

PUERTO RICO 1994

Addicts get a fix. "I needed to get close
to show this," says Kasmauski. "I had to trust
that they wouldn't accidentally stick me."

GEORGIA 1994

Overwhelmed by AIDS, the exhaustion
of caring for her two children, and the
aftermath of an argument with her
estranged husband, Scott, Fanny Tremble
collapses on her bed as Scott, also HIV
positive, retreats into his own world
of frustration and anger.

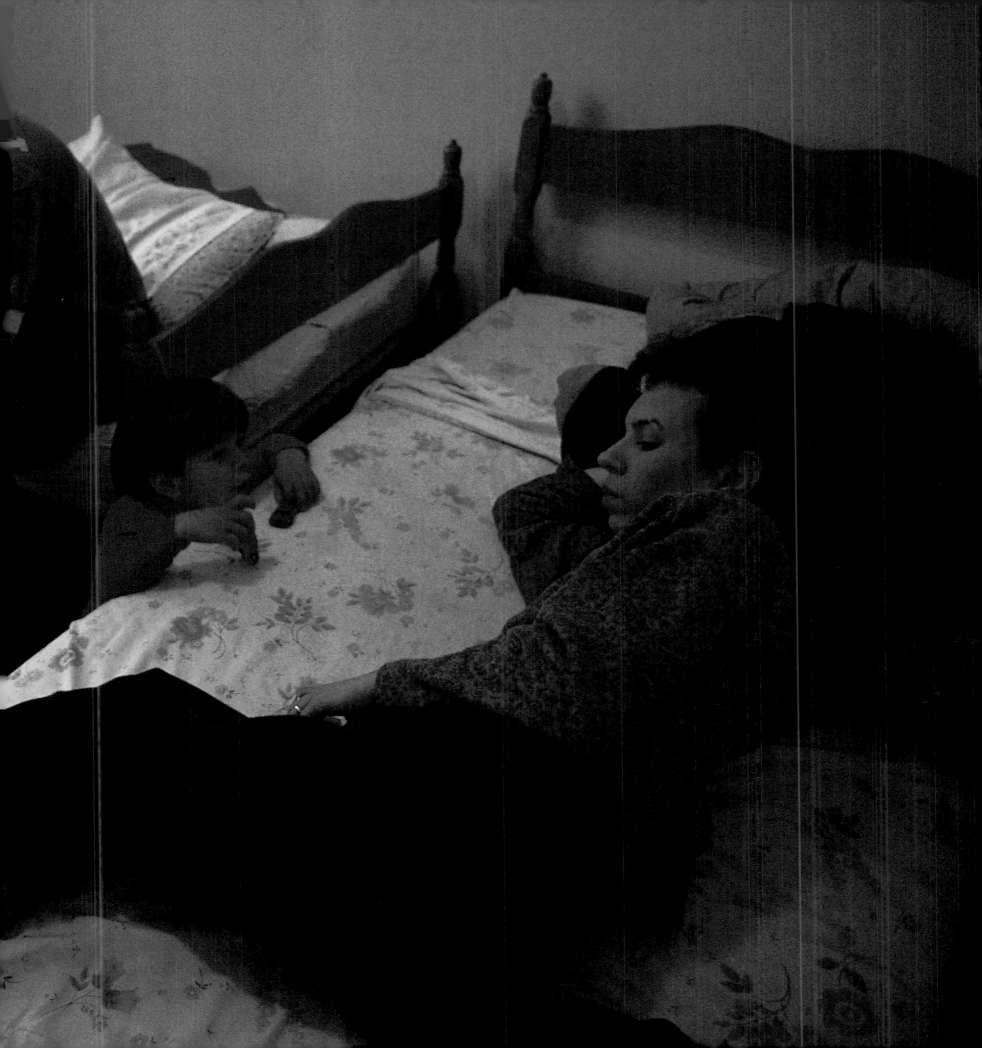

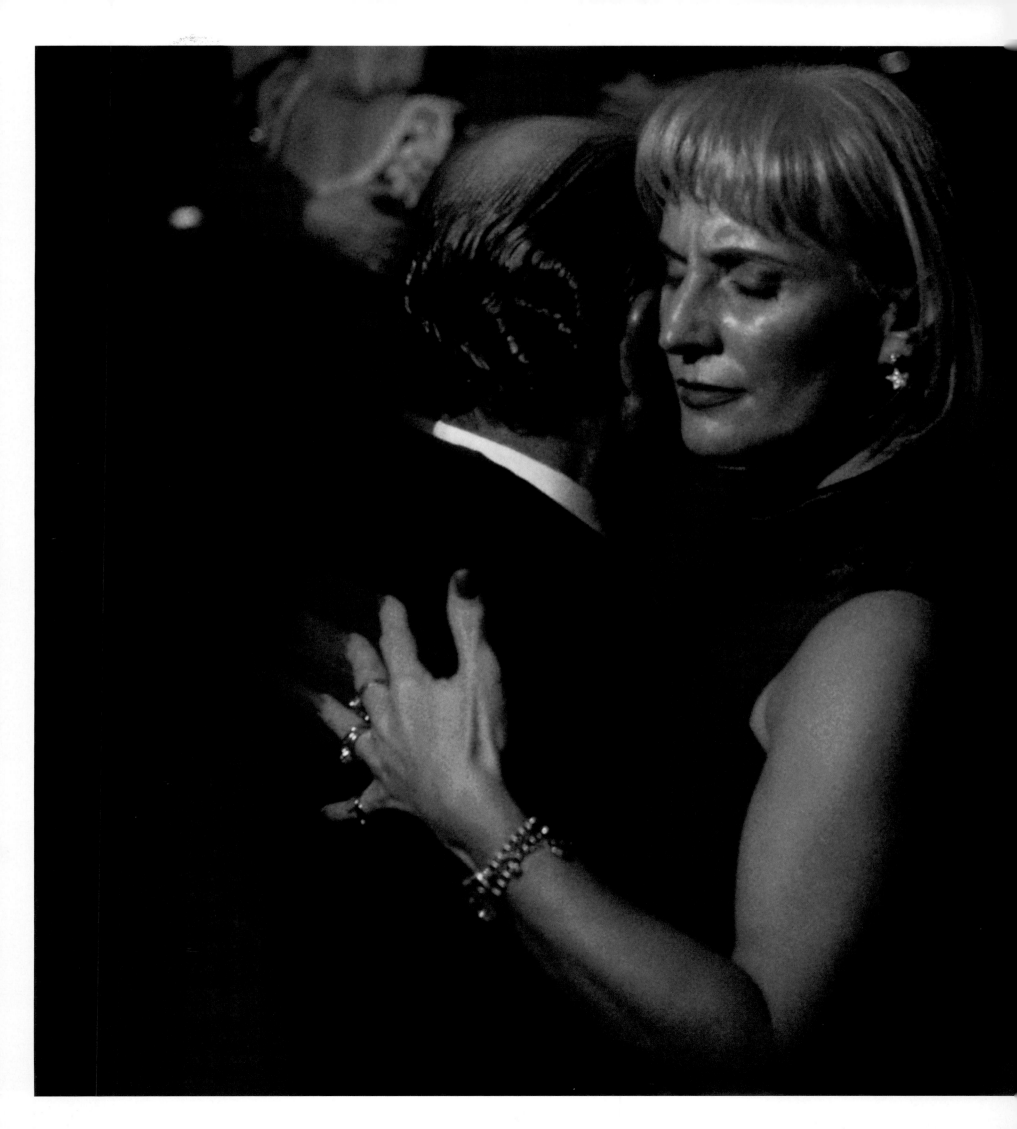

BALANCING ACT

JOANNA PINNEO • SPAIN 1995

The bond between father and son shines from the faces of five-year-old Andoni Legorburu and his father Ixidro, a shepherd in the Basque highlands.

PREVIOUS PAGES

SUSIE POST • ARGENTINA 1999

Lost in a world of music and movement, a couple in a Buenos Aires nightspot aptly named Club Alegro, dance to the beat of a tango.

VERA WATKINS • AFRICA 1954

Massive earrings and beadwork proclaim
a Masai woman's marital status. The
jewelry of an unmarried girl is sparser.

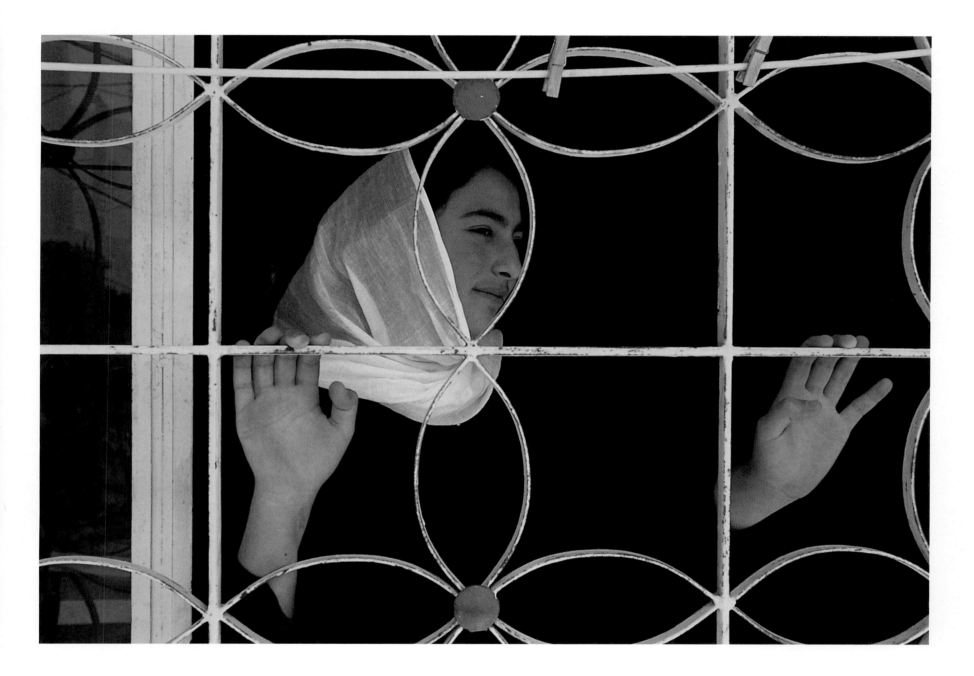

ANNIE GRIFFITHS BELT •
SYRIA-ISRAELI BORDER 1995

A young Druze woman gazes out
from her house at a demonstration.

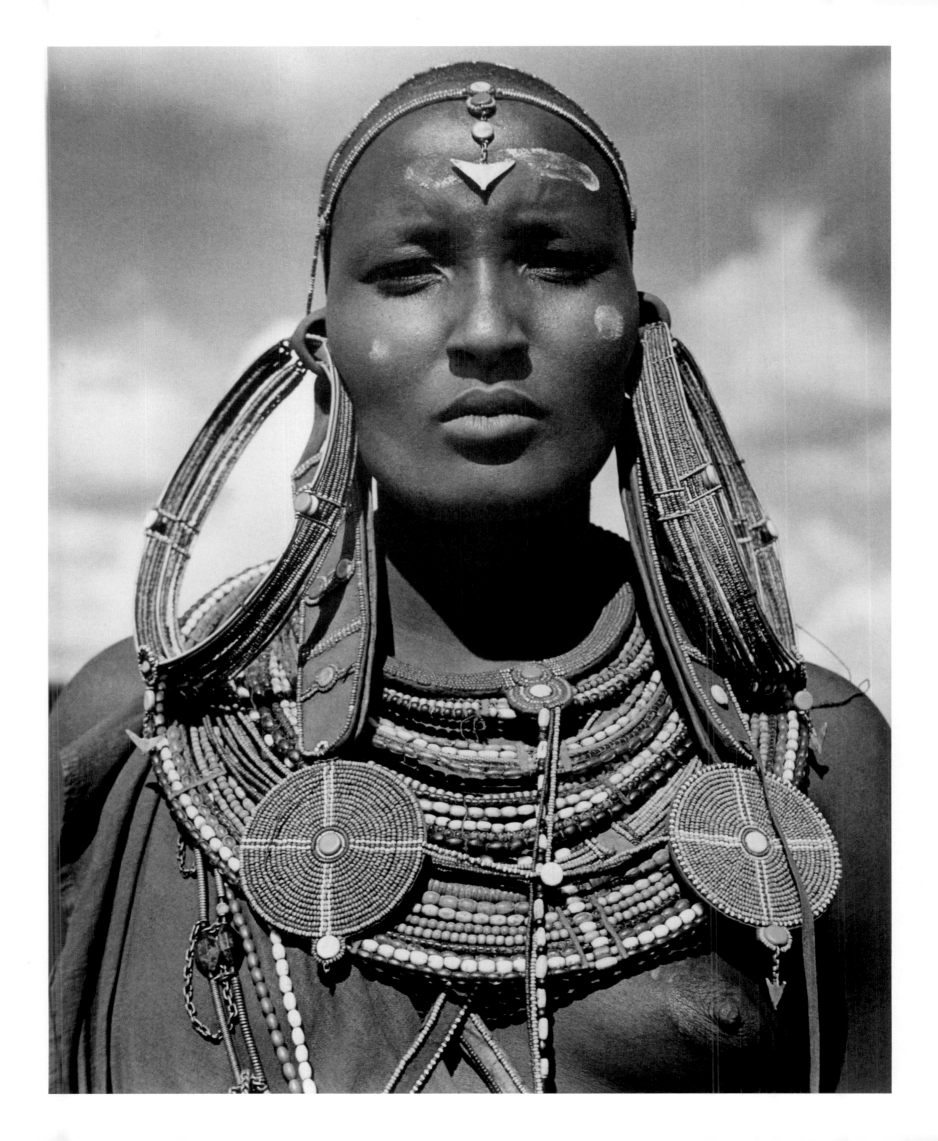

"WE ALL DO THE SAME WORK," says Michael Nichols, a staff photographer who specializes in wildlife photography for NATIONAL GEOGRAPHIC. "What's different is what women have to do to get there and stay there. It's not politically correct to talk about this, but there's this biological clock that kicks in. It shortens careers. Lately, I've had to realize there is more to life than photography; I think women are forced to face that earlier."

Married with two kids, Nichols is 47 years old on the day he makes those observations. What's more, he is about to step on a plane to Africa for a year-long expedition across the Congo. The imminent separation from home has triggered some introspection of his own struggle with the conflicting demands of career and family.

"How come I seem to get away with it?" he asks rhetorically. "It's easier for me to be totally obsessed with this work than it is for a woman. If she focuses 100 percent on the career, she leaves something else behind." A glimmer of self-revelation lights his face. "I've been allowed to have my cake and eat it, too."

There is always a price to pay for what you take in life—an emotional balance sheet that can never conform to standard accounting practices. This, then, is the price of choosing to be both a photographer in the field and a spouse, mother, sister, friend at home: Marriages that will not hold. Friendships that decay. Children who grow up without you. School plays missed. Soccer games missed. Weddings missed. Anniversaries missed.

"The plane moves faster than the heart," is the way one woman puts it. She means that guilt is part of the baggage she carries to the airport every time she leaves.

"I live separate lives," says Sisse Brimberg. "My first priority is my children. But in the field, I'm immersed in the story; the family fades." First there is that abrupt transition between being at home and being in the field, and it can be sheer hell. Take the time Brimberg got on a plane headed for France to shoot an assignment on early humans. The family—her husband Cotton, son Calder, and daughter Saskia—came to see her off. "I boarded the plane," Brimberg recalls. "I found my seat, settled into it, heaved a sigh of relief, and as I did, I heard Saskia crying and screaming, even through the shut doors. It was torture. You just had to hope that the plane would take off real soon. It did. If it hadn't, I would have stood up and walked out."

For some, being single seems to be the solution. Margaret Bourke-White was married—and divorced—twice. "It was not that I was against marriage," she wrote years later in her autobiography. "But I had picked a life that dealt with excitement, tragedy, mass calamities, human triumphs, and human suffering. I needed an inner serenity as a kind of balance…something I could not have if I was torn apart for fear of hurting someone every time an assignment of this kind came up."

In the field, life is lived totally in the present. Other aspects get pushed into the background. Says Jodi Cobb, "You can have a life in the field, or you can have a life at home. But it's hard to have both. When you're on location for a long time, you know everyone in town from the king to the hotel housekeeper. You come home. You don't have a mission. You have housework and unpaid bills—and it can seem like you're starting over with your friends and relationships."

The stay-at-home partner easily puts on the hair shirt of martyr. "You're in Paris, Hong Kong, Tangiers and I'm not," the litany goes. Stress cracks appear. Resentment seeps in. Absence makes the heart grow cold.

Joanna Pinneo reflects on the end of a 16-year relationship, eight in marriage. "He was my high school sweetheart. I always told him I wanted to travel; he didn't really believe me," she says. "He wanted to settle down, and I didn't. We parted when I was 31.

"When I was first divorced, I didn't want to get involved. I didn't want to hurt anyone again or involve anyone else in my decision to be gone. I also thought a relationship would be a distraction. I remember thinking, 'I'm single now. Now is the time to push the envelope.'"

So she pushed. She worked on tough, challenging stories on the Basques, the Palestinians, and climate until there was scarcely room for anything else.

"I had wonderful assignments," Pinneo says. "I didn't want to come home, and when I did, I felt very disconnected. I was absorbed in the Palestinian assignment for a year. Afterwards, I went to Richmond to visit a girlfriend who'd had a baby while I was away. She held up her baby; it was her first. I held up a copy of the magazine with my story as if to say: 'This is what I've been doing for my nine months.' We both giggled at the irony. Afterwards, to continue the analogy, I went into a postpartum depression. I tried to have a relationship with a correspondent who lived in India. It seemed romantic and glamorous. Of course it didn't work. What was I thinking? Then I did a story on European immigration and I got as much into that as I had into the Palestinians story. I flew from country to country and soon got the feeling I could get on any plane anytime and go anywhere. I could just keep going and going. It was an odd feeling. I liked it and yet it frightened me. I seemed to be losing touch with who I was and where I came from."

Many jobs require travel. Not so many require travel for months at a time to such remote and exotic locales as NATIONAL GEOGRAPHIC photographic assignments demand. Even fewer have the power to take over the heart and soul the way such an assignment can. The center of the universe shifts. "I'd been away so long my dog growled at me when I got back," a photographer once said. It was a joke, but a serious one. A growling dog is the least of it.

"Things corrode in your absence," says Sarah Leen, speaking of the struggle to keep a marriage intact. "It's a challenge to know how to balance your life. In this respect, shorter assignments are better. The days of going on the road for ten weeks at a time are over. When you're younger you don't know any better. I like to immerse myself in where I am. But I can't act like I'm not married. This job is not a normal one. Most marriages don't have to put up with this."

For the editors in charge, there is a dilemma. There is the need to get the assignment done balanced against concern for the well-being of those who do it. "I think women are forced to make more difficult choices, particularly as they age," says Tom Kennedy, a former director of photography who hired many of the current generation of women who shoot for NATIONAL GEOGRAPHIC. "It's not that it wouldn't be hard for a man, but I think that most men have a greater ability to compartmentalize the family/job decision in favor of their careers."

Some do it better than others. Kennedy mentions a male photographer, blessed by a brilliant career, cursed by a personal life in shambles. "He may well have regrets about the way he's lived his life," Kennedy comments. "When the demons come out—and I have seen them come out—they're incredibly intense. I was always aware that family/career was a problem that could be helped or hurt by the way we dealt with it," Kennedy continues. "Not that we could be responsible for how someone chooses to live their life, of course. But it made me sad and uncomfortable to envision a

photographer coming to the end of life and being full of regret and rage at what he or she did or didn't do."

Women photographers at National Geographic who combine family and work are so few that there is no path cleared for those who would follow. It is improvisation every step of the way.

"I teach at workshops," says staff photographer David Alan Harvey, "and when my female students say, 'Okay, let's get real. How hard is it going to be to do this and have a life?' I say, 'It's going to be harder for you.' But I point to photographers like Annie Griffiths Belt and Sisse Brimberg as proof it can be done."

"Role models?" muses Annie Griffiths Belt. "There aren't that many. When I was pregnant, Sisse Brimberg was the first person I talked to. When she had Calder, I asked: 'Is it difficult traveling with Calder?'

"'Oh, it's so difficult,' Sisse responded. 'The most difficult thing I've ever done. Except, it's almost as difficult as traveling without him.'

"Then, when she was pregnant with Saskia, her second, I said: 'Oh, Sisse, how wonderful. Was it hard to decide whether you could keep up the job with two?'

"'Well,' replied Sisse, 'I decided I could have maybe three or four extra stories in the NATIONAL GEOGRAPHIC magazine. Or I could have a son and a daughter.'"

Belt, who is ferociously organized and who credits her efficiency to her early years as a waitress, tried to do both—get the extra three stories in the magazine and have a son and daughter. After Lily and Charlie came along, she and her husband, Don, worked out a shared system of responsibility. The basic rule in the family was that if she had an assignment that would take her away for more than two weeks, the kids would travel with her. Otherwise they'd stay home with Don. The choreography was intricate, to say the least. As it was, many of her trips ended up being a lot longer than two weeks. She'd scope out the assignment, figure out where she could set up a temporary base in the country she'd be working in, line up an apartment or rental house, and hire an au pair to help care for the children. It worked well for a time, although some colleagues had their doubts.

"When Lily was about three," Belt says, "the classic line was, 'Well that might be all right now…*but*….' And what they were really saying was, 'What you are doing with the kids is really not okay.' It was like being in Catholic school with a nun wagging a finger at you.

"I remember one depressing lunch, where the consensus of all the photographers was: 'either you're going to screw up your kids or you're going to screw up your career.' I left that lunch so discouraged, thinking, 'You guys, my work's okay, my kid's are fine. Why are you doing this?'"

Nonetheless, Belt had a plan. She kept shooting assignments while also carving out time to teach workshops and edit pictures as preparation for the day when she might have to stop being a field photographer. Finally, last year, after 20 years as a photographer, she decided it was time for a shift and accepted a position as a senior illustrations editor in the Geographic Book Division.

A few days before she left for Australia and New Zealand to photograph what may end up being her last work for the magazine, Belt reflected on her full career as a NATIONAL GEOGRAPHIC photographer.

"There will be days when I'll feel very left out," she says. "I'm going to miss the life experience. I'm going to miss being part of that group of people. I'll have to remember that I got to do that

"Her tranquility and vibrancy reminded me of water," says Steber of Laura Hill, a teacher and member of the Cherokee people. So she photographed her subject with the Oconaluftee River as background.

for 20 years. Now I've got another 20 years to give to something else. It's nice to go out when things are going well. There will be a lot less pressure and it's better for my family. But I know there will be days when I will feel like an old horse put out to pasture. There's a part of me that says: 'Oh, I hope I don't stop shooting.' But you know, I probably will.

"I've always known that 25 years from now, nobody will remember what I did. The people who will remember are my kids, parents, husband, and best friends. So how can I feel sorry for myself when I got to live this crazy life for 20 years? I've got these kids for ten more years. They've got to come first."

There is another party to the decision and it is her husband, Don, an editor for NATIONAL GEOGRAPHIC.

"It did work and it still could work," he says of the juggling act they participated in for years, "but it would be more and more difficult." The stay-at-home job happened to coincide with the increased difficulty of traveling with the children as they reached school age, he explains.

Any misgivings? he is asked. As a writer he too understands the electric thrill of being in the field and what his wife is giving up.

He considers the question and carefully frames his reply.

"We've never lived a normal life before," he says. "Everything was always up in the air. We could never get into any routine. Now we're making plans and we're finally able to stabilize. But, how do I put this? We've always had the space of travel between us—the idea of being away for several weeks, refreshing oneself, and then coming back to the marriage. Now, we'll have to create our own excitement to substitute for the travel. What happens now that we're in the box? This is unexplored territory."

There is a cautionary tale that is told around the offices of National Geographic, and it resonates in the heart of every photographer—male and female—who struggles to balance the professional and personal. On the day he retired, staff photographer B. Anthony Stewart pulled his younger colleague Bruce Dale aside. "Bruce," he said, "it's been an absolutely marvelous 42 years...but if I had it to do again, I wouldn't…. I have a son that I not only do not know—I never even met him."

So how to make it work? Susie Post is sitting and thinking about this and wondering how she might, as Michael Nichols says, have her cake and eat it, too. Post is going from strength to strength as a photographer. She has just had a story published in the magazine on the New River in West Virginia; she is now working on another assignment in Central America and has been published in a book on the Pan American Highway. The career has clicked into place and now she is 37.

"I was born knowing I wanted a family," says Post. "I came from a family of five brothers and sisters. They are all married with kids. I might have gotten married when I was 22 and had six kids by now and been very happy.

"Some time ago my sister paid a professional to interview the family about its history. I'm listening to this tape, in which the interviewer is asking my Dad about his marriage and the family and she asks him, 'Is there anything that would make you particularly happy?' And my father answers, 'If Susie would get married and have kids.'"

Her face darkens at telling this. "What's the answer?" she asks.

There is no answer, she is told. Certainly there is no good answer. There is only a sort-of-answer and everyone wings it as they go along. Much in life is negotiable. Biology is not. Only women bear children. Sooner or later women confront the choice: To have or have not. Who knows how circumstance and character conspire to write the narrative we come to recognize as our life?

Of course, one part of the answer is that we bear responsibility for our own narrative. How we handle the structure and plot of our lives is, in the end, up to us.

"I'm exceptionally close to my family so being away is hard on me," says Alexandra Avakian. "Because of my work, I have missed six Christmases and most Easters."

Now, she says, things have changed. "Before 1996, when I broke my leg while working on the story in Romania, I would work, pause for two weeks in a place like Paris, and go on to the next job." The "next job" might be in Haiti, the Sudan, or Iraq. During that period of her life, she was out of the country and away from home nine months out of the year.

"Finally," Avakian explains, "I felt, 'that's enough.' I had covered revolutions and some civil wars and had been lucky and was alive and well. I didn't want to go to another funeral. And there were other things I could do. Now, I do my job and come home. I've opened myself to a whole other way."

Opening herself to a whole other way included marriage. Of course she'll continue to shoot; that is clearly her calling. But marriage can have a way of rearranging one's priorities.

Perhaps, suggests Kent Kobersteen, current director of photography, the relationships that have the best chance of succeeding are those in which both partners do similar work. They understand. They know.

Bill Douthitt, now senior assistant editor in charge of projects, is married to Karen Kasmauski, a photographer for the magazine. "When we got married, I had been working in layout," Douthitt says. "I wasn't too happy in that department and wanted a change. The associate editor told me, 'You can be a contract photographer or a picture editor.' Karen and I were planning to have children and I was watching my colleagues having trouble with their marriages. I could see that two photographers in the family just wouldn't work. Anyway, I was an okay photographer, but Karen had more insight, nuance, and far more ability."

So the two came to an agreement. If there was room for only one photographer in the family, it should be Karen. If someone had to stay at home, that someone should be Bill. Which meant that Douthitt signed on for the jobs as picture editor and stay-at-home parent. Kasmauski became the photographer and traveling parent.

"When Karen travels, we go through a lot of rituals," Douthitt explains. "We all go to the airport. We see Mom get on the plane, so the kids understand it's not just a trip to the grocery. And we all go to pick her up. We spend a fortune on phone calls. I put up a big map with pins in it: 'Here's where Mom is.' These kinds of things are important for them to understand that Mom's job may not be like others.

"With Karen on the road, it's a tight schedule. The kids get fed in the morning and dropped at school, then I go to work. I leave at five and pick them up and make dinner. I become the single parent."

Yva Momatiuk and her husband and co-photographer John Eastcott took the opposite approach. Their daughter, Tara, now 19 and a senior at Mount Holyoke College, traveled everywhere with them on assignment.

"She went on her first GEOGRAPHIC assignment when she was 13 days old—to New Hampshire," Momatiuk says. "At seven months, she went to Poland. We carried 4,000 diapers. She flew on the Concorde and on a helicopter before she even got into a sandbox. In the field, we'd just put her in a backpack and go to work. I nursed her for two years, which I feel can be very beneficial. It worked for all of us because she did not get sick in spite of changes in diet and water.

"The travel made her enterprising and curious, and it gave her life skills. She began to read when she was four. She went to college when she was 16. She saw her mother as focused and competent. She never saw her mother sitting and waiting for a man to come up with solutions."

But there was another side, too, Momatiuk says, adding that the lifestyle worked fine until their daughter began to attend school. It became increasingly apparent she would just as soon stay at home.

"She would make friends during our trips—which she does easily—and in three days, I would say: 'We have to go now.' She would never protest, but she would hang her head and I could tell she was sad."

A taste for the unconventional comes with age and experience. The last thing a child wants is to be perceived as different—no matter how exciting or exotic the difference. It would take another decade or so for Tara to understand the gift of her nomadic upbringing and appreciate the self-reliance and worldly perspective it gave. At the time, there was none of that. Only a discomfiting sense of being set apart from others.

"We would pitch a tent in the backyard and spend the night in sleeping bags to show her you can camp in the middle of the winter," recalls Momatiuk. "When we came back to the house, she would mumble under her breath, 'I am not going to mention this to anyone.' She was afraid the other kids would laugh.

"Once she came to me and said, 'Could you please work at IBM?'

"We lived near Kingston, New York, and most of her friends' parents worked for IBM. She was saying she wanted to stay at home and not go away and not feel different. In Kingston, mothers took daughters to the mall. Tara didn't have that. She was around for a while, and then she was gone, off to wherever the next assignment took us."

It is every parent's angst. What to do about the children. The collision between the welfare of the child and the well-being of the parent. It is worse than a tug at the heart. It is a tearing of the heart and there is nothing new about it.

Gertrude Käsebier, the 19th-century American photographer who specialized in portraiture, waited until her children were nearly grown and then enrolled at the Pratt Institute in New York to study painting. It was a long-deferred yearning, and finally she could realize it. "My children and their children have been my closest thought," wrote Käsebier, "but from the first days of dawning individuality, I have longed unceasingly to make pictures…."

In the 1930s, Dorothea Lange, famous for her social documentation and portraits, left her children with friends and relatives while going on the road to shoot her memorable photographs of migrant workers for the Farm Security Administration. The FSA project, under the aegis of Franklin Delano Roosevelt's New Deal, documented the work and life of farmers impacted by drought and the Depression. There were nine photographers in the project. Two were women: Lange and Marion Post Wolcott. "The women's role is immeasurably more complicated," Lange said, and she spoke from experience. "They produce in other ways. Where they do both there is conflict."

In the 1980s Yva Momatiuk dealt with the conflict, bringing her young daughter along while she and her husband worked on assignments. "I would probably perish if I just had to stay

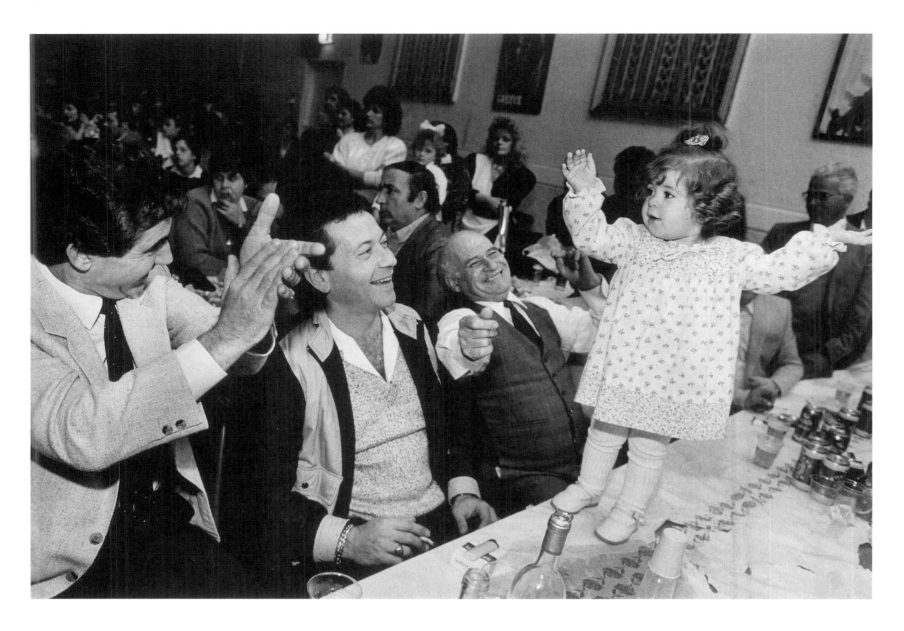

MARY ELLEN MARK • SYDNEY 1988

Playing to her father and grandfather, Irene Sifniotis presents an informal encore following a recital of dances at an afternoon
school for the study of Greek language and history.

home and take care of her," Momatiuk says in retrospect. "I was probably a much better mother
taking care of her in the field and going crazy."

There are many ways to cope, but there is no escape from conflict. There is only angst and
the hope of doing the right thing, whatever that may be. "You come to the office and insist you want to
be treated as a photographer, not as a woman," says Annie Griffiths Belt, "and then you go home and
you *are* a woman and a mother and have to do all those things that go with it." To be a woman photog-
rapher is to realize somewhere along the way that you are both a woman *and* a photographer.

Thoughts on the road not taken. Lynn Abercrombie, whose husband Tom worked
as a NATIONAL GEOGRAPHIC staff photographer and writer for more than 38 years and who is a
photographer herself, is looking back on her life and late-blooming career. "Tom always wanted me to
travel with him, but I didn't want to leave the kids. I didn't have the courage that Annie Griffiths Belt

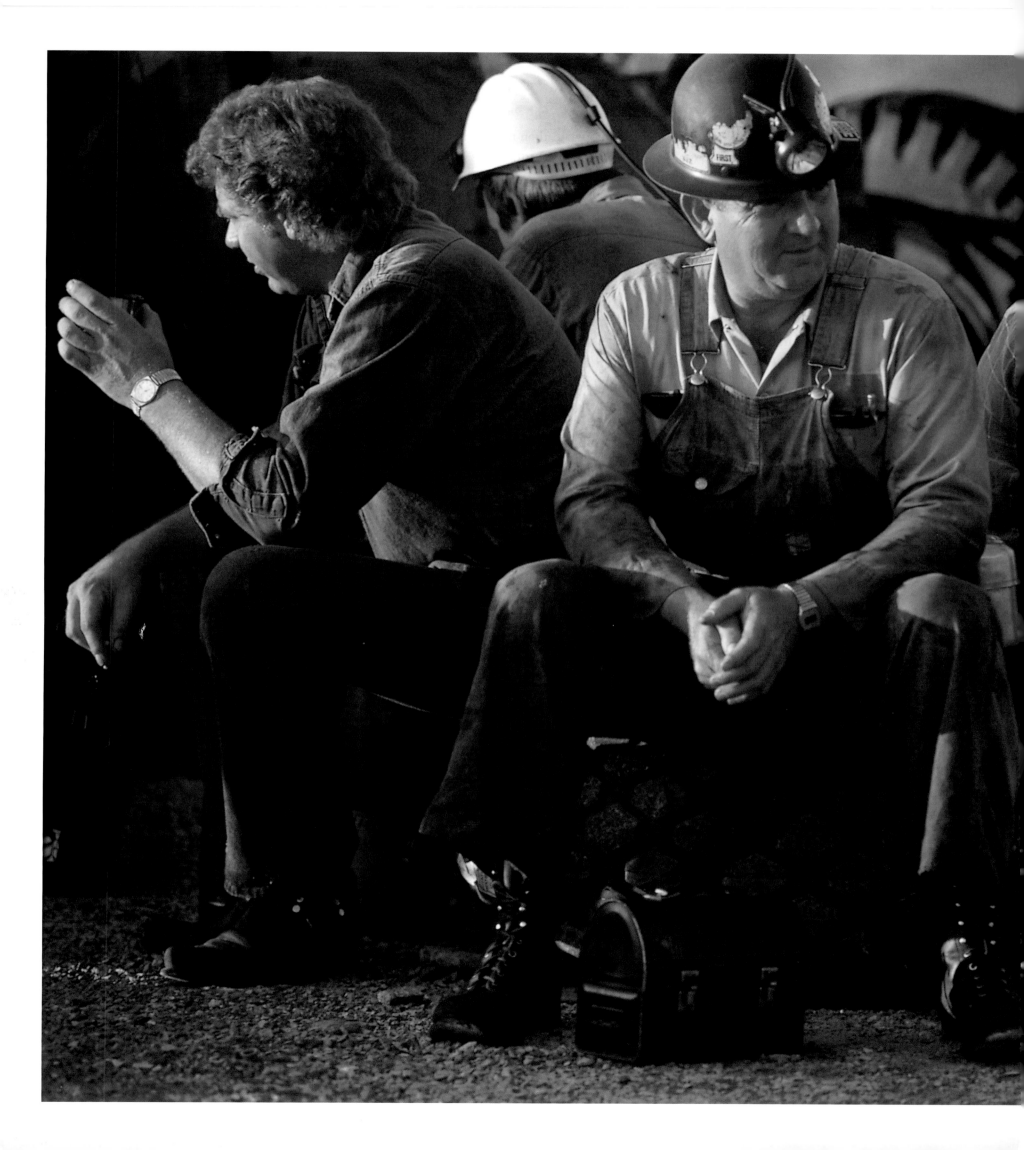

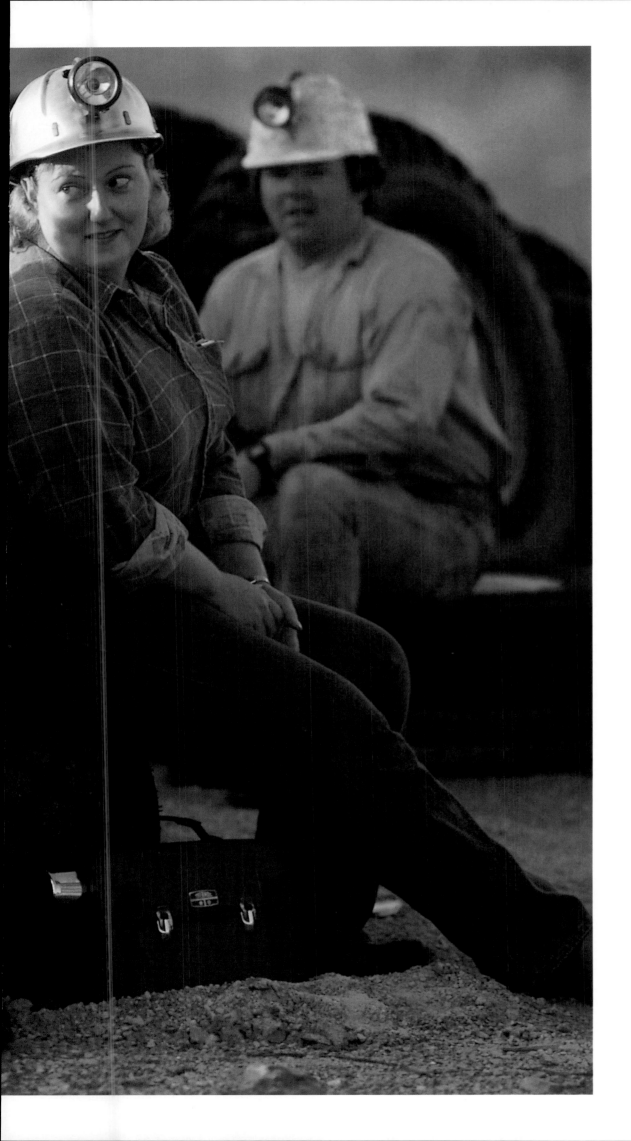

KAREN KASMAUSKI ✦ TENNESSEE 1986

In east Tennessee, superstition holds
that women bring bad luck to the zinc
mines. Carolyn Wood turned that one
on its head when she showed up for
work and "just decided to stay."

FOLLOWING PAGES

ALEXANDRA AVAKIAN ✦ IRAN 1999

Under the watchful eye of a chaperon,
a betrothed couple relaxes on a bridge
above Isfahan's central river.

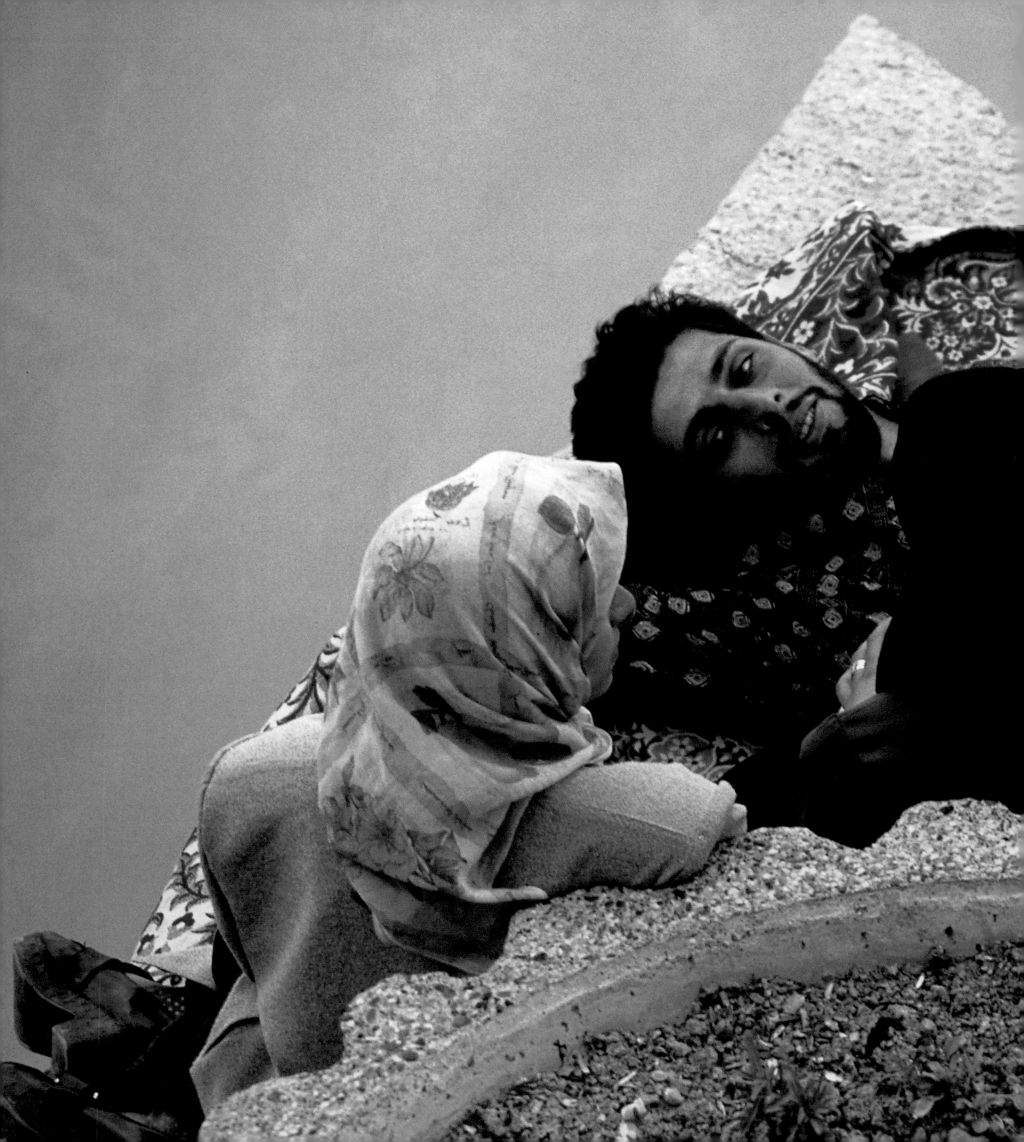

SARAH LEEN • RUSSIA 1992

Tradition mandates a wedding portrait
with Russia's Lake Baikal in the back-
ground. Natasha Shirobokova and Igor
Karpov comply even in dead winter.

FOLLOWING PAGES

HARRIET CHALMERS ADAMS • SPAIN 1929

A letter writer's booth advertises
"The Truth"—*La Verdad*—above the
door. Other services include posting
and filling out official documents.

ANNIE GRIFFITHS BELT • JERUSALEM 1996

The secular—an off-duty soldier—and
the ultrareligious—an Orthodox Jew—
stand side by side at a phone booth.

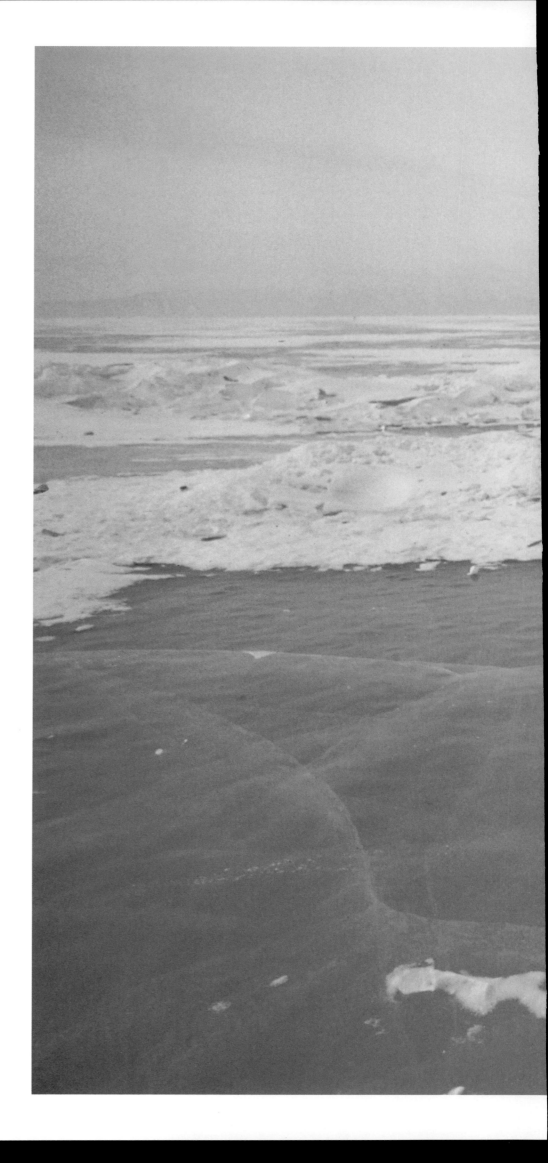

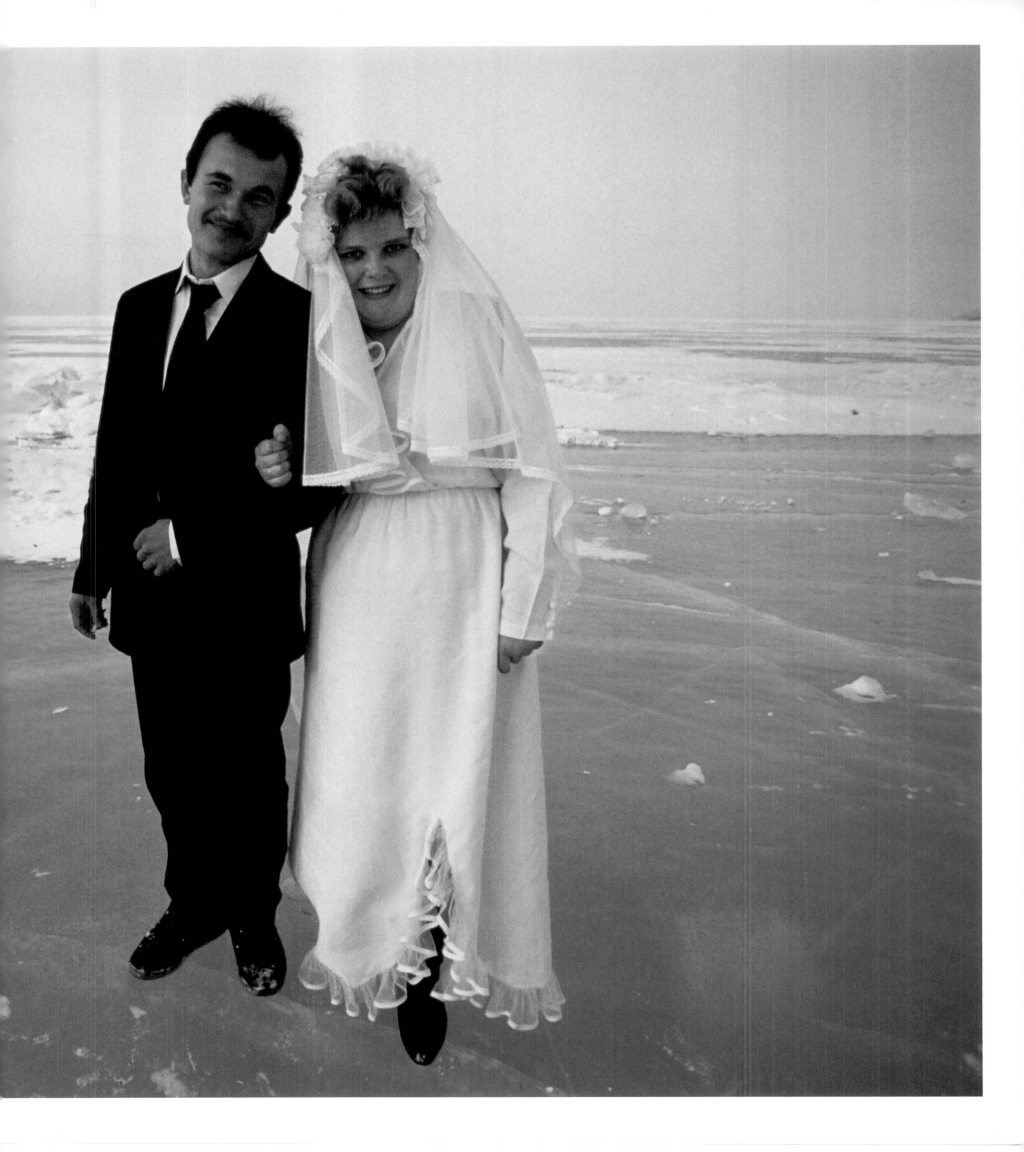

SARAH LEEN • KAMCHATKA 1994

In the shadow of two active volcanoes,
Petropavlovsk lives under the constant
threat of an eruption. But shoddy
housing causes residents to fear earth-
quakes even more.

PREVIOUS PAGES

KAREN KASMAUSKI • SAN DIEGO 1989

Slouching at attention, a crew of young
recruits line up for their first swim at
the San Diego Naval Training Center.

205

LYNN JOHNSON • THE HAGUE 1997

A prostitute in Amsterdam's red light
district evokes an echo of the woman
artist Vincent Van Gogh hoped to marry.

LYNN JOHNSON • BELGIUM 1997

Former coal miner Giovanni Russo fingers
the portrait of his wife, who prayed to St.
Anthony to bring him home safely each day.

Annie Griffiths Belt

INTIMACY

ONE OF THE MOST SIGNIFICANT photographs Annie Griffiths Belt ever took was of a seemingly insignificant subject: a golf course being watered by a sprinkler system. "I shot the picture for my first photo class at the University of Minnesota," Belt explains. "I was 21 years old. I was so lost in capturing the morning light filtering through the spray of water, I didn't realize I was lying on top of another sprinkler. It went off, soaking me. But I got my picture." She got her picture and fell in love with photography. Belt, who has published 17 stories in NATIONAL GEOGRAPHIC, has been capturing the light ever since. The privilege of photography is the privilege of access: to people's lives, their hearts, their souls. It's the privilege to make intimate photographs, such as the ones that follow, selected from stories Belt has covered in the Mideast. "Covering a major league game or riding in *Air Force One* is a thrill," she says. "But in the long run they don't satisfy. The greatest satisfaction is to arrive on the doorstep of a stranger and say, 'May I come in?' and be allowed in." How to get the door to open when language is a barrier? For Belt, a gesture is worth a thousand words. "I rarely work with an interpreter. I can get closer without one. I make myself understood through charades. It forces you to use touch, eye contact, and laughter." She uses that and more. She becomes part of the family—bathing the kids, changing diapers—camera always in hand, capturing the intimate moment as it unfolds.

GALILEE 1995 Marking a year of mourning, the women of the Zuabi family visit the grave of their brother Hisham, killed in an car accident.

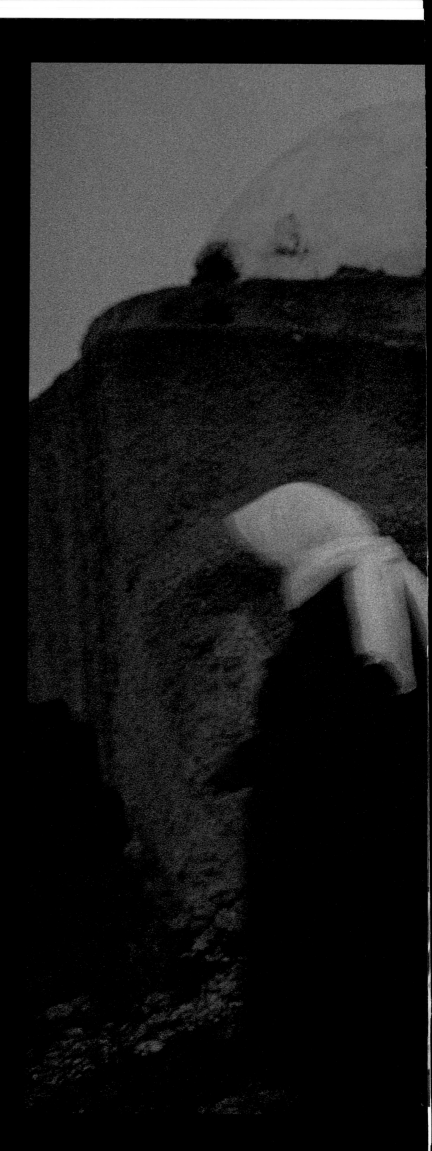

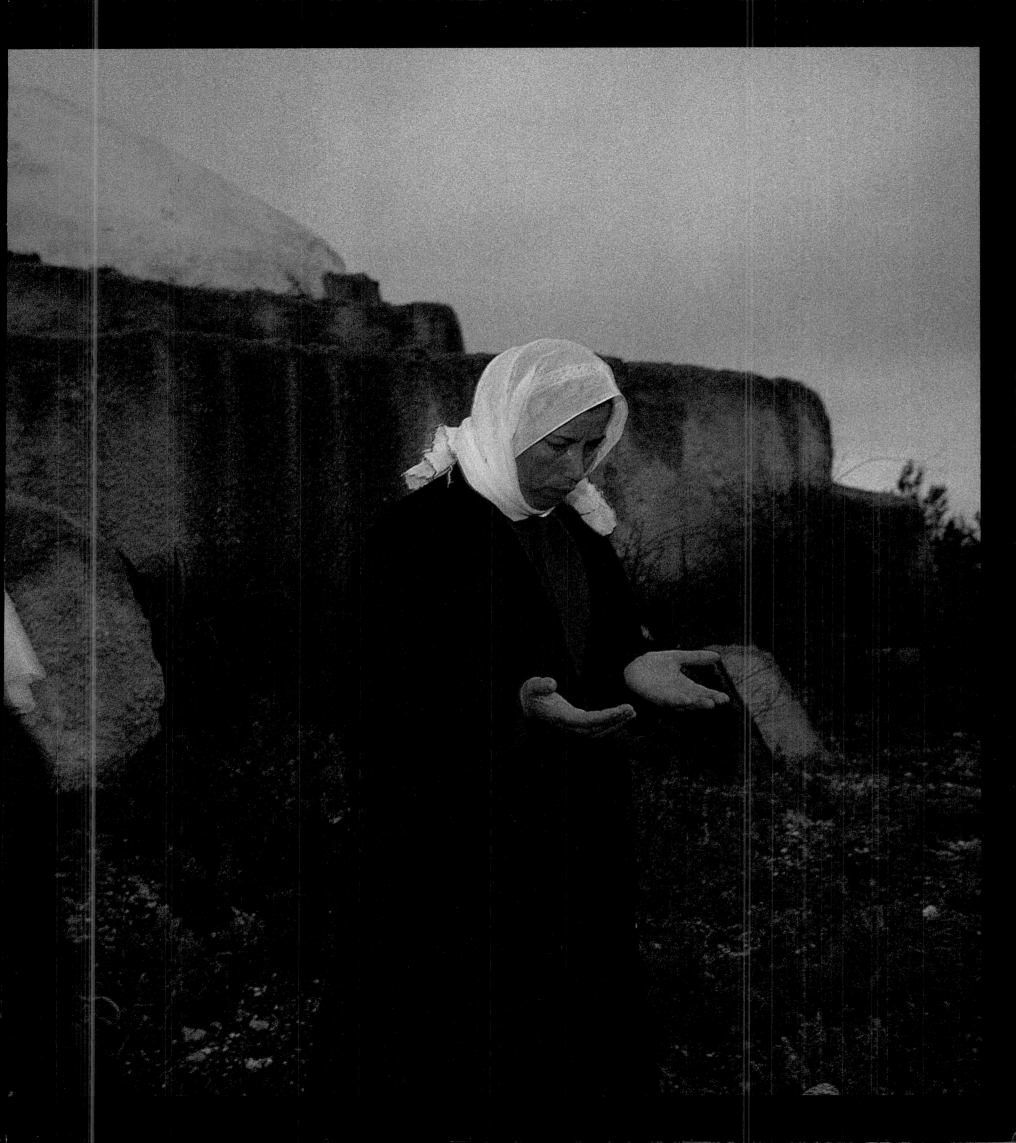

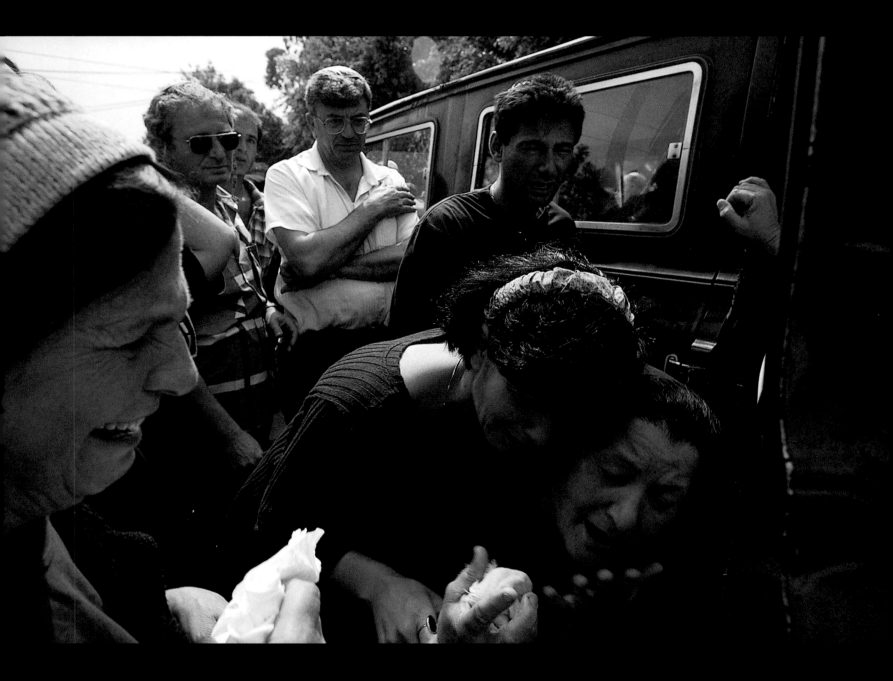

GALILEE 1995

The family of Asher Attia collapse in grief
at his funeral. He died when a car bomb
exploded beside the bus he was driving.

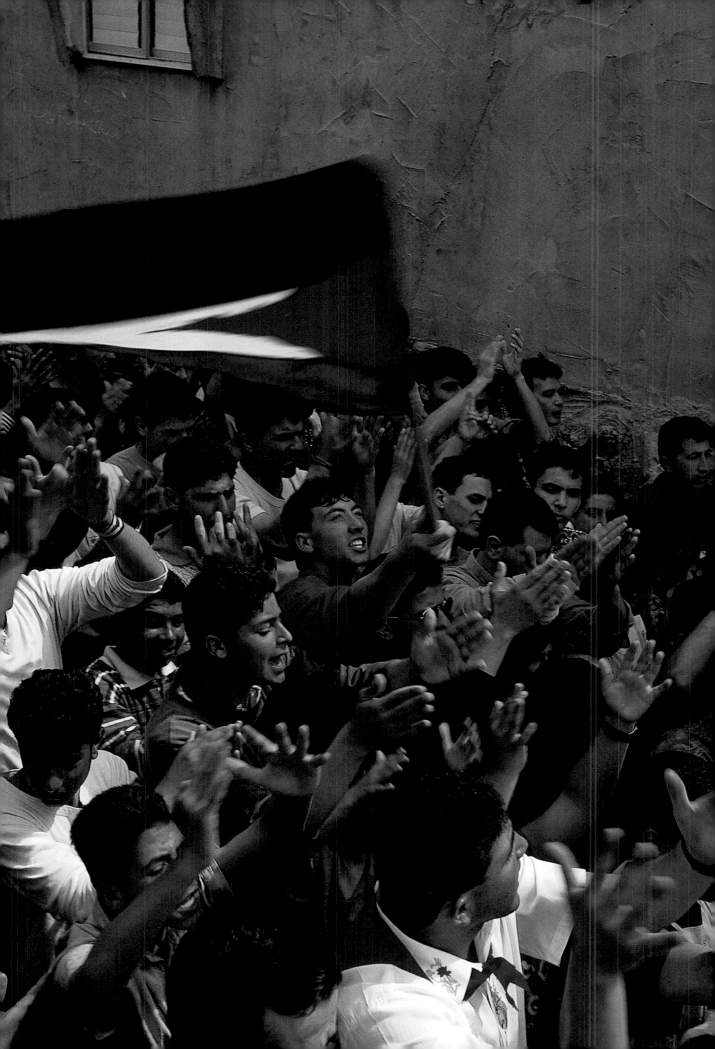

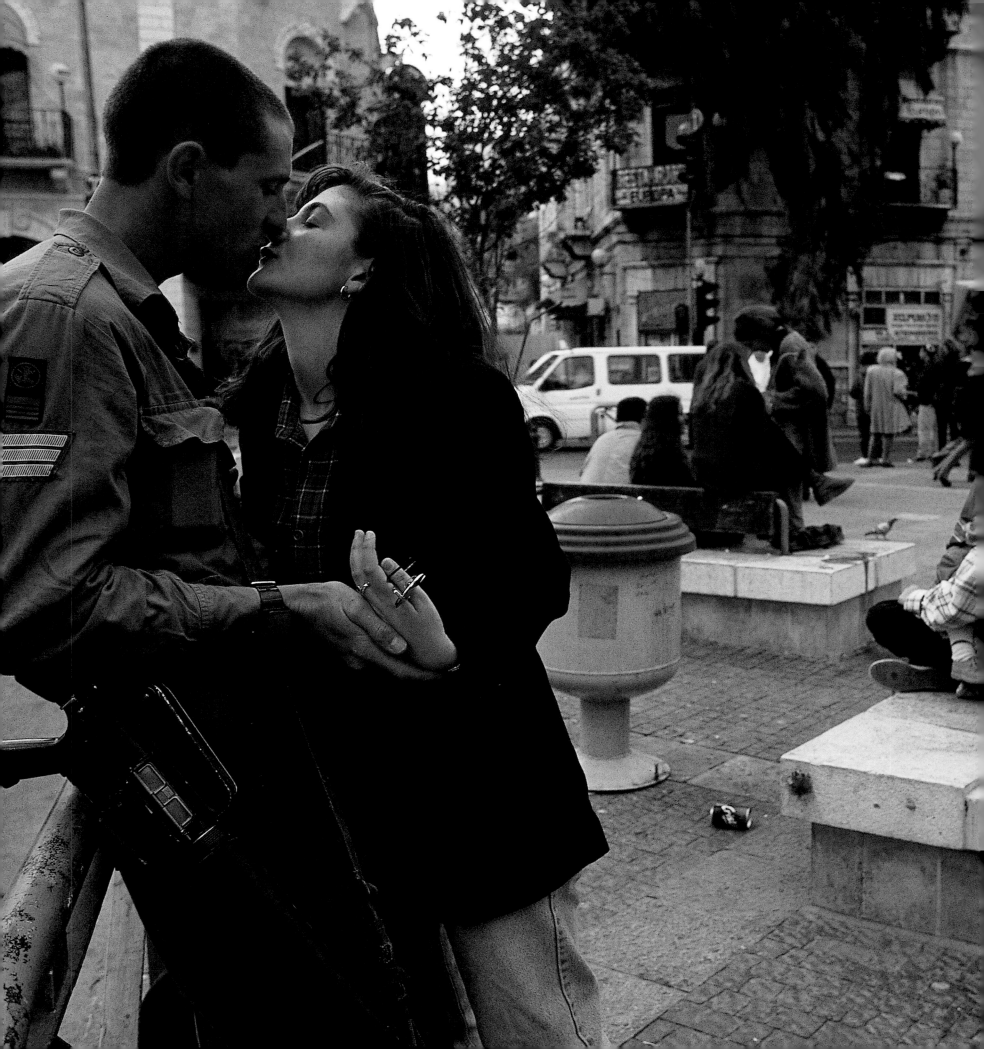

JERUSALEM 1996

A stolen kiss between an off-duty Israeli
soldier and his girlfriend goes unnoticed
in West Jerusalem's Zion Square, where
young people socialize on stone benches

221

GALILEE 1995

Faith burns brightly during the Jewish
holiday of Lag b'Omer when Hasidic
Jews light bonfires to honor Rabbi
Simeon, survivor of the Bar Kokhba
revolt of A.D. 132-35.

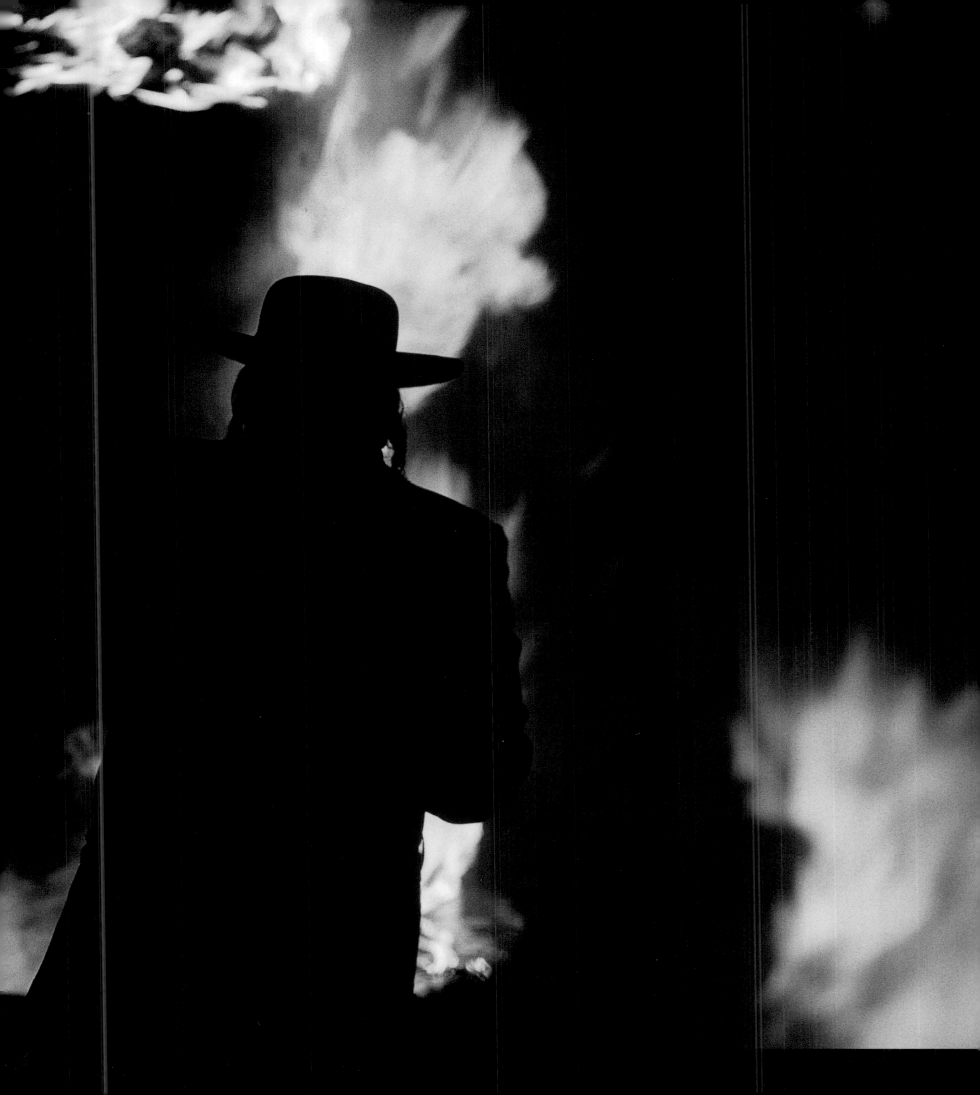

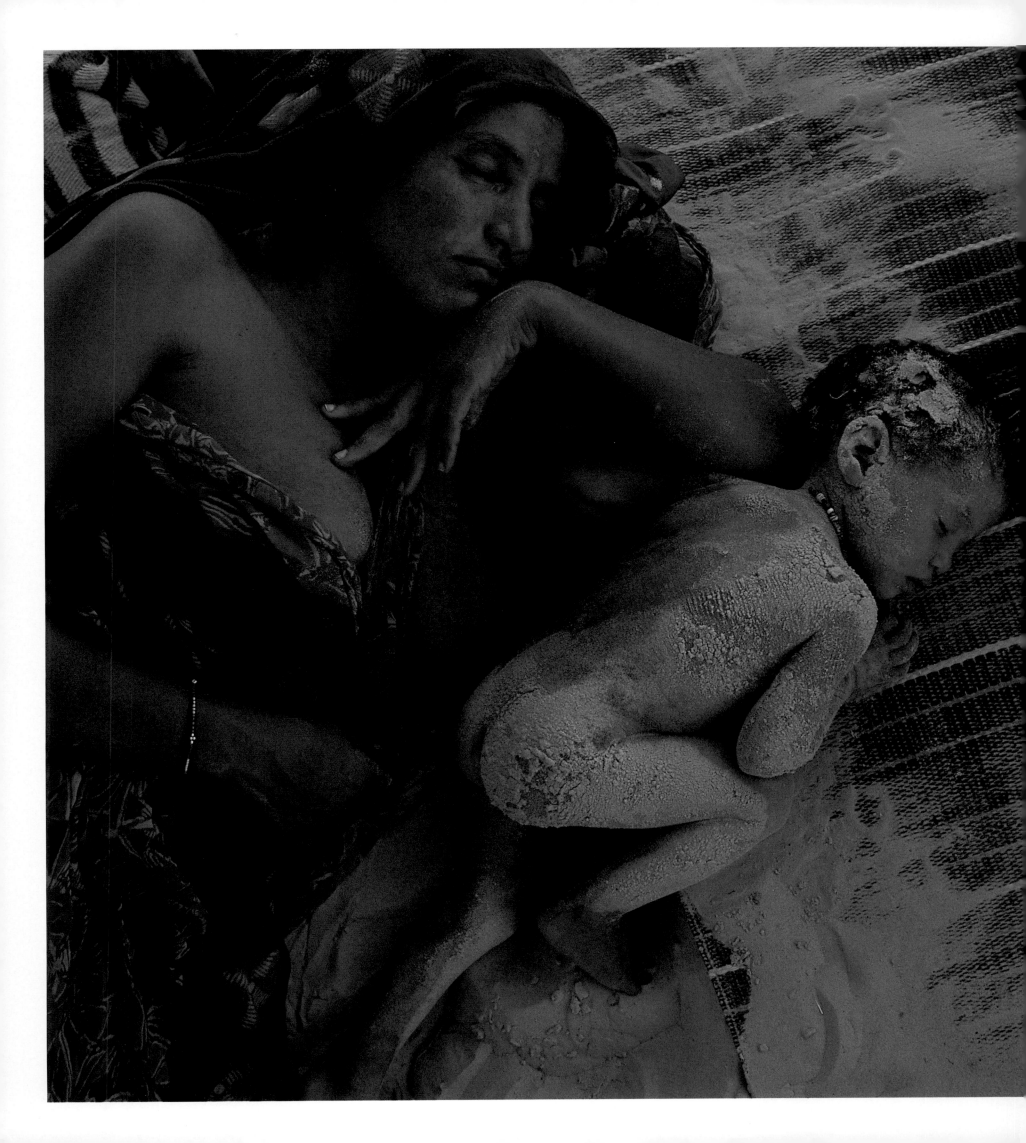

THE
INCANDESCENT
MOMENT

MARGARET BOURKE-WHITE • RUSSIA 1930s

Children in the village school in
Kolomna gaze solemnly into Bourke-
White's camera during her visit to
the Soviet Union.

PREVIOUS PAGES

JOANNA PINNEO • MALI 1998

Covered by a blanket of sand from
a dry lake bed, a family naps in the
middle of the afternoon.

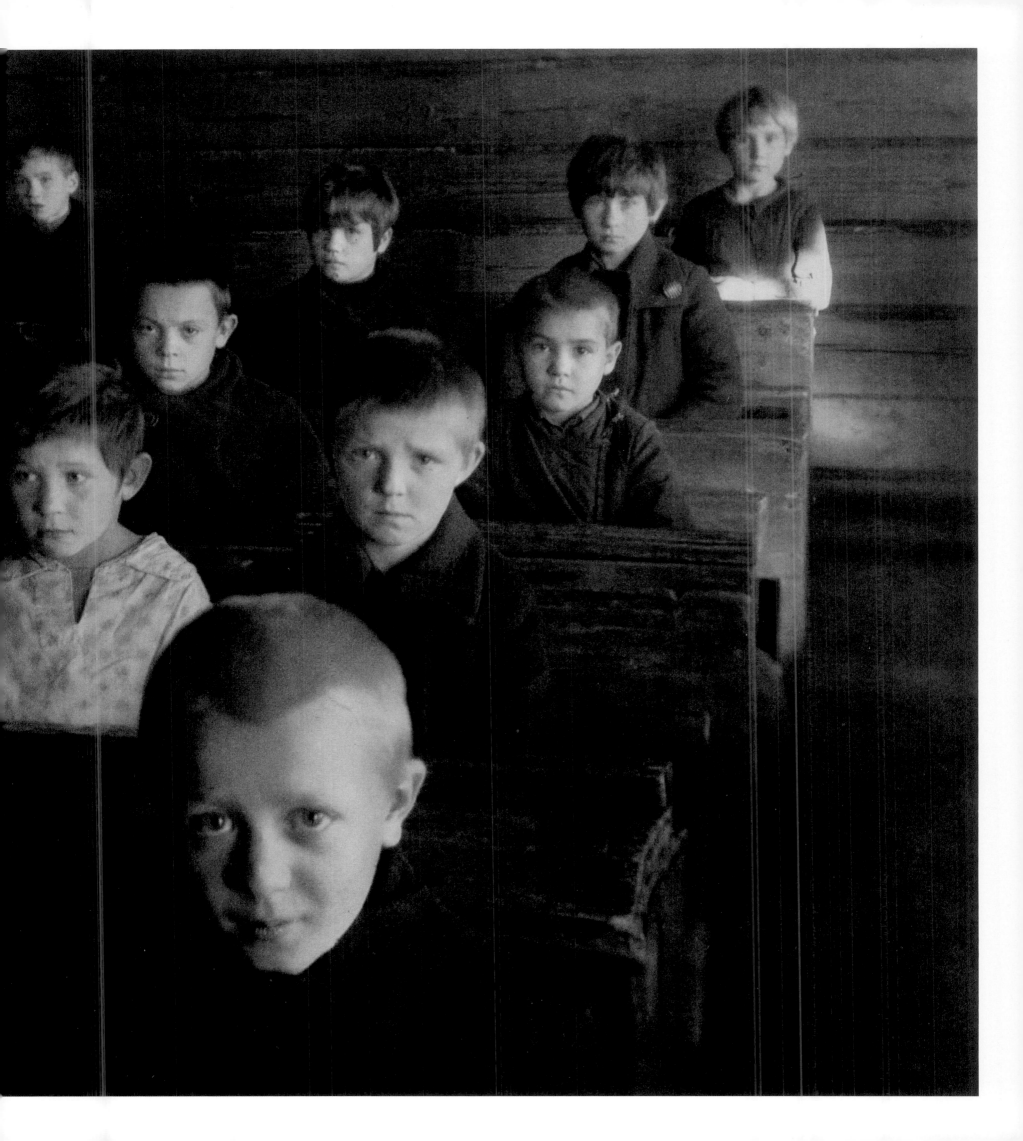

ALEXANDRA BOULAT • ALBANIA 2000

For a clean start on St. George's Day,
Arian Parllaku gets a traditional scrub,
with flowers and an egg rub for luck.

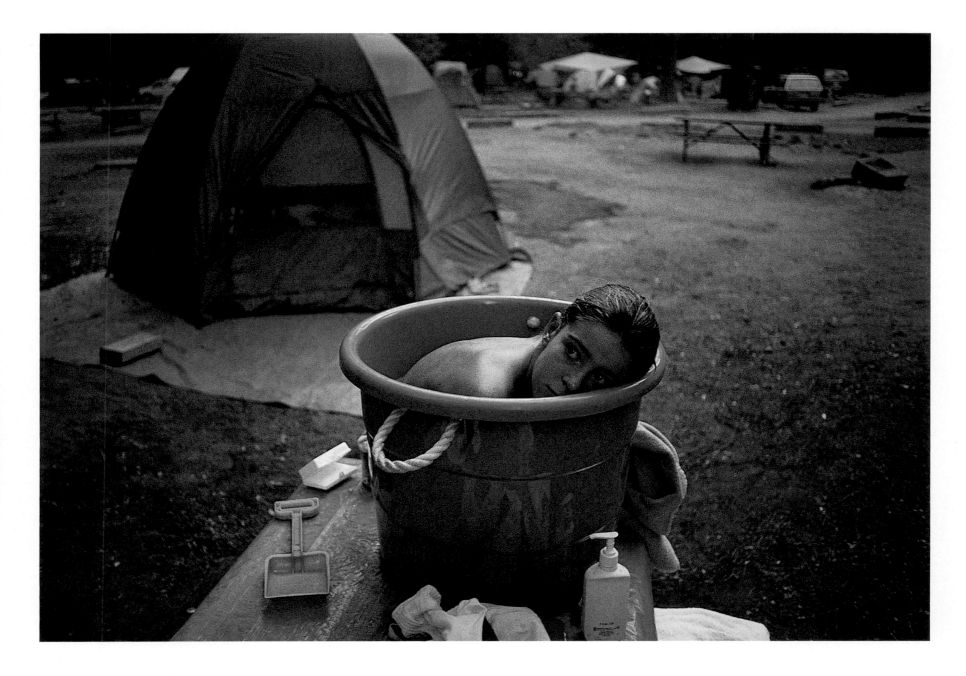

MELISSA FARLOW • YOSEMITE 1994

Snug in her tub, a young camper takes
an outdoor bath in Yosemite, one of the
treasures in the U.S. National Park System.

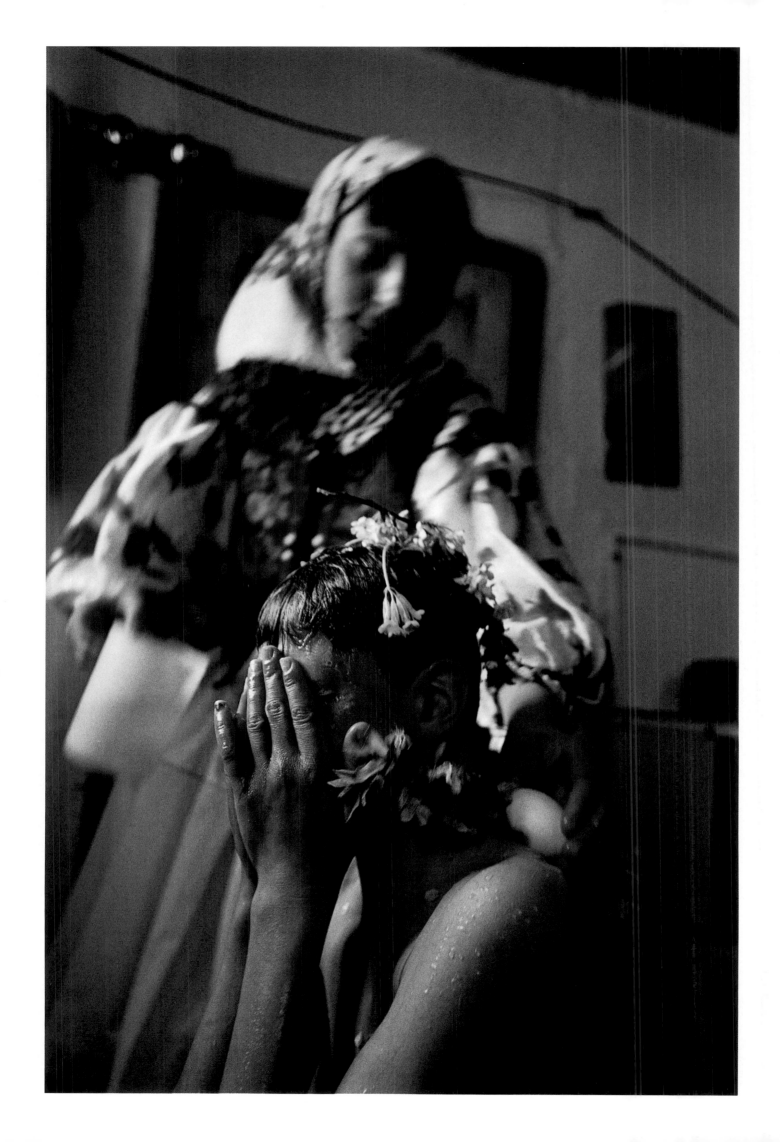

THERE'S A KNOCK ON THE DOOR of an apartment in Helsinki and Ella Eronen, one of Finland's most beloved actresses opens it and lets a photographer in. "Wait," she says to the photographer, who is unpacking a camera. "You don't want to photograph me; you want to photograph 'Madame.'"

She puts on the costume of "Madame," her most famous role, and poses with the theatrical flair of the actress she is, moving around and stationing herself at various spots in the living room. The shooting progresses, formal, posed, and then there is a pause as Eronen sits down on a snow-white couch for a brief rest.

She is in her 80s now. Her skin has the translucence of parchment, her face the delicacy of porcelain, with the fine cracks and traces aging imparts. A gilded wall clock hangs above her couch. Opposite that there is her portrait painted by her husband. In the painting, done decades earlier, she is also dressed in costume—an extravagant cascade of black silk and lace. It's the same costume she wears now, the costume of "Madame," an actress who felt lost unless she had a role to play.

As her younger self stares down with gentle irony from the portrait, Ella Eronen lifts a hand mirror to check her makeup. At that nanosecond, the camera clicks, recording the chimera of age seeking to recapture youth.

It's a magical photograph. To Jodi Cobb, the photographer, it's something more. It's that thrilling elusive "moment between moments," the culmination of hours with a camera trained on a subject, days of waiting for appointments to fall into place, weeks of preparation, months of separation from family and friends, and the eternity of angst that goes into putting together a story in pictures.

A photographer walks the narrow streets of Jerusalem, and comes upon a cobblestone square in the business district of the western part of the city. Young people sit on stone benches. Traffic whirls past; red lights blink on and off. In the middle of the flow, two lovers meet by a guardrail. She leans against him, head tilted up for the kiss. He cradles her head, his automatic rifle hanging by his side. As the kiss joins the lips, the camera clicks and records two people lost in each other, oblivious to a world around them that requires even amorous off-duty soldiers to carry weapons at all times. It's a photograph of intimacy in a totally public setting. Annie Griffiths Belt, who took the picture, had been seeking a human face for the young soldiers who live everyday lives in uniform in a city where war seems never to end. After weeks of searching, she found it in that fleeting instant.

Such pictures are a heartbeat in time. To seek out and pounce on those moments is the passion of photography. The women who have claimed this passion as their own approach their work in different ways. They may be driven to shoot for different reasons. They may be drawn to different subjects. Their styles may vary. But they pursue the same elusive goal: to preserve that instant when the stars align to make magic. Such moments are as incandescent and ephemeral as a dream.

"I remember being in Nigeria and entranced by this African woman's skin," says Joanna Pinneo. "It was like velvet. I looked at her eyes; she seemed to know me. I remember her turning and looking at me. I remember the light. Although I kept taking pictures, she didn't look startled; she just moved calmly on. I remember coming to the realization I hadn't had a conversation with her, but I *thought* I'd had a conversation with her, and I felt I knew her and she knew me. Not only the whole world of her beauty was open to me, but this wordless relationship we had experienced."

How do these things happen? Who knows? The goal is not to explain, but to capture.

"In Haiti, I would spend a lot of time in the slums," Maggie Steber recalls. "It is hell on earth, just endless garbage and filth. Then out of nowhere, a little girl in a tattered dress skips by. In her hair, she's wearing a new red bow that cost a penny. She's singing a song. If that's not confirmation of the human spirit, what is?"

The human spirit, perhaps, is photography's greatest subject. "To be good," Dorothea Lange said, "photographs have to be full of the world."

It's a world full of sadness and joy. Photographs record it all. They tell of birth and death and most things in between.

Much has been said about the aggressive, acquisitive language of photography. Photographers "take" a picture. They "get" this; they "capture" that. Photographers give, too. They illuminate the human condition. In doing so, they also give hope. "Photography can change people's ideas, can change their minds, can change their actions," says Jodi Cobb. "I guess that's one of the things that keeps us getting up in the morning and going out with our cameras."

There is an enchantment to photography: For every picture that gets away, something turns up in its place. Life balances itself. Equilibrium settles in. The passage of time smooths the rough edges. The world takes a quarter turn. The moon lifts into view. The impossible happens. Magic happens.

"There's not a trip that something miraculous doesn't happen," says Sarah Leen. "These are soul-changing moments. Whether it's being invited into a house. Looking at a vista. Seeing the light. That's when you think. That's when you know and can say: 'This makes it worthwhile.'"

Such incandescence can happen anywhere, anytime. It can happen almost without warning. "I just shake at new experience," says Annie Griffiths Belt. She describes the time a fisherman welcomed her to his waterborne realm on the Sea of Galilee. He made a place for her in his small wood boat. He made strong, dark coffee and offered it in a tiny cup. His graciousness overwhelmed her. "I had tears in my eyes," she remembers. Such moments of grace are one of the rewards of a photographer's life. There are the things that happen when you least expect them and they inspire, if not awe itself, then something close.

"The best moments are the surprises," explains Jodi Cobb. "The unexpected elements that slipped in from the side. Or how the film translates the colors and light. The way the light hits a surface and makes it sparkle. The way all the expressions of the people in a picture line up." There are many such moments in her photographs. The mysterious figure in black darting across the Saudi desert. The soft shimmer of white satin on a model's body. The vibrant, exclamatory red of a geisha's lips. They are wonderful images, but more than that, they are memorable.

"There's a photograph she did in Jordan in the early 1980s when she had access to the Royal family," recalls illustrations editor Kathy Moran. "It's a little red tricycle that belongs to one of the princes, and it is parked right at the bottom of a long sweep of red-carpeted steps. It's a small touch that most people wouldn't have noticed, and every time I see that photograph I laugh."

For Cobb, part of the joy of photography is that it is active, not passive. "It's the dance, the motion, the choreography I love—the sheer physicality of it," she says. "The moving around, the working with people; moving close, moving back, getting out of the way, and catching other people in

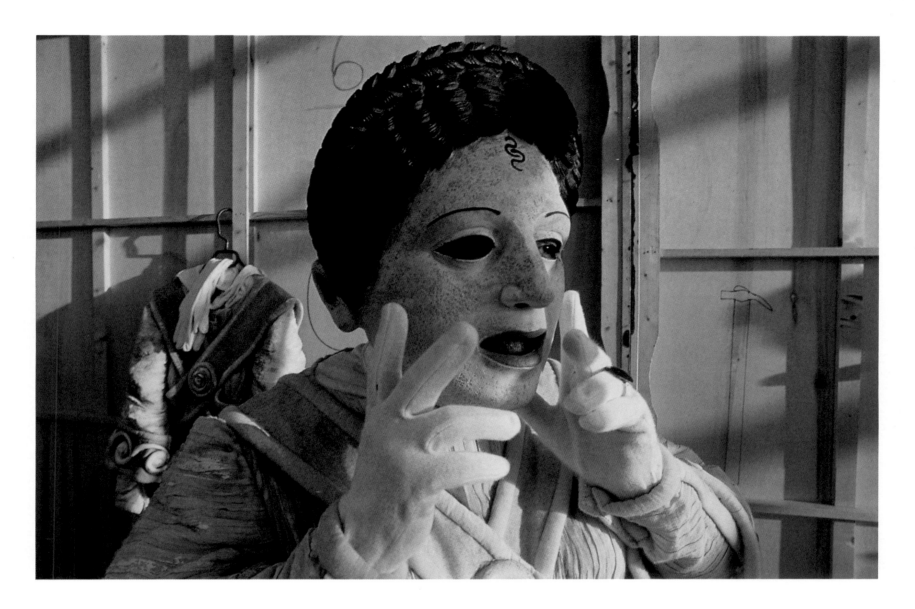

SISSE BRIMBERG • SICILY 1994

The drama of the past unfolds when actors like this one from the Classical Theater School of Syracuse take the stage of an
ancient Greco-Roman theater south of Palermo, Sicily. The ruin is open for performances 14 days a year.

movement. It's not standing behind a tripod, organizing everything in front of me. I want to surprise
myself, too."

Sometimes the joy comes from small, quiet moments. While covering a story on the
American poet Walt Whitman, Maria Stenzel immersed herself in the man's work, finding inspiration
for the photographs and for herself in the poems. She brought the poems to visual life with images of
the things Whitman wrote about: the blunt vitality of the New York skyline; the stormy swell of the
ocean; the soft summer light on dune grass. She carried Whitman's *Leaves of Grass* with her in the
field and would call a picture editor back at Society headquarters from a phone booth:

"Listen," she would say, and launch into a poem:

"Afoot and light-hearted I take to the open road,

Healthy, free, the world before me...."

Her voice glowed.

232

Sometimes that joy comes when, after many long, lonely hours of work, light, color and

composition suddenly come together and a photograph happens.

"I was on the Marquesas Keys, 30 miles west of Key West, trying to photograph frigate birds," recalls Bianca Lavies, a retired staff photographer who specialized in natural history subjects and worked for the magazine in the 1970s and '80s. "They were nesting there for the first time in the United States. The United States Fish and Wildlife Service was fussy about how long I could spend shooting them and had come along to monitor my work. I had to wade through waters frequented by sharks to get to them. I was allowed to have three sessions, a half-hour each, to photograph the birds. The first day nothing much happened, but the next morning I went back, and the rim light was great, and I knew I was getting something fantastic." That something fantastic—a mother frigate bird sheltering its nestling—ended up as a cover photograph on the magazine. "I was often cold. I was often wet. I was often tired," Lavies says, looking back on her 18 years on the magazine. "But I was always happy."

Life doesn't hold still. Time passes. Faces fade. Events grow dim. Only a photograph holds the moment in thrall. A photograph brings it back—real, vivid, immediate. We look at it and laugh or cry. Sometimes both.

Why take pictures? To preserve that moment. To hold fast to an instant that is scarcely a blink in eternity. "Photography documents history," Maggie Steber says. "I could almost weep about it. Sometimes I think the only important thing photography can do *is* document. I frankly don't care if anyone remembers me. But remember the pictures and remember the people in the pictures."

What motivates Maggie Steber to document history, or Jodi Cobb to wait for an aging actress to put down her mask, or Annie Griffiths Belt to capture a stolen kiss in the middle of a Jerusalem square? There are many reasons. Listen:

To peel back a curtain.

"I like intimate stories that show a closed world, whether it's Saudi women or the Japanese geisha," says Jodi Cobb. Her story on Saudi women was a near-miracle. Photography is taboo in that culture. The assignment was an unbroken litany of rejection and refused permissions. First she got stopped taking a picture of the outside of a building. Then the police stopped her and said it was illegal to photograph anything in Saudi Arabia, especially women. Then, the Saudi government withdrew her travel permissions halfway through the assignment. She ended up shooting indoors with the consent of her subjects ("The women didn't mind me photographing them, but they didn't want the men to see me photographing them.") or from the backseat of a car with a 400-millimeter lens. "It was the fewest number of rolls of film I've ever shot in my life," she says. "I didn't think I was going to pull it off up until I looked at the film afterward."

In her work on the geisha, Cobb penetrated the hidden world of women forced into their role by adversity or tragedy. Out of such stricture and sorrow, the triumph of the geisha was to transform themselves into living works of art. "The two cultures—Saudi and Japanese—are as different as you can get, but in their heart and soul women want the same things," Cobb observes. "They want dignity, they want respect, they want love, they want a sense of security, and they want personal freedom."

To bear witness.

"I covered the velvet revolution in Czechoslovakia, the fall of the Berlin Wall, the breakup of the Soviet Union," Alexandra Avakian says. "I was fascinated with what people will

do to change their situation. I was drawn to aspiration born of desperation. I felt it was important to be a witness."

To bear witness, even if it breaks your heart.

It was the period of the first elections in Haiti, in November 1987. "Every day 20 to 30 people were being killed to frighten people and keep them from voting," Maggie Steber says. "Every morning the journalists would get up and drive around and look for the dead bodies. We were driving around, looking; people would stop and pull you over to show you a body. One morning, I said to a Haitian friend who was with me, 'I can't do this again. I feel like a vulture.'

"Then my Haitian friend, said, 'Look Maggie, you *have* to photograph these people. You have to record that they lived and died. They died for a reason. You are their only voice, and if you don't record their death, you don't record their life.'

"I said, 'Beatrice you are right.' It was easier after that."

To find a connection between work and oneself.

"I wanted my work and my heart to be in the same place," says Susie Post. As a freelance photographer she worked for nonprofit groups, including a Baptist mission, and photographed stories about the orphaned children of parents taken by AIDS, the drought in Kenya, and migrant workers in Texas. Later, that same sense of purpose would carry over into her work at NATIONAL GEOGRAPHIC in stories on West Virginia's New River, the Aran Islands and a book on the Pan American Highway. "It is important that I do work that feeds the soul," she explains.

To find solid ground, perhaps, even, a home, for oneself.

"I feel as though the Wodabe nomads in Niger became my home and family," says Carol Beckwith. "I lived with them and learned their language. They became my roots. I was much happier living that life than I am living a Western life. I find the Western world more difficult. In Africa, you're always a part of the community; you don't feel the kinds of isolation you often feel in Western culture. Dealing with basic survival among the Wodabe has more immediacy for me than dealing with survival in the world of 20th-century London or New York. It gives me a greater sense of myself than paradoxically I could expect to find here."

For the experience.

To say you were there on the day a Maya tomb was opened. There for the fall of Duvalier in Haiti or the rise of Khatami in Iran. There the instant a shaft of sun touched a peak in Peru. There for shivery magic of the northern lights in Canada. "I'm like a collector," says French photographer Carole Devillers, who has covered stories on the Wayana Indians of French Guiana and Africa's Sahel for NATIONAL GEOGRAPHIC. "I don't want the past to go." A photograph is proof positive. You were there. You saw. You heard. You felt.

For the sheer pleasure of it.

Says a photographer of her discovery of the camera as a young girl of eight, "I loved having a camera in my hand and a pocketful of film. I shot cats, the way shadows fell on the ground, the life around me." There was excitement in her voice and a sense of urgency. It was as if there would never be enough film to capture everything she saw.

To change the world.

"I see photography as a crusade," says Lynn Johnson. "I'm not just here to hold up the

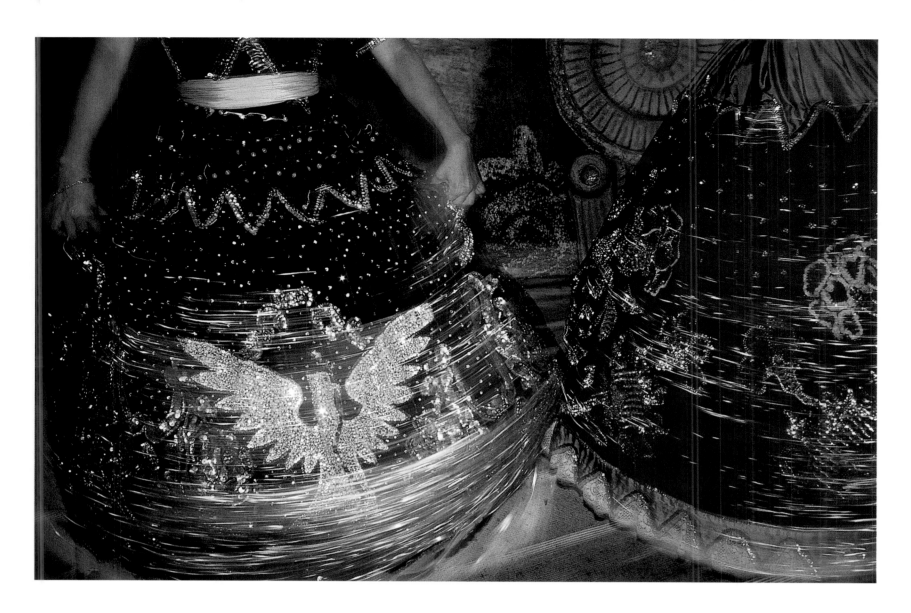

SISSE BRIMBERG • MEXICO 1990

A blur of sequins shimmer from swirling "China poblana" dresses worn by dancers in Acapulco.

mirror. I think we're supposed to improve the world. We're not just here to distill it down to color and composition. Editors have seen the extremes of the world. We are always being asked to come up with superlatives, to take the next step. It can corrupt the process. Every so often I talk to myself. I say, 'What is your intention?' It has to be right. It has to be true."

To show that people have the same needs; the commonality of joy, sorrow, hope, and fear.

"The more I travel, the more I see we're all alike, whether Bombay or Boston," says Karen Kasmauski. "We show who these people are…."

They're all of us, of course. Photography is biography, displaying humanity in all its joy and sorrow, glory and shame. Photography is a spreadsheet of nature, showing a world rich in diversity: animals, fish, birds, people. It is a historical record, confirming the reality of what was. Here is what your Aunt Nancy wore at cousin May's birthday party. Here is how your mother looked as a young woman. Look at how vibrantly yellow the wildflowers were that day in the mountains.

And in looking for the moment between moments there is joy.

"I find myself laughing out loud when I'm taking pictures," says Jodi Cobb.

JODI COBB • THAILAND 1996

One of the many faces of gender,
a *katoey*, or transvestite, works at an
upscale cabaret featuring male performers.

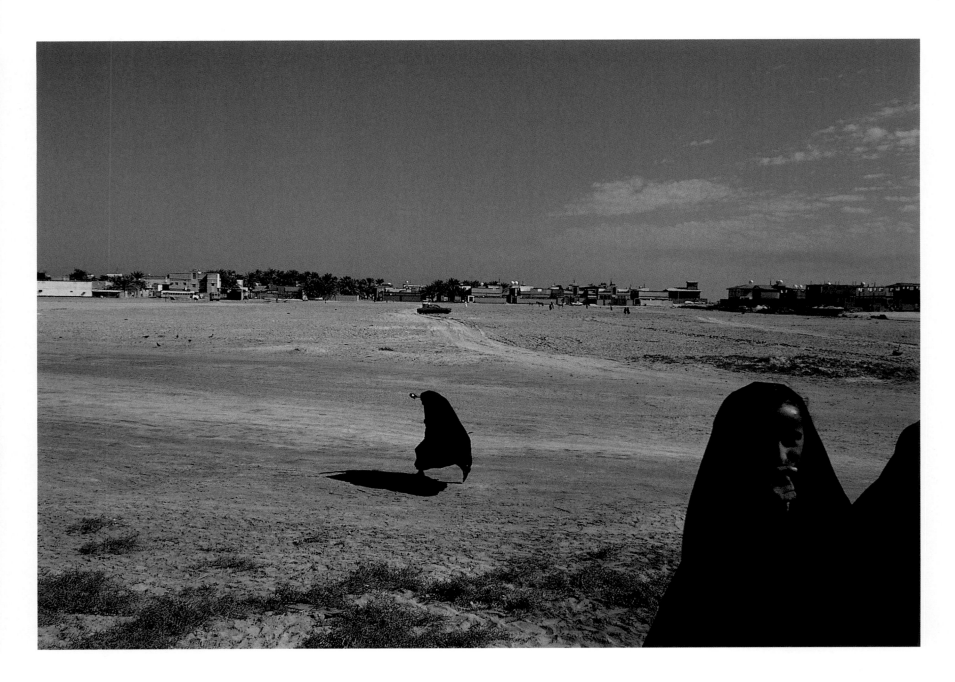

JODI COBB • SAUDI ARABIA 1987

The enigmatic figure of a girl in a cloak
scurries along an oasis. "I was shocked to
see the cloak on girls so young," says Cobb.

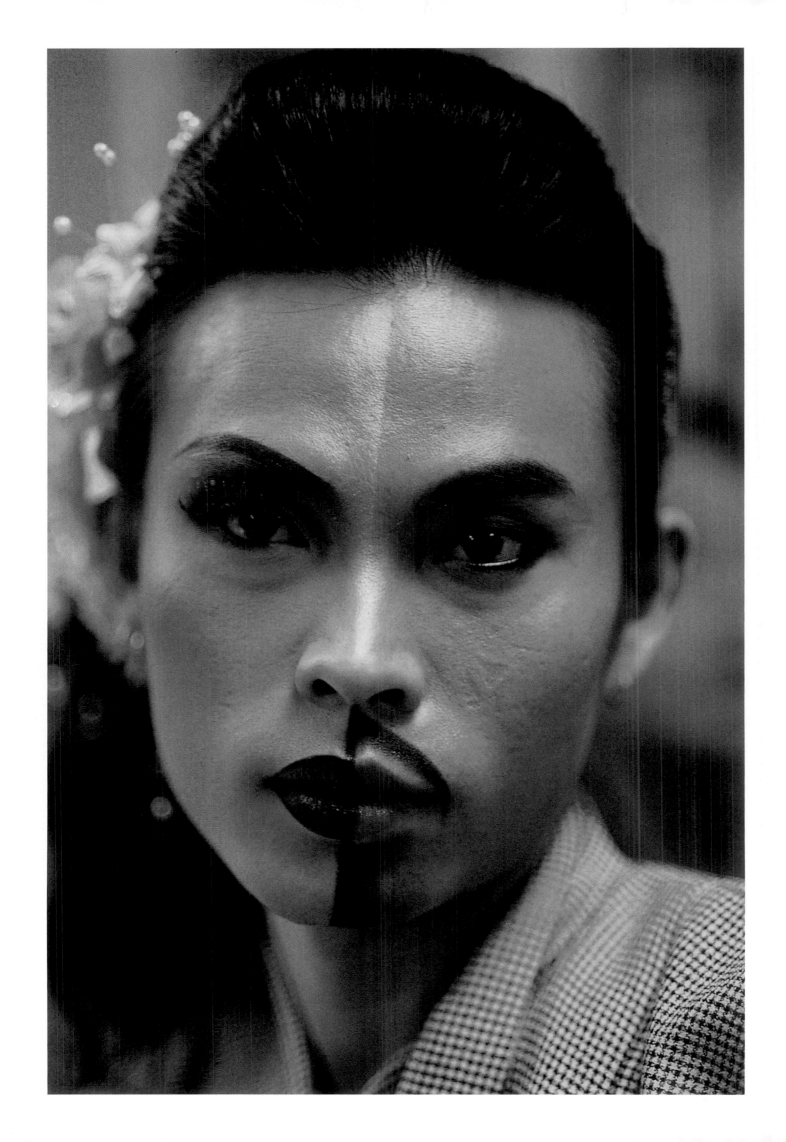

MAGGIE STEBER • MIAMI 1992

The drama of everyday unfolds before
Manuel and Ruben Rodriguez. Behind
them: a homeless man pushing his cart
of possessions. In front: a jitney bus in
flames. Neither seems odd.

258

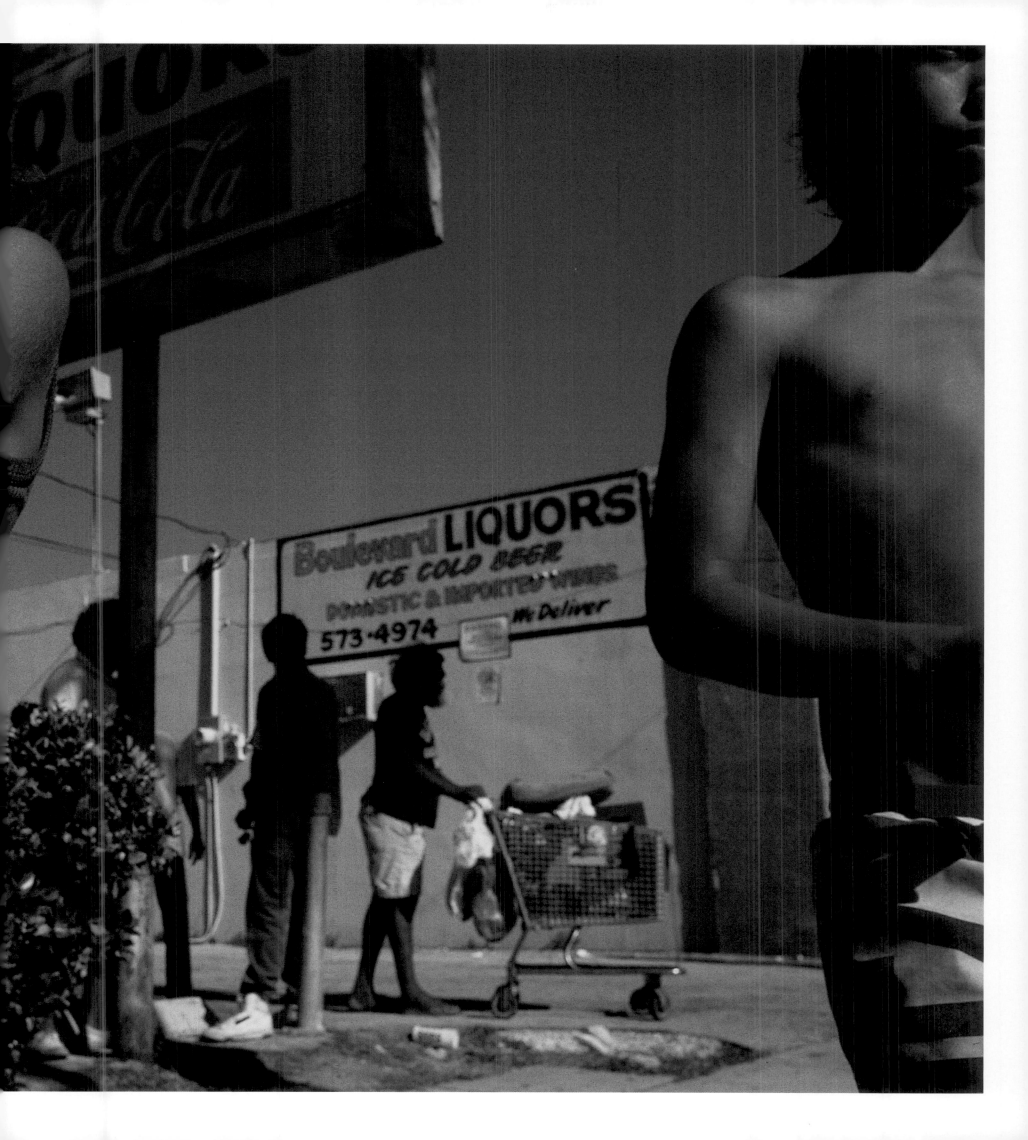

AS ONE OF THE MOST versatile photographers at NATIONAL GEOGRAPHIC or anywhere else, Sisse Brimberg can shoot practically any kind of story and do it beautifully. She has covered stories on natural history ("Sea Otters"), archaeology ("Lascaux Caves"), history ("Magna Graecia"), geography ("Yakima Valley"), and biography ("Hans Christian Andersen"). Brimberg is confident with light. She is confident without light and can turn a technically difficult situation into a tone poem of a picture. She also has a rare talent: the ability to do studio photography as skillfully as field photography. "She dismisses her talent at still-life photography," says a picture editor, "but it's a fine art to take a rock and make a beautiful image of it." Brimberg trained as a photographer in her native Copenhagen, and like many young hopefuls harbored the dream of working for NATIONAL GEOGRAPHIC. Unlike many others, she made it come true. "She wrote to me from Denmark, saying she wanted to work for NATIONAL GEOGRAPHIC," recalls Bob Gilka, the former director of photography who hired her in 1976. "I wrote back and said: 'There's not much chance,' What a sucker! One day I'm sitting in my office and get a call from the reception desk: 'There's a woman named Sisse Brimberg here to see you.'" She proceeded to talk her way into a job, and the rest, as they say, is history. Biographical subjects like "Catherine the Great," shown here, are particularly challenging. The photographer must feel her way into the shoes of the subject, then conjure the past with only imagination and serendipity as allies.

RUSSIA 1998 Two women nearing St. Basil's evoke the eve when a German princess, later Catherine the Great, arrived in Moscow with her mother.

RUSSIA 1998

With her admiral grandfather, a young
girl watches graduation at a Russian
naval school.

RUSSIA 1998

Soaring on the wings of private joy, a young
woman skips down the embankment of
the Neva River in St. Petersburg.

RUSSIA 1998

With a bit of show-off self-mockery,
a sculptor displays his muscles in an
old Russian bathhouse.

RUSSIA 1993

A ballerina sits in quiet solitude before
a performance of *Swan Lake* at the
Mariinsky Theatre in St. Petersburg.

267

WOMEN PHOTOGRAPHERS
AT NATIONAL GEOGRAPHIC

Published by the National Geographic Society

John M. Fahey, Jr. President and Chief Executive Officer

Gilbert M. Grosvenor Chairman of the Board

Nina D. Hoffman Senior Vice President

Prepared by the Book Division

William R. Gray Vice President and Director

Charles Kogod Assistant Director

Barbara A. Payne Editorial Director and Managing Editor

David Griffin Design Director

Staff for this Book

Barbara Brownell Editor

Marianne Koszorus Art Director

Kathy Moran Illustrations Editor

Mary Jennings Researcher

R. Gary Colbert Production Director

Richard Wain Production Project Manager

Lewis Bassford Production Manager

Janet A. Dustin Illustrations Assistant

Peggy J. Candore Assistant to the Director

Robert Witt Staff Assistant

Elisabeth MacRae-Bobynskyj Indexer

Manufacturing and Quality Management

George V. White Director

John T. Dunn Associate Director

Vincent P. Ryan Manager

Phil Schlosser Budget Analyst

Library of Congress Cataloging-in-Publication Data

Newman, Cathy
 Women Photographers at National Geographic / Cathy Newman.
 p. cm.
 Includes bibliographical references (p.)
 ISBN 0-7922-7689-2
 1. Photographs and photographers. I. Title.

00-037993

x

NOTES ON THE CONTRIBUTORS

CATHY NEWMAN began her career writing for the *Miami News* and joined the staff of NATIONAL GEOGRAPHIC magazine in 1978. As a senior staff writer, she has covered such diverse subjects as the Shakers, trout, beauty, the English Channel Tunnel, and Cape York Peninsula, Australia. Her first book, *Perfume: The Art and Science of Scent,* was published by National Geographic in 1998.

KATHY MORAN has picture edited a wide range of articles for NATIONAL GEOGRAPHIC magazine, from history to natural history to underwater adventure. She edited the book *Cats,* published by National Geographic in 1998, and co-edited *Odyssey,* by Thomasson Grant, in 1988.

TIPPER GORE is a photographer and author whose career began at *The Tennessean*. Her photographs have appeared in newspapers and magazines, including *Newsweek* and *American Photographer*, and recently were exhibited at the Corcoran Gallery. Her book *Picture This,* 1996, documents her life during her husband's first term as Vice President of the United States. Her images also appear in the multi-photographer book, *The Way Home: Ending Homelessness in America,* 1999.

NAOMI ROSENBLUM is an independent scholar and author of the acclaimed *World History of Photography, A History of Women Photographers,* and *Lewis Hine.* She lectures widely and has taught art history and the history of photography at New York's Brooklyn College and Parsons School of Design, as well as abroad. With Milton Brown and others she co-authored the *History of American Art,* and she has written in monographs, books, and periodicals on Adolphe Braun, Lewis Hine, Paul Strand, and other contemporary photographers.

ACKNOWLEDGMENTS

When Nina Hoffman, senior vice president of The National Geographic Society, proposed the idea of this book, it proved, among other things, that the politics of gender was alive, well, and kicking furiously. Thank you, Nina, for putting the subject of women photographers out there for discussion and for supporting this book through its journey into print. Much appreciation is also due Barbara Brownell, the project manager and editor, who, gracefully, but with great firmness, kept those of us who worked on this book on track and headed in the right direction. I am grateful to my colleagues who made this a collaborative project with a true sense of mission: Kathy Moran, illustrations editor; Marianne Koszorus, designer; and Mary Jennings, researcher. Additional thanks to Naomi and Walter Rosenblum, Bob Poole, Susan Smith, Mary McPeak, Mark Jenkins, Heidi Splete, and most of all to the women and men I interviewed who so generously and openly shared the joys and anxieties of their passion for photography.

Cathy Newman

Many thanks goes to the National Geographic Image Collection, whose staff worked steadily to retrieve the photographs for this book—especially Flora Davis, Hilda Crabtree, Steve St. John, and William Bonner. I am especially grateful to Al Royce for giving me the green light to work on this project and to Zain Habboo for always "jumping in"—to do a lab run, return transparencies, or to lend support in any number of ways.

Kathy Moran

The Book Division would also like to thank Martha Christian and Lyn Clement for their reviews of the text.

PHOTOGRAPHIC CREDITS

DUST JACKET: front cover, Joanna B. Pinneo; back flap, Sisse Brimberg; back cover, clockwise from top left, Hien Huynh, Kim Gooi, Jesus Lopez, Don Belt, Wade Davis.

FOREWORD & INTRODUCTION: 6, National Geographic Photographer Jodi Cobb; 8-9, Anna Susan Post; 10-11, Jodi Cobb, NGP; 12-13, Annie Griffiths Belt; 14-15, Jodi Cobb, NGP; 16-17, Jen & Des Bartlett; 18, Eliza Scidmore; 21, Harriet Chalmers Adams; 22, Margaret Bourke-White; 24, Ella Maillart; 27, Kathleen Revis.

INSIGHT: 28-29, Jodi Cobb; 30-31, Maggie Steber; 32, Jodi Cobb, NGP; 33, Lynn Abercrombie; 36, Karen Kuehn; 42-43, Alexandra Avakian/Contact Press Images; 44-45, Jodi Cobb, NGP; 46, Stephanie Maze; 47, Natalie Fobes; 48-49, Harriet Chalmers Adams; 50-51, Sisse Brimberg; 52, Lynn Johnson/Aurora; 53, Mary Ellen Mark; 54-55, Jodi Cobb, NGP; 56-57, Alexandra Boulat/SIPA Press; 58-59, 60, Jodi Cobb; 61, 62-63, Sisse Brimberg; 64-65, Jodi Cobb, NGP; 66, Karen Kasmauski; 67, Edith S. Watson; 68-69, Karen Kasmauski; 70-71, 72-73, 74-5, 76, 77, Jodi Cobb, NGP.

BEYOND THE HORIZON: 78-79, Carol Beckwith & Angela Fisher; 80-81, Jodi Cobb, NGP; 82, Bianca Lavies; 83, Dr. Darlyne A. Murawski; 87, David and Carol Hughes; 90, Dieter and Mary Plage; 94-95, Beverly Joubert; 96-97, Joanna B. Pinneo; 98-99, Maria Stenzel; 100, Laura Gilpin; 101 Jinx Rodger; 102-103, Alice Schalek; 104-105, Carol Beckwith & Angela Fisher; 106-107, Melissa Farlow; 108-109, Sarah Leen; 110-111, 112, Dickey Chapelle; 113, Harriet Chalmers Adams; 114-115, Jean and Franc Shor; 116, Lynn Johnson/Aurora; 117, Stephanie Maze; 118-119, Jodi Cobb, NGP; 120-121, 122-123, 124, 125, 126-127, Maria Stenzel.

WOMEN'S WORK: 128-129, Annie Griffiths Belt; 130-131, Lynn Johnson/Aurora; 132, Lyda I. Suchý and Mišo Suchý; 133, Dorothy Hosmer; 136, 140; Karen Kasmauski; 144-145, Lynn Johnson/Aurora; 146, Marty Cooper; 147, Carol Devillers; 148-149, Belinda Wright; 150-151, Karen Kasmauski; 152-153, Jodi Cobb, NGP; 154, 155, Joanna B. Pinneo; 156-157, 158, 159, Alexandra Boulat/SIPA Press; 160-161, 162-163, Joanna B. Pinneo; 164-165, Lynn Johnson; 166, Sarah Leen; 167, Maria Stenzel; 168-169, Alexandra Avakian/Contact Press Images; 170-171, 172, 173, 174-175, 176-177, Karen Kasmauski.

BALANCING ACT 178-179, Anna Susan Post; 180-181, Joanna B. Pinneo; 182, Annie Griffiths Belt; 183, Vera Watkins; 187, Mary Ellen Mark; 191, Maggie Steber; 194-195, Karen Kasmauski; 196-197, Alexandra Avakian; 198-199, Sarah Leen; 200, Harriet Chalmers Adams; 201, Annie Griffiths Belt; 202-203, Karen Kasmauski; 204-205, Sarah Leen; 206, Lynn Johnson/Aurora; 207 Lynn Johnson; 208-209, Maria Stenzel; 210-211, Karen Kasmauski; 212, Melissa Farlow; 213, Yva Momatiuk; 214-215, Jodi Cobb, NGP; 216-217, 218, 219, 220-221, 222-223, Annie Griffiths Belt.

THE INCANDESCENT MOMENT: 224-225, Joanna B. Pinneo; 226-227, Margaret Bourke-White; 228, Melissa Farlow; 229, Alexandra Boulat/SIPA Press; 232, Sisse Brimberg; 238-239, Jodi Cobb, NGP; 240-241, Lynn Johnson/Aurora; 242, Melissa Farlow; 243, 244-245, Jodi Cobb, NGP; 246, Lynn Johnson; 247, 248-249, Sarah Leen; 250-251, Sisse Brimberg; 252, 253, Annie Griffiths Belt; 256, 257, Jodi Cobb, NGP; 258-259, Maggie Steber; 260-261, 262-263, 264, 265, 266-267, Sisse Brimberg.

Composition for this book by the National Geographic Society Book Division. Printed and bound by Cayfosa Quebecor, Barcelona, Spain. Color separations by North American Color, Portage, Michigan.

ADDITIONAL READING

Allen, Thomas B., ed. *Images of the World: Photography at the National Geographic*. Washington, D.C.: National Geographic Society, 1981; *American Photo*. Special Issue: Women in Photography. March/April 1998; Bendavid-Val, Leah. *National Geographic: The Photographs*. Washington, D.C.: National Geographic Society, 1994; Bourke-White, Margaret. *Portrait of Myself*. New York: Simon & Schuster, 1963; Bryan, C.D.B. *The National Geographic Society: 100 Years of Adventure and Discovery*. New York: Harry N. Abrams, Inc., 1987; Didion, Joan, *The White Album*. New York: Simon & Schuster, 1979; Fisher, Andrea. *Let Us Now Praise Famous Women*. New York: Pandora Press, 1987; Hendrickson, Paul. *Looking for the Light: The Hidden Life and Art of Marion Post Wolcott*. New York: Knopf, 1992; Hurley, F. Jack. *Marion Post Wolcott: A Photographic Journey*. Albuquerque, New Mexico: University of New Mexico Press, 1989; Livingston, Jane, Frances Fralin, and Declan Haun. *Odyssey: The Art of Photography at National Geographic*. Charlottesville, Va: Thomasson-Grant and Washington, D.C.: The Corcoran Gallery of Art, 1988; Moeller, Susan D. *Shooting War: Photography and the American Experience of Combat*. New York: Basic Books, Inc., 1989; Rosenblum, Naomi. *A History of Women Photographers*. New York: Abbeville Press, 1994, and *A World History of Photography*. New York: Abbeville Press, 1997; Sullivan, Constance, ed. *Women Photographers*. New York: Harry N. Abrams, Inc., 1990; Tucker, Anne, ed. *The Woman's Eye*. New York: Alfred A. Knopf, 1973; Whelan, Richard. "Are Women Better Photographers than Men?" Artnews, October 1980; Palmquist, Peter E. *Camera Fiends and Kodak Girls*. New York: Midmarch Arts Press, 1995.

BIOGRAPHIES

JODI COBB has been a staff photographer for NATIONAL GEOGRAPHIC magazine since 1977, and has worked in more than 50 countries, specializing in the Middle East and Asia. Cobb was one of the first photographers to cross China when it reopened to the West, traveling seven thousand miles in two months for the book *Journey Into China*. She covered Israel during Palestinian uprisings on the West Bank. And, as one of the few Westerners ever to enter the closed world of the women of Saudi Arabia, she photographed in the palaces of princesses and the tents of Bedouin for a landmark article in 1987. Cobb entered another world closed to outsiders, the geisha of Japan, for the book *Geisha* published by Alfred A. Knopf in 1995. She has most recently photographed an article, and is working on a related book, which examines notions of beauty and human adornment on every continent. She also recently photographed a project on homelessness in America. Cobb has photographed for seven books in the "Day in the Life" series, including *Australia, Soviet Union,* and *America*. She was a major contributor to a book on the Viet Nam Veteran's Memorial, *The Wall* (Collins 1987); and a book on Hong Kong, *Here Be Dragons* (Stewart, Tabori & Chang, 1992). Cobb's photographs have been in exhibitions at the International Center of Photography; the Corcoran Gallery of Art; the Neikrug Gallery; Visa Pour L'Image, at the International Photojournalism Festival in Perpignan, France; in Amman, Jordan, sponsored by Queen Noor; at the Jimmy Carter Presidential Library; at the Freer Gallery of Art; and in Steamboat Springs, Colorado. Cobb has taught at the Maine, Missouri, and Eddie Adams Photographic Workshops, and has lectured at the International Center for Photography and the Smithsonian. She was featured in the PBS documentary "On Assignment" and has appeared on segments of the *Today Show*, *Sunday Morning with Charles Kurault,* and *20/20*. She has won numerous awards, including White House

Photographer of the Year, the first woman so honored; and the National Press Photographers Association and World Press awards. Cobb received the American Society of Media Photographers Special Achievement Award in 1996 for *Geisha*. Her slide show/video on the women of Saudi Arabia won a silver award at the Association for Multi-Image International Festival. Cobb received her Master of Arts and Bachelor of Journalism degrees from the University of Missouri. As a child, she traveled the world with her family, and grew up in Iran. She now lives in Washington, D.C.

MARIA STENZEL'S photographic career began with National Geographic in 1991. She has completed a dozen stories in less than a decade, including coverage of Antarctica, Las Vegas, and beyond. Stenzel began as a student of photography at the University of Virginia while pursuing her Bachelor of Arts in American Studies. She joined the staff of the National Geographic Society in 1980 as a member of the Photographic Division's Film Review Department where she examined film for technical flaws and delivered reports to photographers in the field. This allowed Stenzel to study the shooting styles of the world's top photographers from whom she sought advice and encouragement for her own work. She attended workshops and began producing stories for the *Washington Post* magazine. In November 1992 her first story, "The Lure of the Catskills," was published in NATIONAL GEOGRAPHIC. Her background in American Studies contributed to her early coverages of the Catskills, America's beekeepers, and Walt Whitman. Stenzel's transition from national to international photographer has helped establish her reputation for adaptability. She celebrated Christmas in a tent in Antarctica while on assignment for her October 1998 story, "Timeless Valleys of the Antarctic Desert." She has since traveled to Kenya, Argentina, Borneo, Bolivia, Tibet, and Hawaii. Stenzel's confidence in her travel skills and ability to grasp the illustrative requirements of a story have resulted in an ever increasing repertoire of published work.

Born and raised in Minneapolis, ANNIE GRIFFITHS BELT earned her Bachelor of Arts degree in photojournalism from the University of Minnesota. Her professional career began while she was still in school, working as a staff photographer for the *Minnesota Daily*. After graduating in 1976, she joined the staff of the award-winning *Worthington Daily Globe* in southern Minnesota. Belt began assignment work for the National Geographic Society in 1978. Since then she has worked on dozens of magazine and book projects for the Society, including NATIONAL GEOGRAPHIC magazine stories on Baja California, Israel's Galilee, Britain's Pennine Way, Vancouver, England's Lake District, Jerusalem, and Jordan. Her photographs have been exhibited in New York, Washington, Moscow, Tokyo, and France. She has received awards from the National Press Photography Association, the Associated Press, the National Organization of Women, and the White House News Photographers Association. She lectures and teaches workshops regularly and has been visiting professor of photography at Ohio University, a featured speaker on the National Press Photographers Flying Short Course, and the subject of a public television documentary about her work. Belt recently joined the National Geographic Book Division as a senior illustrations editor and is editing an atlas of exploration as well as a photobiography of Edward Curtis. With her husband and two children, Belt makes her home in Great Falls, Virginia.

KAREN KASMAUSKI has worked as a contract photographer for NATIONAL GEOGRAPHIC magazine since 1984. She also contributes to a range of other publications produced by the

National Geographic Society, including TRAVELER magazine. Kasmauski's work covers a wide range of interests, from major worldwide science stories on radiation and viruses to a detailed examination of Japan, in coverages of Japanese women and Japan's economic role in Asia. Kasmauski has also looked at subcultures within the United States, such as the African-American culture of the Georgia-South Carolina Sea Islands, and the mountain people of Appalachia. Her work on the global effects of radiation won a first prize in the prestigious Pictures of the Year competition. Kasmauski is a frequent winner in POY as well as the White House News Photographers competition. She is a contributor to *Travel-Holiday* and the German magazine *GEO,* as well as to *Fortune, Forbes, Business Week, Time,* and *Money*. She has worked on several books in the "Day in the Life" series, including *Christmas in America, Baseball in America, Passage to Vietnam,* and *Seven Days in the Philippines*. Kasmauski's own book, *Hampton Roads,* is a photographic exploration of her hometown area, based on her first assignment for NATIONAL GEOGRAPHIC magazine. Prior to working for the Society, Kasmauski was a staff photographer for five years with the *Virginian Pilot/Ledger Star* in Norfolk. Her work at that paper brought her several awards in the Pictures of the Year competition including a first in picture essay, as well as special recognition in the Robert F. Kennedy Awards for outstanding coverage of the disadvantaged. Kasmauski has degrees in anthropology and religion from the University of Michigan. She lives in Virginia with her husband and two children.

MARIE-LOUISE "SISSE" BRIMBERG was born in Copenhagen, Denmark, in 1948. While attending photography school, where she graduated cum laude, Brimberg worked as an apprentice in a commercial photography studio. After her apprenticeship, Brimberg established and managed her own photography studio for five years in Copenhagen. Using funds provided by a Danish grant, she came to the National Geographic Society to study photographic techniques and to manage the internal photo studio. Brimberg's hard work and dedication to developing her craft paid off. As a regular "shooter" for NATIONAL GEOGRAPHIC magazine, she has published more than 20 articles. From her work documenting the life of fairytale author Hans Christian Andersen, to her elegant and lyrical photographs in "The Magic of Paper," to her creative chronicling of the Viking culture, Brimberg's images are enchanting. In 1998, she documented the National Geographic Society's landmark 100th anniversary. Her work has also been featured in traveling exhibits: In 1996, a companion exhibit to "Track of the Manila Galleons" story traveled through public museums in Mexico. Her photographs from "The Magic World of Hans Christian Andersen," were exhibited in New York and Denmark in 1980. Her work has also been on display at the White House Press Photographers Annual Exhibition and with a National Geographic traveling audiovisual exhibit. Brimberg has participated in many educational seminars and served as a principal speaker at the Sociedad Mexicana de Fotógrafos Profesionales, the National Press Photographers Association Annual Conference, and the Bellevue School's Masters series. Her contributions to the field of photojournalism have been noted. Her story on migrant workers won first prize for Picture Story of the Year from the National Press Photographers Association. She is a member of the White House Photographers Press Association. Sisse Brimberg lives in Mill Valley, California, with her husband and two children.